D0788502

Pilgrim Chaucer

Center Stage

Pilgrim Chaucer:

CENTER STAGE

Dolores L. Cullen

FITHIAN PRESS · SANTA BARBARA · 1999

Published by Fithian Press
A division of Daniel and Daniel, Publishers, Inc.
Post Office Box 1525
Santa Barbara, CA 93102

LIBRARY OF CONGRESS CATALOGING-IN-PUBLICATION DATA
Cullen, Dolores L., (date)
 Pilgrim Chaucer : center stage / by Dolores L. Cullen.
 p. cm.
 Continues: Chaucer's host.
 Includes bibliographical references (p.)
 ISBN 1-56474-306-3 (alk. paper)
 1. Chaucer, Geoffrey, d. 1400. Canterbury tales. 2. Self in literature. 3.
Psychoanalysis and literature—England—History—To 1500. 4. Christian
pilgrims and pilgrimages in literature. 5. Chaucer, Geoffrey, d. 1400—
Psychology. 6. Tales, Medieval—History and criticism. 7. English poetry—
Psychological aspects. 8. Storytelling in literature. 9. Narration (Rhetoric).
10. Rhetoric, Medieval. I. Cullen, Dolores L., (date) Chaucer's host. II.
Title.
PR1875.S45C85 1999
821'.1—dc21
 99-11191
 CIP

In gratitude
to
Professor Richard Barnes
for
his open mind
and
generosity

First of all…it should be clear that there is only one speaker of the entire poem and that he is also the poem's maker.

—H. Marshall Leicester, Jr.

CONTENTS

ACKNOWLEDGEMENTS

This second Chaucer volume exists thanks to Sabrina and Judy Wenrick—their continuing interested response, even at a moment's notice; thanks to the San Dimas Writers Group—their willingness to travel back with me in time; thanks to Ted Cullen—his expertise as a computer language translator; and thanks to Margie Johnson —her taste-testing reassurance.

Our reactions, which vary according to our frames of mind, become part of the experience of reading...if we do not in some measure project our private thoughts upon the author, we are not reading with the fascination the author presupposed. That he intended us to react does not mean he intended us all to react in the same way.

—*Donald R. Howard, Writers and Pilgrims (1980)*

Preface

PLEASE JOIN ME for the second of three volumes of a new explication of Chaucer's *Canterbury Tales.* Because this new interpretation is a significant departure from what you may have seen or heard elsewhere, it is essential that you know the main point of the first volume, *Chaucer's Host: Up-So-Doun.* That main point is that the Host—the Guide and Judge of all the pilgrims—is a surface image which conceals Christ Himself. This central guiding image of Christ is the heart of Chaucer's creative allegory.

Part of Chaucer's allegorical technique is his skillful use of ambiguous words. The word *host*, for example, has several meanings. A host can be a man who provides hospitality to travelers, a hosteler. The primary medieval connotation of the word, however, is unquestionably the Eucharistic Bread of the Catholic Mass. The dogma of Christ's Presence within this Host gained tremendous prominence in the fourteenth century. Miri Rubin, in her recently published comprehensive study of the effect of the Eucharist on the Middle Ages, declares that "the eucharist provided an axis around which worlds revolved."[1] It would be difficult to exaggerate the importance of this Host, who is Christ present in everyday life.

Having established the fact of the Christic identity in Chaucer's Host, let's turn our attention now to Chaucer himself. We will not analyze whether the narrator is someone other than the poet,

nor whether there is a storyteller separate from the narrator. What do we gain if we specify that Chaucer's "literary character as *persona*...is an upside-down mirror of the author" or "the shadow in reverse of the author"?[2] Chaucer chose to put his thoughts into an imaginative work of literature, rather than a straightforward tract or a treatise. This choice puts him at arm's length from his ideas. Such precautionary measures allowed the poet's controversial, covert statements to escape detection by political or church authorities. These measures were described in *Chaucer's Host: Up-So-Doun*.

Our point of view, now, will be pre-Freud, pre-Jung. I think the poet intended to portray *himself* in some manner as he told the tales. I also believe he carefully trained his words so that they would play games with his audience. His words conceal, divert, challenge, fascinate, and reward readers. Situations the poet creates allow for more, or less, direct communication. More direct would be a story from his own lips, the poet telling of personal "adventures that had befallen" *him*. (This was the directive to *each* pilgrim, according to the plan stated in the *General Prologue*, A 793-95.[3]) Less direct communication would be Chaucer-the-narrator in a dream-world where anything can happen, where limits of time and space do not exist, where symbolic language may predominate. He had previously written several dream sequences so popular in his day: *The Book of the Duchess*, an elegy commemorating Blanche, the wife of John of Gaunt; *The House of Fame*, in which the dreamer is carried aloft by an eagle; *The Parliament of Fowls*, a Valentine's Day debate between an assortment of birds.

The *Canterbury Tales*, however, is probably not a dream (this time Chaucer does *not* say he fell fast asleep and dreamed the adventure he relates), but at the opening of the story the time for rest is not far off. The poem begins at night with its author already lodged in the Tabard. In a short time a company of nine-and-twenty arrive. Chaucer makes the acquaintance of each, and all of the travelers agree to rise early next morning. Then, instead of heading for sleep, the poet seems to make time stand still. He tells us that he will take this opportunity to describe each member of the company, and proceeds to set forth an entertaining cast of characters the like of which had never been seen (or heard) in English literature before. With

many intimate details, we come to know about these pilgrims. They have such diverse personalities, possessions, and peculiarities that we can hardly wait to meet them and hear their stories.

There's a Nun who has a beautiful singing voice, delicate table manners, loves little animals, and wears expensive jewelry. A poor Plowman, who somehow has managed to afford these lodgings, does manual labor to earn his living, transports dung, and faithfully pays his tithe. A Monk, who loves to hunt, keeps greyhounds, fancies roasted swan, will ride with them attired in his fur-trimmed robe. A grotesque Miller, with a hairy wart on his nose, and his thumb on the scale, performs on the bagpipe for the group. (We mustn't allow ourselves to get too interested in these fanciful companions, however, because we will not deal with their detailed explication until the third, and final, volume.) Now let's return to the purpose at hand: Chaucer the pilgrim, the narrator, the storyteller, the penitent.

As Chaucer announces his presence, in lines A 20-22 of the *General Prologue*, he provides a "curiously specific touch" first noted by Ralph Baldwin.[4] The poet says "as I lay ready to wend on *my* pilgrimage." As yet there are no other pilgrims in the picture. They arrive several lines later. The newcomers will accompany the poet on *his* pilgrimage. This emphasis acts like a spotlight on a character with a special part to play. If this is *Chaucer's* endeavor and the other pilgrims are there as an accompaniment, perhaps we should take a closer look at the stories told by this primary Pilgrim. Rather than ignoring them or merely sampling their contents, as is standard practice, a careful study might reveal that his stories are the focal point of the collection. We may also find that they contain more important information than has previously been brought to light.

So our plan now is to meet Chaucer in the *General Prologue*. A review of the basic facts of the poet's life will follow. These facts will serve us like an actor's credits on a theatre program, a documentation of past experiences that prepared him for the performance he is about to give. Next we will listen carefully to the conversation he has with the Host (with Christ) when it is the pilgrim poet's turn to tell a story. We'll examine that story—the tale of *Sir Thopas*—and I guarantee that you will not find it dull, as it is reputed to be. The

Thopas story is eventually interrupted by the Host, by Christ. The interruption is succeeded by a unique situation in the *Tales*: Pilgrim Chaucer is given a *second* chance. Christ stops the poet in mid-adventure and will not allow him to continue, but He asks to hear a *second* tale. Why does Christ precipitate a confrontation? Why does Pilgrim Chaucer get special treatment? One reason might be what was said at the beginning: this is *Chaucer's* personal journey. As a spiritual analogy, the story of Chaucer's *pilgrimage* can be the story of Chaucer's *life*. The Middle Ages did indeed understand man's life to be the road we travel to the heavenly city.

Pilgrim Chaucer's second offering, the translation of an old French story, follows the interruption. We hear of Sir Melibee and his wife Prudence. It will be our purpose to see how Chaucer adds to, deletes from, or modifies the original. How is Chaucer's version different? How is the atmosphere changed? Following *Melibee*, we will close, as Chaucer does, with his Retraction, his review of the works of his life, and the solicitation of God's pardon.

Chaucer holds center stage here. His plan, his creativity, his vocabulary need careful examination. The image you now have of Chaucer will change in the pages ahead. The changes will not diminish him as a poet. On the contrary, a better understanding of his creative plan, along with what he reveals about himself, will endow his image with fullness and life.

PILGRIM CHAUCER
CENTER STAGE

Part of Chaucer's idea is simply that no literary idea can approach its full potential of 'poetic truth' unless it engages the reader's interest and enlists his participation. It demands of us an act of will, for the truth of a poem is in our idea of it.

—Donald R. Howard, "Chaucer's Idea of an Idea" (1976)

I: Introduction

IN THE *Canterbury Tales*, Chaucer as narrator is the first person we meet. Chaucer the penitent is the last one to speak. And, as V. A. Kolve has pointed out, Pilgrim Chaucer's *personal* performance is called for at the mid-point between the curtain going up and his closing monologue.[5] Chaucer is the beginning, the middle and the end. I take this to be more than a chance arrangement.

Some readers will have a problem with my lumping Chaucer the narrator, Chaucer the penitent and Chaucer the pilgrim-storyteller all together instead of cluttering the stage with bit-players. But consider this: When a man tells a joke, he doesn't become a different person during the telling, does he? Or if Robert Redford acts a part in a film, we still recognize him as Robert Redford, don't we? As narrator, as Pilgrim Chaucer, or as intrusive author, I see Chaucer as a lively constant behind these personalities and their actions.

A way of thinking that has always troubled me comes from the following kinds of statements: Chaucer will do the narrating "unbeknownst to the Host." Or, when Pilgrim Chaucer's story is halted, "the author thus is forced to come to the rescue" of the storyteller.[6] A similar point of view gives credit to *Pilgrim Chaucer* (whose existence, in truth, is merely part of a printed page) for his "critical ability" in literature because, quite impossibly, it "had been

developed by many hours spent with his books." It has even been proposed that this parchment-and-ink character has a scheme to use his story "for the purpose of showing up" the Host's lack of ability as a literary critic.[7] These are statements a la Pirandello, a character from a printed page developing an independent life.

It brought me reassurance to find that Bertrand Bronson did not subscribe to the "schizoid notion" of two Chaucers with independent "attitudes and intelligences."[8] Now I know that I need not try to understand how other scholars pictured creative fantasy retaliating against reality, or acting independently without informing the author's imagination. Chaucer, the man who was alive in the fourteenth century, is always in control of all aspects of his creation. The challenge in his creativity involves his *audience*, his readers, not his characters. Imagined actors cannot be pleased or offended by, nor cooperative with, what he portrays them doing. Chaucer presents the pilgrims as living beings, but we must never lose sight of their limitations. Though they had a life in his mind, their only reality now is as words on a page through which the poet still communicates with *us*.

So who is this Chaucer that I have asked to take center stage? He is the composite of all aspects of Chaucer; they are all making the pilgrimage. I am assuming that when the poet identifies a character as "Chaucer," he wants us to know something about himself, about his personal thinking.

The first "Chaucer" we meet is the narrator. He has been called "naive," a "cheerful numbskull."[9] If we blithely go along with this thinking—by ignoring or disregarding his odd ideas, seeming misconceptions, or contradictions as being evidence of simple-mindedness—we could be blind to the *author's* tricking us, misinforming us, concealing his intentions from us.

Though it is said that the narrator appears to lack mental skills, it is also said that he appears to be "strangely omniscient." The author creates a *fantasy* of nested, remembered images. As the production begins "we pass through the looking-glass of the narrator's mind into the remembered world of the pilgrimage; from it into the remembered worlds of the various pilgrims; and from these sometimes even into the remembered worlds of their characters."[10] And we cannot forget that this narrator's mind is part of

Chaucer's mind, Chaucer's creative genius. The poet had used this technique before. In *The House of Fame* he is explicit in saying that the action of the story takes place in his mind. (523–27; 1101–03)

Chaucer the poet, then, is outside the poem. The narrator, Pilgrim Chaucer, and all the actions *in* the poem are made of the poet's thoughts. As Donald Howard says, "given all the formalistic distinctions we can make between the man and the artist, or among the man, the pilgrim, and the poet, *we never know* positively which we are hearing *and are not meant to know.*"[11] I find this appraisal comfortable, straightforward. Chaucer the medieval poet uses his skills of construction to teach and delight his audience: How will my audience be most entertained? How can a point be most cleverly concealed to make the search stimulating? (The Middle Ages loved the search.) Shall my narrator give an indication? Who shall express a helpful hint? How can I confide the importance of a detail without making it obvious? How shall I demonstrate a change? What can I do that I've never done before? How to bring it to a conclusion? Have I remembered everything?

Though much of what Chaucer gave us was material garnered from his reading (books found or not yet found), his imagination deserves more credit than it is generally given.[12] The stories are not what makes the *Canterbury Tales* so remarkable. It is Chaucer's genius for creating the world of the pilgrimage that is unique and captivating. He adds a personal touch and complexity by having his alter ego perform as the actual teller of *all* the tales, and doubly significant (perhaps doubly challenging), he includes stories inspired from inside of himself.

We, his audience, are ready to begin our search for the "sentence," that is, the concealed meaning—the "fascinating pursuit"—so precious to the medieval mind.[13] We travel with the poet on *his* pilgrimage, as we listen at a deeper level to disclosures concerning his life.

The romantic form of the pilgrimage, as an enveloping structure for Chaucer's vision, is the ideal form to convey such meanings [regarding Christian moral vision] as grow out of a theocratic view of the universe.

—Paul G. Ruggiers, *The Art of the Canterbury Tales* (1965)

II: The General Prologue

ANYONE WHO has taken a Chaucer course has heard about April with its "shoures soote (sweet)," and the small birds that "maken melodye" and sleep "with open yë." The well-known *General Prologue* of the *Canterbury Tales* opens in the spring. Of the timely activities one might associate with the season—love, renewal of life—Chaucer associates a penitential journey.

This is not difficult to explain. It's the time of Lent and Easter, penance and salvation. *Lent*—in another connotation now obsolete —would have been understood by Chaucer to mean *spring* as well as the forty penitential days of preparation for the Paschal Feast.

The narrator describes how the time of year makes folks long to go on pilgrimages. Palmers ("professional" pilgrims) would head for the Holy Land or a shrine in a foreign country, he confides. But our cast of pilgrims, who will be drawn from every part of England, are bound for the popular shrine at Canterbury, the cathedral where Thomas á Becket gave his life for his beliefs. They come

> Especially from every county's end
> Of England to Canterbury they wend.

Please understand that those words are my own. Just below is Middle English for the same lines.

And specially from every shires ende
Of Engelond to Caunterbury they wende.

(A 15–16)

(Chaucer's words hold the *real* story, and in most cases—if we don't worry about pronunciation—they are quite readable for a twentieth-century audience. For general ease of reading, however, the lines will be given in Modern English. You might imagine that an interpreter is supplying today's words as we listen to the Pilgrim storyteller. For readers who want the Middle English words as well, they can be found with the notes. Only in the story of Thopas, because of its special reputation, will this plan be changed; that's all that need be said for now.)

Pilgrims could have many reasons for their journey. The *only* reason given, however, is that they wish

The holy martyr (Thomas á Becket) to seek,
Who had helped them when they were sick.[14]

Why would no other reason be mentioned? There could be *so* many instances of blessings to be grateful for—a gaining of knighthood, a beneficial marriage, a bountiful harvest, a renewed friendship, a safe sea voyage, a timely inheritance, a favorable legal decision—but only one possibility is expressed. Actually, a reason need not have been given. They could simply visit the shrine of St. Thomas out of reverence for the saint himself. The important thing is that a reason *is* given and that reason is that St. Thomas had been a help in time of illness. Do you suppose that Chaucer is recalling a personal illness, and that's why this single reason came to mind? It's an odd thought, but one to be considered.

Now our narrator, who has been describing the setting from backstage, comes into view.

In Southwark at the Tabard I lay
Ready to wend on my pilgrimage
To Canterbury with a very devout heart.[15]

He confides readiness "to wend on *my* pilgrimage." Baldwin remarks

that "the use here of *my* rather than the indefinite article one might expect, is a curiously specific touch."[16] Chaucer is alone and devoutly anticipating his journey to Canterbury. Then, as if by coincidence, or by Providence, a large group arrives.

> At night there came into this hostelry
> Nine-and-twenty in a company,
> Of sundry folk, who by chance were drawn together
> In fellowship, and pilgrims were they all,
> Who toward Canterbury would ride.[17]

Chaucer takes immediate interest in these folks. By sunset he has spoken with every one of them. He says this with one information-packed sentence:

> Shortly, when the sun had gone to rest,
> I had spoken with every one of them
> So that I was of their fellowship immediately.[18]

I am confused and flip the page back and then forward again to make sure that line A 23 says they arrived at *night*, and seven lines later it says that when the sun had gone to rest (that is, by the time the sun had set), Chaucer had spoken to each of the travelers. If we agree that "night" means *night*, the indications of time are backwards. On the other hand, if we explain that "night" in this case really means *evening*, we have the amazing accomplishment of the poet speaking to, and becoming acquainted with, each of the twenty-nine of this diverse company of personalities and ranks—from humble folk to figures of authority—within minutes. The time elapsed would be the brief period between what we recognize as evening and the moment when the sun disappears below the horizon.

My feeling is that "night" means *night*, and the references to time are actually given in reverse order: our attention is directed to the night and then toward the sunset. We will find that *Time*, in this adventure, will never be what we expect. Chaucer will see to it that before the end of the *General Prologue* the whole idea of time will be a blur.

The group is apparently quite compatible. The trip should be a

pleasant one. The efficiency with which the poet gets to the heart of his subject, the economy of words used to arrive at their time of departure, is remarkable—but misleading.

> And we agreed early to rise,
> To make our way as I will describe to you.[19]

We would expect that the venture would begin immediately following "I will describe to you." But our expectation of the progress of linear time is side-stepped once again. We move from night, to sunset, and then to a plan to rise early. In spite of this quickly-to-bed-and-early-to-rise impression, what was originally said in two lines (A 31–32) will now be expanded to six hundred seventy-one lines. Chaucer, with time on his hands, is ready to tell us *all* about his companions.

The descriptive section which follows, the narrator's extended monologue, is some of the most entertaining reading in the English language. But while we are being entertained, a problem is developing: We have been cut adrift. Is this the same night? Or is he speaking from a time in the future looking back? Is Chaucer talking to us from the Tabard, or telling us recollections of bygone days? It's no longer clear. We are losing touch with where we are.

If we disregard the problem of "where or when," the poet seems to have an otherwise well-thought-out plan to describe each of his companions.

> Methinks it according to reason
> To tell you the *condition*
> Of each of them, as it seemed to me,
> And which they were, and of what *degree*,
> And also what *array* they were in.[20]

The words I have emphasized can have several meanings. Their multiple meanings will take on real importance when we compare what happens to Chaucer's stated plan as the pilgrim introductions are completed.

Chaucer's presentation of his characters, seen in modern terms, is very much like the ingenious technique used by animators in

films. The poet is equipped with a life-size sketch pad. He indicates the name of a character at the top of the pad ("The Physician," for example) and then quickly, but deftly, develops a colorful image for us to see. While he is engaged with a sketch the figure is well-lighted and has life and movement. But as soon as Chaucer moves on to a new sheet and indicates the next name, the previous pilgrim's actions are suspended and the brightness dims. Each retains its colorful potential, but they wait to be called on again by the poet in order to regain the spotlight. We watch with keen attention as the characters come to life: the lusty, curly-haired young bachelor, who wears a short, embroidered garment with long, wide sleeves; the solemn merchant with the forked beard, who wears elegant boots and a fur hat; the hardy seaman, survivor of many storms, who has his dagger dangling from a cord about his neck; the much-married, gap-toothed woman, who wears spurs and scarlet stockings; the hard-drinking churchman whose cherub-like face is marred by scabs and pustules. These are only a few of a variety so splendid that it is more than we could ever have anticipated.

Some of the travelers are grouped together because of a special relationship. Three such groups are: the Knight, his son, and their servant; the Prioress (the primary nun in authority in her convent) and her traveling companions; and the five Guildsmen and their hired Cook. Most of the folk, however, are riding individually: the Monk, the Merchant, the Physician, etc. When we have seen most of those who travel alone, Chaucer forms a cluster of all the remaining pilgrims.

> There was also a Reeve (Keeper of Accounts of all that
> was produced on a manor), and a Miller,
> A Summoner (minor Assistant to a Churchman), and a
> Pardoner (minor Cleric) also,
> A Manciple (Purchaser of provisions), and myself—there
> were no more.[21]

Though this could be seen as a means of finishing the introductions in quick order, it doesn't prove to be so. The poet will again name the Reeve and Miller and Summoner and Pardoner and Manciple separately, and produce a detailed sketch of each, as he

did for all the preceding characters. If he isn't using words eco-
nomically, then he is actually being wordy or redundant. Why
make a featured presentation of them (and himself) as a unit?

Chaucer must have had a special reason for drawing attention
to his association with them. Other designated groups, to this
point, have some common interest, but the only thing common to
the five named here is that they are all described as more or less re-
pulsive, and they are certainly immoral as they steal, lie, swindle,
fornicate, and prey upon the poor. One reviewer was kind in calling
them "rascals."[22] *We* don't yet know all their unsavory qualities, but
Chaucer does. We might consider that humility caused him to
place himself among this cluster of rascals. Perhaps. Then again,
the poet may be thinking of his daily life and may have felt that his
days were naturally spent surrounded by many unsavory characters
such as these. But, then again, what if he is admitting that he truly
qualifies, by immorality, to be among obvious sinners? Whatever
conclusion is to be drawn, Chaucer's reason for creating this little
troupe of rapscallions, and for placing himself with them, is not to
be seen as accidental.

Now we'll take a second look at the narrator's original plan to
acquaint us with the pilgrims: their "condition," their "degree,"
their "array." Comparing those categories with what we find at the
completion of all the sketches, Chaucer seemingly reminds us of
his earlier plan.

> Now I have told you briefly, in a clause,
> The estate, the array, the number, and also the cause
> Of why this company was assembled.[23]

How odd that of the several classifications noted before the por-
traits, only *one* (array) is here at the conclusion. This altered list is
presented without explanation, without drawing attention to the
changes, without any excuse. As listeners, the fourteenth-century
audience would have had difficulty remembering the original plan.
But as readers, we can turn a few pages back, compare his words,
and wonder why they are not the same. Is Chaucer teasing? Is he
trying to keep us off balance? We really don't know where we are,
or what time frame we're dealing with, or—for all the specifics and

details—what Chaucer's scheme is. He tells us (A 715) that he has fulfilled his intention. Has he? I'm *sure* he has fulfilled his intention; we just aren't privy to what his intention is.

Some may feel that the inconsistency in the list of topics demonstrates a lack of organization, a lack of brain-power in this narrator. I prefer to believe that this *inconsistency* is akin to the *inconsistency* of time. The poet is being anything but straightforward.

Having formally concluded the introductions, Chaucer says,

> Now it's time to tell you
> How we occupied ourselves that same night,
> When we stayed in that hostelry.[24]

He'll give us the information *now* (after another delay) that was concealed *between* lines A 32 and A 33 of his early synopsis. Then he provides another two-line synopsis covering all that is yet to come.

> And after I'll tell of our journey
> And all the remainder of our pilgrimage.[25]

These two lines potentially contain all the stories and their imaginative entr'actes. When he says, however, that he'll tell us the "remainder" of the pilgrimage, this is another false impression, because the pilgrimage has not yet begun.

And does he follow through now with the activities in the Tabard? No. Another digression intrudes.

> But first I pray you, that of your courtesy,
> You will not count it my ill-breeding,
> Though I speak plainly in these matters.[26]

This time he asks us to bear with his inadequacies. He goes on to tell us to understand that the words he will use will be the words as he heard them. (A 731–38) At times they are bound to prove offensive because some of the pilgrims are churlish. Crude words are justified, he explains, because if a poet chooses different words in order to be genteel, he is not telling a true story. To be faithful to

the tale, he can spare no one. Courageous words. Their effect, how-
ever, is soon minimized when he begs our indulgence because his
"wit is short." (A 746) He has covered all areas for complaint. If a
tale is too bold, it's because he must use the words he had heard. If
it's too dull, it's because of his lack of mental ability. Now he has li-
cense to do anything he pleases.

For example, he will shortly reopen the subject of describing
his companions, although he claimed it was closed twenty-six lines
before. The ploy is that he must apologize for another failure. (I
consider all his apologies suspect.) This time he humbly asks,

> I pray that you will forgive me,
> As I have not set folk in their degree
> ...as they should stand.[27]

He doesn't refer to the other omitted categories, or tell why he al-
tered the list. Why open the subject again just to cite one omis-
sion? Perhaps he wanted to isolate the topic and bring it to our at-
tention. (We'll pursue this idea further in Book III which concen-
trates on the travelers.)

When Chaucer finishes telling us about his pilgrims, and ex-
cusing the words he'll use, and apologizing for his failings, we are
at the beginning of the evening once again. What he covered in
lines A 33 and A 34, near the opening of the *General Prologue*, is
now expanded to seventy-four lines. We are in the Host's, in
Christ's, Tabard where all the pilgrims are fed and sheltered. To
complete the spiritual parallel of the hidden meaning (the "sen-
tence"), Christ will also offer Himself as their guide. When the ac-
count of the evening activities finally does conclude, the night
passes without so much as a line of comment.

> ...and to rest we each went,
> Without tarrying any longer.
> In the morning, when the day began...[28]

the Host, Christ, gathers the pilgrims in a flock, and the journey
begins. Chaucer resumes his place behind the curtain, becomes in-
obtrusive, once again. The prologue to the *Tales* draws to a close,

and the pilgrimage becomes Christ-centered, as the Host comes to the fore as guide of the pilgrims.[29]

What Chaucer accomplishes in the *General Prologue* is to captivate us, to confuse us, and generally to demonstrate that he is in control. He can make time expand, contract, invert, or even stand still. He can surround us with the conviviality of the Tabard, or immerse us in the adventures of the road. Or he can deliver monologues that delight us, in spite of our being uncertain where we are. The one thing that is certain is that Chaucer has been kind enough (perhaps concerned enough, also) to invite us to enjoy the world he has created in his mind. So, ultimately, having transcended space and time, that is where we are—in the mind of Geoffrey Chaucer.

We are not deeply involved with them [the Pilgrims], nor does he
[Chaucer] ask us to be; but we are very personally involved
with him, to our delight, and with his entire assistance. For he is
almost the only figure in his "drama" who is fully realized
psychologically, and who truly matters to us.

—Bertrand H. Bronson, In Search of Chaucer (1960)

III: A Portrait of Chaucer

IN THE pilgrimage proper, Chaucer makes only one "visual" appearance—when he is called upon by Christ, the Host, to tell his own tale. We will get to that in a bit. But taking a cue from the poet himself—while we have space and time—we will create a portrait of the poet. Through an examination of the minimal evidence about his life, and the remarks made about him by his characters and his contemporaries, his personal storytelling will become more meaningful. When he described each of the pilgrims, he refrained from including a portrait of himself. That's understandable. His fourteenth-century listening audience *knew* him, could see him face to face. But today's audience will gain rapport with the writer/ director/star of the production if the program includes a modest likeness and a biographical sketch.

Scholars have done a meticulous Chaucer-search through records of the 1300s. We are fortunate to have any precise information about him. Most fourteenth-century commoners, as Chaucer was, lived and died without a recorded trace. Diligent researchers have gathered together an assortment of entries from which we know, or can make solid assumptions, about Chaucer's fortunes and how he spent his days.

The year 1340 is a round figure that generally serves as the agreed-upon year of his birth. It actually may have been two or

three years later. Because of the common background of medieval England and France, his family name, *Chaucer*, can be seen as a form of the French *chasseur*, meaning *hunter*.[30] (Some suggest that the family name is a form of *chaucier*, shoemaker. If I were a poet, I'd insist on *hunter*. Just consider, when they created the name "Jeffrey *Hunter*" for the handsome actor, would he have had the same appeal as "Jeffrey *Shoemaker*"?)

We know that his youth was spent in service to the household of Lionel, Duke of Ulster (third son of King Edward III). Countess Elizabeth, wife of Lionel, paid for young Chaucer's clothing in 1357. He was with their family in Yorkshire at Christmastide that year. John of Gaunt, Lionel's younger brother, who was close to Chaucer's age, was also in attendance for the holidays. (John would come to wield great political power and be the poet's patron in years to come.)

While work was being done at Westminster Abbey in the late 1800s, Chaucer's bones (which rest in the Poet's Corner in the Abbey) were exposed, and we learned that he was about five-foot-six.[31] Several portraits exist that show Chaucer to be more or less average in girth, not slender but certainly not obese.

In 1359, when he was nineteen or younger, he had the experience common to generations of young men—he joined the army. King Edward III was renewing his effort to gain the French crown, to rule both England and France. (His claim in France was based on his mother's being of the French royal family.) A considerable advantage to the English was the fact that the French king, in a prior campaign, had been captured. King John was a prisoner in England, being held for ransom. The English army, estimated to be as great as 30,000, included 6,000 men-at-arms, Geoffrey Chaucer's probable rank.[32]

Edward planned to cross the English Channel to Calais, an English possession on the coast of the County of Flanders, and march into France with his army as "a coronation procession on a large scale."[33] His forces would move peaceably through the countryside— only fighting if attacked—until they arrived at Rheims, whose cathedral was the traditional site of the coronation of French monarchs. The army would simply lay siege to Rheims until the

inhabitants acquiesced and accepted Edward's claim to the troubled French throne. The campaign, however, did not develop as planned.

This maneuver was only one of a succession of ongoing phases of what we now call the Hundred Years War, which was "a series of wars waged between England and France in the later Middle Ages, substantially 1337–1453. For most of the period the initiative lay with the English, and the main fighting and resulting devastation took place exclusively in France."[34] Reasons for the conflict were complex. Desire for the French mantle of authority was only one element.

Edward's strike would reasonably have been set for spring, the beginning of good weather, but preparations were prolonged. The landing at Calais (a city which had been won by the English in an earlier engagement of the war) did not happen until October 28. Edward's army had to deal with "a steady downpour" of rain and then with bitter cold. Men and horses suffered greatly. A four-teenth-century chronicler alluded to "the pomp and display of the expedition as it marched out of Calais, [but] it soon degenerated into a…miserable march."[35]

Rheims had been forewarned of Edward's plan; plentiful stores had been laid in. The siege was a failure before it began. Weeks went by; the English army waited and endured. Knowing how spirit and discipline decline in a do-nothing army, Edward allowed (or ordered) his commanders to send out raiding parties to keep up his army's morale. Although French forces did not mount an offensive to break the siege of Rheims, they did confront these smaller groups and "slew, or captured, stragglers and foragers."[36] (Remember the idea of "foragers." You'll need it later.) In a raid on Rethel, a village twenty-five miles northeast of Rheims, Chaucer was among those captured,[37] and was held prisoner until March 1360. King Edward contributed £16 toward the ransom of his valued young servant.

Shortly after Chaucer's release, a French contingent had the effrontery to cross the English Channel and inflict a surprising amount of damage to coastal towns on English soil. In reply, the peaceable plans of the hopeful king-to-be were replaced with "the old policy of devastation." The countryside was ravaged at will.[38]

❧

The Italian humanist Petrarch, in a letter written in February of 1361, describes the campaign's aftermath: The French kingdom had been "laid waste...with fire and sword. Thus when recently I journeyed there...I could hardly be persuaded that it was the same land I had seen before. Everywhere was dismal abandonment, grief, destruction, weedy, untilled fields, ruined, deserted houses... Everywhere appeared the melancholy vestiges of the English passage, the recent, horrible wounds of their devastation." A French observer laments the "pillaging of churches, destruction of bodies...violations of girls and maidens, foul treatment of married women and widows, the burning of towns.... Righteousness has vanished; Christian faith has grown cold; commerce has perished; and so many other evils have followed that they could not be said, numbered or written."[39] This was Chaucer's maiden venture into war. It would not be his only such experience. He would testify some years later that he had borne arms for twenty-seven years.

The brutal English onslaught proved effective. During the peace negotiations in the summer of 1360, Chaucer received his first recorded assignment as an envoy of the English crown, carrying official letters from England to Calais. Part of Chaucer-the-man would be his youthful memories of France, of Flanders, as a soldier in the victorious army that had its will with the country folk.

From 1360 until 1366 no record of Chaucer's whereabouts has been found. He may have been in Ireland with Lionel. He may have been at the English court. Relevant information exists, however, because of another occurrence. In 1363 Lionel's wife, Elizabeth, died. Following her death, one of the young women in her service was sent to serve the queen, Lionel's mother. The young woman's name is recorded as Philippa Chaucer.[40] When or where Philippa and Geoffrey Chaucer were married is not recorded, but we know that our poet, by age twenty-six, had taken a wife.

In 1367 he was living at court and handling an increasing number of responsibilities. From the small beginning as messenger between England and Calais, he went on to serve in positions of increasing trust. Diplomatic missions on many occasions, over the years, took

him far afield—Spain, Italy, Flanders, and other areas of France. Some were secret missions. He is the image of a young hard-working servant to the king. From his late twenties and into his thirties, he traveled across Europe as a representative of the English crown. It is not difficult to imagine that the energetic, young emissary was well-treated, catered to, in households and courts wishing to gain favor with the English.

At thirty-four he was made Controller of Customs, and several years later was made Controller of Petty Customs, as well, keeping the accounts in his own hand. His duties entailed collecting taxes on wool, hides, and other commodities. Both titles were his until he was forty-six.

Other entries that mention his name have been found—grants of wine, payments, a seat in parliament, and other privileges. The poet, a bright, young, up-and-coming servant "had his eyes open to every movement of European culture."[41] History records what his writings reflect. In the course of his writings, we gain knowledge through the poet's remarks about his work, and about himself.

As the Pilgrim narrator in the *Canterbury Tales*, he is usually content with the role he plays from behind the curtain; still, he cannot resist poking his head out occasionally, and we catch a glimpse of him. For example, he intrudes to give notice that, because we know the Miller is a churl, if we don't want to hear the Miller's story, we should "turne over the leef and chese (choose) another tale." (A 3177) Rarely does he speak so directly to his readers.

We are the privileged audience in the theatre of Chaucer's mind, but he disguises his physical presence. As if with lapel-mike in place, he is doing all the voice-overs for the characters he presents. Perhaps we've never thought of the essential part he plays. Compare the scene where Audrey Hepburn, as Eliza Doolittle, is so enthused that she "could have danced all night." We never think of the voice-over of Marni Nixon as an essential part of the enjoyment. Or, when Bugs Bunny and Elmer Fudd get into a fracas, we hardly give a thought to the talent of Mel Blanc, the voice that lends life and personality to the images before us. So it is with Chaucer. It is *his* voice that brings action to the situations, breath to the characters.

One of his pilgrims, the Man of Law, in the introduction to this lawyer's own story, digresses to recommend some of Chaucer's poetry. Though it may seem a blatant boast on the part of the author, I look for a deeper motive. From all the possible choices—longer and shorter works, translations from French and Latin, prose and poetry—the digressing pilgrim draws attention to a special category: stories of wives who were faithful despite great hardship and temptation, and loving women who were wronged and abandoned.[42]

> [Chaucer] hath told of lovers up and down
> More than Ovid made mention
> In his Epistles…[43]

If the poet is going to interject a recommendation, why does he choose to list and praise these distressing stories? While considering this question, another comes to mind. Why is it the Man of Law (a lawyer) who speaks of these disadvantaged women? Always feeling that there is purpose behind Chaucer's designs, there has to be a reason for the *lawyer* to raise this subject.

Actually, the law and a wronged woman converge in Chaucer's memory as an event that occurred in his own life in 1380. Discovery of the several legal entries is part of that dedicated scholarly scrutiny of historical documents that adds bits and pieces to our knowledge of Chaucer's life. We will delve into enough detail to become familiar with the situation because, chances are, you may know nothing about it at all.

A charge of "*raptus*" was brought against the poet, a charge often explained as "abduction." To soften the accusatory possibilities, it is even hinted that the abduction was necessary for a lady's protection. *Raptus*, however, also means *rape*, plain and simple. It seems almost impossible for Chaucer-lovers to admit that this poet, with his head among the stars, could have had moments when his feet were in the mire.[44] A twentieth-century lawyer was good enough to sort out the information (and misinformation) being circulated nowadays about the case. He gave us an analysis of the intent of fourteenth-century legal terms and procedures. Thanks to

his work, lay folk—average readers and literary critics—are now in possession of accurate information to guide their interpretation.

Chaucer's "strange case" is to be found in *The Law Quarterly Review*, (October, 1947). After half a century, the findings of P. R. Watts, the enterprising lawyer, are still not common knowledge. There is a need to know the facts to make a proper judgment when *raptus* is associated with *Chaucer*.

Lawyer Watts surveyed nineteenth- and twentieth-century writings of literary critics in order to assess their thinking. In the 1870s Frederick J. Furnivall, a noted Chaucer scholar, was ready to accept rape as the charge against the poet, but later opinions shy away from the accusation. The general attitude holds the poet above human failings—a "vicious imagination," it was claimed, would be needed to see Chaucer as the cause of a lady's ruination. In 1926, a Chaucer biographer goes so far as to say our poet "figured as the hero" of the action. The scenario created to achieve this point of view is, according to Watts, "entirely unsupported by evidence."[45]

Misconceptions regarding legal terms and attitudes of the Middle Ages have created confusion and erroneous impressions. To be able to make an evaluation, it is essential to grasp the medieval use of *raptus*, as well as the intention and substance of an *appeal*, along with the fourteenth-century method of dealing with felonious rape.

In the early medieval period the term *raptus* could mean either the abduction or deflowering of a woman. Use of the term was gradually limited to the more serious charge. If a man was formally accused by a woman of the felony and then found guilty, the penalty was loss of a limb. After a statute of 1285, *raptus* can always be interpreted as rape, unless the circumstances of the case do not lend themselves to that assumption.

The second term, *appeal*, is a problem to us because the meaning is at odds with what generally comes to the modern mind. To *appeal* meant to *accuse*. An *appeal* was "the action of one who brings a criminal charge against another" person.[46] It was an *appeal* for justice to be done, for a criminal to be punished.

Many a man, upon being accused, has learned that defense against the charge of rape is difficult. There was an added level of difficulty in the Middle Ages: "the law did not at that time allow an accused person to give evidence in his own behalf." If the man was

unmarried, however, he might have an advantage: taking the lady as his spouse could satisfy the charges. To illustrate how the court might react, Watts cites a case from Chaucer's era: A woman named Alice accused a man named John of having ravished her virginity. Although John claimed innocence, he was found guilty. John had a wife, so marriage could not resolve the problem. Fortunately for John, Alice withdrew her appeal (her demand for justice). He was fortunate because the judgment handed down was that Alice was to "tear out John's eyes and cut off his testicles."[47]

With the necessary definitions in place, and knowing what the threat of a guilty verdict could be, let's look at Chaucer's recorded involvement with the lady who brought the appeal against him.

Speculation began about one hundred years ago when Chaucer's name was found in records concerning the year 1380. A document dated May 1 states that a woman released Chaucer from her appeal of *raptus*. Critics have declared that Chaucer was only an accessory, *or* (using more imagination) he was really doing her a favor because her guardian was mismanaging her affairs, *or* one of Chaucer's friends wanted to marry her and couldn't get her guardian's permission. Our twentieth-century lawyer bursts these admirable bubbles.[48] None of these speculations could be true because the lady had no guardian; she was not under age. She was an adult, not someone's young ward. And, regarding her finances, she was hardly likely to have business affairs to mismanage because there is proof that her brother was ordered to prison for business debts. Besides gaining these clarifications, we must also ask ourselves how likely it seems that a mature, well-respected servant of the king would risk the kind of punitive measures we have read about in order to abduct the woman a friend wants to marry. Chaucer's position at court (his favor with the king) could not protect him, if he were found guilty, because the king had no jurisdiction in cases between two citizens—rather than between an individual and the crown.

If we suppose that the matter must be trivial, because it would not involve the king, this is not true. The woman executed "a formal release under seal duly enrolled in the Chancery,"[49] and five prominent friends of Chaucer witnessed the action. Among them were Sir William Beauchamp, the King's Chamberlain, and John

Phillipott, later to be the Mayor of London.

Record of the release makes it a logical assumption that Chaucer had earlier been accused. Watts explains that both Chaucer and the woman accusing him must have agreed to use of the term *raptus* in the document, in full knowledge of the word's primary meaning. Two things the agreement makes certain are: first, Chaucer had been threatened with prosecution for rape; second, the woman, in releasing him from the appeal, removed the possibility of further demands on her part. Why would she release him? After we've gathered a few more facts, we will address that question.

Following the first discovery, nineteenth-century research brought two more pertinent entries to light. These are two additional deeds of release transacted about eight weeks after Chaucer's release. In the first, John Grove and Richard Goodchild give a general release to Geoffrey Chaucer. In the second, a release (by the lady in question, once again) is given to Grove and Goodchild. A connection is established between the three men—Chaucer, Grove, and Goodchild. Along with the releases, there is a document of recognizance indicating that John Grove is to pay the sum of £10 to the lady.[50] What the releases appear to say is that Grove and Goodchild were Chaucer's accomplices.

If Chaucer had conspired with the two men to trick or force the lady to come to Chaucer's house—or another location—it looks bad. Though a man could make amends by marrying the lady, Chaucer was already married to Philippa. Taking his accuser to wife was impossible, but an offer of money might assuage the complainant. Receipt of a sufficient sum could be the answer to the question of the release, could be the reason the woman's appeal against Chaucer was dropped.

Knowing the hazards of being accused, one can see how even an innocent man might make a settlement rather than risk a judgment. Settling out of court, however, as Chaucer did, demonstrates "a strong presumption of guilt,"[51] though it is not actual proof. The amount of cash given over by him is not known. Such transactions were usually not recorded. We can reasonably assume, nevertheless, that the amount must have been substantial. Watts speculates that another document, which records Chaucer's relinquishing the rights to his father's London house (June 19, 1380), could be directly

related to raising money for a generous settlement. Generosity would be good for the poet's reputation at court. We will soon take a closer look at Chaucer's situation at the royal court.

Judging from the evidence (dates and types of entries), Watts concludes that the lady in question, having successfully obtained a settlement from Chaucer, had an afterthought and made (financial) demands on Grove and Goodchild, as well. The releases and demands appear to indicate that the two men were uninformed agents on Chaucer's behalf, assisting without full knowledge.

Now, to understand the process expected of a woman who wished to make an accusation, let's consider the general legal status of women in fourteenth-century England. Appeals were allowed in only three crimes against a woman: the death of her husband, the death of her child *in utero*, and rape. In the case of rape, she was required to travel to the next town immediately and inform a trustworthy person about the offense. Then she must notify an official of the law. She had forty days, following the offense, to make her appeal, that is, her formal accusation. And, though it is difficult to accept today, if a woman was found pregnant as the result of rape, the man would not be held guilty of a crime. The reason: conception, it was believed, was only possible with mutual cooperation.

With the imposition of so many requirements, it would take a woman of determination to accomplish the law's demands. The time element raises a question, of course. What if, after forty days elapse and a financial settlement has been made, pregnancy becomes evident? I have no answer, except that the man at fault could no longer be thought a *felon*.

Despite the evidence and the analysis by Watts, many Chaucer devotees refuse to see the poet in a bad light: he may tell a bawdy tale or two, but he would never personally act them out. It is rather like movie censors declaring what is permissible and what offensive in a storyline; in this case, however, we are dealing, not with adjustable make-believe, but with the reality of the poet's life. Rather than turn a blind eye to the potential of misconduct, I choose to see the poet as a man, not an icon.

It seems that Watts' efforts have been mainly ignored over the years. You can understand, then, how pleased and gratified I was to find another paper on the *raptus* case published by Christopher

Cannon in the prestigious journal, *Speculum*, in 1993. Cannon not only confirmed Watts' analysis as an "important study,"[52] but added yet another bit of information which may hold the answer to a question left in the mind of the lawyer.

Somewhat confusing to Watts is the fact that Chaucer, found guilty of a felony, was not indicted subsequently by the King's court: "One would expect an indictment to follow almost as a matter of course." Cannon relates the discovery of a memorandum of importance regarding the May 1 release of Chaucer. The Chancery release was transcribed differently for the King's Court three days later: "Whether by coercion, persuasion or some more complicated manipulation" the wording was modified so that *raptus* was "quietly, but emphatically, retracted," and the number of witnesses named reduced from five to three. The seriousness of the charge was undeniably minimized. Cannon proposes that it may be that this record at the Court of King's Bench "was meant to withhold the very information the original release was designed to disclose." Fortunately for Chaucer, this memorandum was "much more likely to be read [referred to] than any other version of the release."[53] The binding of the parchment at King's Court was like the pages of a book and offered easy access. (Many legal records of the time were constructed as a continuous roll, and therefore information was less accessible.)

Apparently Chaucer's situation at court—powerful friends, and their knowledge of his generosity in making amends—put him in a position of relative security. Was the king, indeed, shielded from complete knowledge? Perhaps the poet was not indicted because no *indictable* crime ever came to the king's attention.

Cannon's recent examination of the evidence puts him in strong agreement with the lawyer of the 1940s. Cannon finds nothing in the records that demonstrates it was *not* rape, asserting that "*raptus* in fourteenth-century English law meant forced coitus." He also agrees that many scholars "have repeatedly tried to protect Chaucer's reputation" by preferring "to introduce or discuss the [woman's] release under cover of a wide range of neutral phrases" and "studiously avoid[ing] the difficult implications."[54] With proper interpretation of legal terms as they were used then, we ought to be able to recognize that Chaucer was not the hero of the

case, nor was he a fool risking all to be a romantic go-between. It is possible that he had a flaw, a moment of weakness. This case alone could be the reason that he placed himself among the group of sinful rascals in the *General Prologue*.

Our analytical, twentieth-century lawyer has one more possible complexity for our cogitation. Chaucer and his wife Philippa were not living together during this legal action. (The poet was residing at Aldgate; his wife was "in attendance" to John of Gaunt's wife.) Watts questions Philippa's attitude toward her husband's difficulties.[55] Chaucer's salutation, that begins his *Treatise on the Astrolabe*, may hold a clue. The *Treatise* was written for "little Lewis, my son," who (in 1391) was ten years old. Comparing the dates, one could be tempted to believe that the boy is the product of the alleged ravishment which would have taken place sometime in March or April of 1380. If Chaucer's accuser was later found to be pregnant, the poet would not bear the stigma of having committed a *forcible* rape. It is possible that "little Lewis" is not the child of Philippa, but, nevertheless, Chaucer's son—by the strong-willed lady in question, Cecilia Chaumpaigne, the woman who brought a public appeal of rape against Geoffrey Chaucer, the courtier.

If we turn to the Chaucer *Concordance* to see if the woman's name—*Cecilia*—has a part to play, we find a cluster of entries within the Second Nun's offering and one other isolated reference. (If you are wondering, there are *no* recorded entries of *Philippa*.) What does the name Cecilia have to do with the Second Nun's story? Everything. Chaucer lifts the entry for November 22 (St. Cecilia's Day) from the *Golden Legend*,[56] translates this account of the life of the saint into English, and has the pilgrim called "the Second Nun" tell the story.

We need to ask, "Who is the Second Nun?" We don't know. We are never told. As I searched through the links between the stories, the snatches of comment and conversation among the travelers, I scolded myself for carelessness and inattention—she *must* be here someplace. She is not. Baffled, I finally had to concede that she is completely a woman of mystery.

When the poet proposes to spend time and space to draw portraits of each pilgrim, the Second Nun is concealed in a shadow

behind the Prioress. All we learn is that "Another nun had she with her, / That was her Chaplain."[57] This Second Nun is her assistant, or, we could say, her understudy. Even when the understudy steps into the spotlight, she is enveloped in black, her veil lowered to conceal her face. She is surrounded by an impression of invisibility. In all of the pilgrimage, she speaks to no one; no one speaks to her. She is not called on by the Host, in his usual fashion, to take her turn. There are no plaudits and no review of the subject of her narration.

From the very first line, the lengthy preface to her story launches into an exhortation against idleness, and the temptations that can result from it. Exhortation is followed by prayer. Fifty-five lines are dedicated to an "*Invocacio ad Mariam*" (Invocation to the Virgin Mary). Those, such as G. H. Gerould, who look for origins of Chaucer's lines have found that there are partial similarities in five literary sources.[58] I prefer, nevertheless, to think that, though influenced by what he had read in the past, the creation of the invocation is his own. It is so much *his* creation that the speaker (a nun?) refers to "I, unworthy sone (*son*) of Eve." (G 62) Ten lines later the penitent bemoans "the contagioun / Of my body, and also by the wighte (weight) / Of erthely lust and fals affeccioun." (G 72–74) *Lust*, here, might mean simply *pleasure*, but to Chaucer, it also meant *carnal desire*. This becomes a problematic thought to identify with a serious characterization of a nun. Naughty nuns were comic characters in margin illumination and later in printed lyrics of bawdy songs.[59] A comic image, nevertheless, is out of place in this edifying and prayerful setting.

Another problem difficult to assimilate is encountered in the final stanza of the invocation, if we picture the words emanating from a nun who is riding along as she addresses her companions. The stanza begins:

> I pray that you who *read what I write*,
> Forgive me that I lack diligence,
> This story to skillfully express.[60]

With the lack of an introduction, we are not absolutely certain that the Second Nun is the speaker of this prologue. The entire prayer,

for example, could comfortably be put within parentheses and heard as words coming directly from Chaucer. Evidence we have seen from legal records shows our poet to be a public sinner—an unworthy *son* of Eve. And he could fittingly (more so than a nun) confess to his body being troubled by earthly lust and false affection. Finally, as the author, he would address his audience as "you who read what I write." At the completion of this seemingly parenthetic prayer, homage to Cecilia begins.

A considerable number of lines are given over to "expounding," as Chaucer says, upon the name *Cecilia* as a prelude to the narration of the saint's life. This elaboration is medieval appreciation of the name as a word, before applying it to a particular historical personage. Demonstration of its eminent appropriateness shows harmony between the name and the bearer of the name.

But why did he choose Cecilia? The *Golden Legend* is a collection of hundreds of saints' lives, both men and women. If Chaucer, a poet to royalty, was to choose at random, why not St. Catherine, or St. Elizabeth (patron saints of women of the royal family at that time)? Better yet, he might glorify St. Mary Magdalene, who overcame the earthly lust of which the invocation complained. The choice of the poet, in any case, is *Cecilia*. The prologue concludes with the analysis of the name, not by historic derivation of the word as in modern etymology, but by a "series of significances, each accurate as it reflects accurately an aspect of the symbolic meaning."[61] We learn that the name is filled with echoes of chastity, honesty, good conscience and reputation. She is "hevenes lilie" (heaven's lily) (G 87), "the wey to blynde" (a way for the blind) (G 92), "the hevene of peple" (a heaven for people) (G 104), and more—a woman of good example; holy and industrious; wise and virtuous. One could hardly speak more glowingly of a devout Christian woman.

To the several verses of expounding, Chaucer adds a closing stanza. He interjects a summary of Cecilia's attributes.

> And just as these philosophers write
> That heaven is swift and round and also burning,[62]
> Right so was fair Cecilia the white (honest, chaste)
> Full swift and busy ever in good works,

And perfect at persevering in good,
And ever burning with charity bright.
Now have I declared to you what she *was called.*[63]
(Chaucer's words: "what she highte.")

Fair Cecilia busily persevered in good works—the proper solution
to the temptations of idleness exhorted against in the introduction,
but this had all been said before within the source. What is the
purpose of this added segment, so different in character, interrupt-
ing the translation he's engaged in? Does Chaucer feel a need to be
redundant? Redundancy may not be the only issue. His final line of
declaration holds an intriguing alternate reading which we will re-
turn to at the end of Cecilia's story.

There were many manuscripts of the *Golden Legend*, so the ex-
act source of the tale is not certain. But source is not our consider-
ation. Chaucer created "a poem of rich tonal beauty" from "a piece
of mediocre Latin prose."[64] This is what we come to expect of
Chaucer: he takes the raw material that interests him and creates a
thing of beauty far surpassing the original. His story tells of Cecil-
ia, a noble Roman woman living in troubled times, who converts
pagans by her example and dies a martyr's death. The poet, no
doubt, had his reasons for praising a noble Cecilia who could turn
men's thoughts to God.

V. A. Kolve senses a similar spirituality shared by the *Man of
Law's Tale* and the *Second Nun's Tale*—the pilgrim lawyer's offering
of exemplary Constance, daughter of the Emperor of Rome; the
nun's offering of saintly Cecilia, Roman noblewoman. The two sto-
ries express "the austerity and conviction of the early Church,"
dedicated to "clarification and renewal," for communities as well as
for each Christian soul. Is Chaucer communicating a message, an
important idea? Is there a significance not wholly understood, as
when the Host is seen in the role of "Servant-Master," by Delasan-
ta,[65] without the Christic identity coming into focus? I believe
Chaucer has concealed (encoded) many significances in the *Tales* in
true, creative, allegorical fashion.

When the tale is finished we are not entertained by reactions
to the narrative or its message, nor are there comments from the
Host or the Nun's companions. The only indication that the story

is where Chaucer intended to place it is the content of the first line of the next prologue: "Whan ended was the lyf of Seinte Cecile...." (When the life of St. Cecilia was finished...). (G 554)

And now, at story's end, the phantom nun resumes her place in the shadows. She was included with the travelers to Canterbury only to tell the story of St. Cecilia. Chaucer chose the name of the saint. Chaucer chose to include her story on the pilgrimage. We are not introduced to the storyteller; she is never given appreciation or acknowledgment. The Second Nun's purpose on the pilgrimage is only to glorify Cecilia.

As the storyteller retreats into anonymity, let's return for that second look at that last line in Chaucer's added section, the seemingly redundant summary between the etymology and the legend. The line in Middle English reads:

Now have I yow declared what she highte.

Reading "I yow declared" as "I declared to you," the line holds no challenge until the final word. "She highte" can say *she was called*, *she was named*. Discovering an alternate meaning, however, was very exciting. "Highte" also says *ordered* or *commanded*.[66] Chaucer could have created the extra stanza so that he could inobtrusively record:

Now I have declared to you what she [Cecilia] *ordered*.

Had Cecilia Chaumpaigne required a boon from the poet who misused her? Could it be that genuine affection or mutual admiration developed between the offender and the offended? If she actually bore his child (little Lewis) and he came to love the child, a relationship between Geoffrey and Cecilia is not beyond possibility. I cannot dismiss the thought that her reputation, before 1380, could have been one of persevering in good works, as that of the glorified Cecilia. Willing "magnanimity" (identified in the name) may have contributed to her jeopardy, her misuse. The poet could have meant this literary expression of admiration as a tribute and perhaps a testimony about a woman of excellent reputation that he had wronged.[67] It could be that she, like her patron saint, was able, un-

der difficult circumstances, to turn men's (even poet's) thoughts to God. Without doubt, Chaucer has immortalized the name *Cecilia*. If being memorable is what Cecilia Chaumpaigne wanted, *Cecilia* will be remembered as long as the *Canterbury Tales* circulate.

As noted earlier, the name is mentioned in the Chaucer *Concordance* in only one other place. Oddly enough it is included in another survey of "works written by Chaucer," as the ones recommended by the Man of Law. This time we turn to the *Legend of Good Women*. In the introductory section to the stories, several long poems are recommended—the *House of Fame*, the *Parliament of Fowls*, the *Book of the Duchess*—along with translations of Boethius' *Consolation of Philosophy*, and then, surprisingly, one of the *Canterbury Tales*, the life of Saint Cecilia. The story of heroic Constance and her troubled marriage (told by the Man of Law) would have been eminently suitable also, but it is not mentioned. Such an omission pinpoints the poet's designed selectivity. Cecilia's story is included in this Prologue to the *Legend of Good Women*, written two or more years after Chaucer's release from the charge of *raptus*.[68] Memories of a wronged woman juxtaposed with the law in Chaucer's real life brought us to Cecilia. Now we see that Chaucer's interest in the name carries us into the *Canterbury Tales* and then returns us once again to legends recommended by the Man of Law at the outset. The associations are woven together in Chaucer's mind.

Leaving the case of Cecilia, we turn our thoughts to the opinions of Chaucer's literary confreres and gain another kind of information about the poet. He received praise for his songs, but the songs have not survived. John Lydgate tells us that Chaucer "made and compiled many a fresh ditty." In Lydgate's opinion, the ballads "among all that ever were read or sung, excelled all other in our English tongue." An admiring John Gower portrays Venus, the goddess of love, speaking of Chaucer as her disciple, who filled the land in the flower of his youth, making songs and glad ditties for her sake.[69]

Perhaps songs were considered too trivial to preserve. Perhaps they were circulated mainly by an oral tradition. What was the poet's mature attitude toward these compositions? In his Retraction,

he confesses to the world that he had written "many a song and many a lecherous poem (lay); that Christ for his great mercy forgive me."[70] It takes no effort to picture Chaucer, with his imagination and wit, keeping a group of soldiers or tradesmen, lords or lawyers, amused with clever and unusual turns of phrase in his bawdy offerings. Late in his life he begs the Lord to forgive any sinfulness he may have inspired. Chaucer admits to being a sinner. Could he have been inspired to make amends by *making* (that is, *traveling* or *writing*) a pilgrimage?

Today we generally think of pilgrimage as traveling to a far away place, but the word had another dimension in medieval thought. In Chaucer's day there was a centuries-old tradition, dating back to St. Gregory the Great (d. 604), which accepted that a commentary on a penitential journey was like the journey itself.[71] In reading a spiritual commentary, the reader vicariously participates in the experience. We can have such an experience by meditating on Bible scenes. Or, compare watching a travelogue about a distant culture; in a way, it's like being there. While we read and imagine, we *are*, for that time, travelers, pilgrims in another land.

To *make* a pilgrimage also involves the writer's point of view. The word *make* served as a medieval expression referring to the endeavor of an author, a writer. Chaucer, at the end of the *Canterbury Tales*, calls himself "the maker of this book." Composing the story of a pilgrimage, then, is another way for Chaucer to *make* a pilgrimage. It can be a means of demonstrating to God the author/maker's penitential resolve.

A pilgrimage could be made as an outpouring of devotion; it could be made as a thanksgiving for the cure of illness, the one motive noted at the beginning of the *General Prologue*; it could also be made as a penance for past transgressions—a pilgrimage could be made *all* of these things.

It's time to declare the Chaucer portrait finished. The events and problems we have reviewed will suffice for the project ahead. We are about to join Pilgrim Chaucer in his first-person presentation at center stage. Before we do, let's take one last glance at the many features of this portrait we've been sketching.

In his fourteenth-century life, we see a man of medium height, perhaps just a bit plump. His family name is the French word for "hunter" (*chasseur*). From an early age he lived as a servant among nobility. In his late teens he traveled as part of the invading English army to Flanders and onward into the heart of France. The tactics of a "peaceful" war were abandoned within a few months, and the army was allowed (encouraged?) to pillage churches, ravage women, and burn towns.

Quick advancement found him serving as foreign emissary on several occasions during his twenties and thirties. He was also given the responsibility of collector of taxes at the Customs House. The Cecilia Chaumpaigne episode occurred when Chaucer was forty.[72] (How did he find time to write?)

Much of what has been put together in this depiction will play a part in reviewing his personal tales. It is a human, fallible poet who is about to tell his own story. In the closing prayer of the *Canterbury Tales*, Chaucer confesses his sinfulness and asks God's forgiveness. The *Canterbury Tales*, this last work of his life, was the *making* of a pilgrimage with Christ as the Guide of Chaucer and of his companions. It is Chaucer on this journey who is about to be called upon by Christ, as each pilgrim is, to give an account of adventures of his life.

*Two men went up to the temple to pray; one was a Pharisee, the
other a tax collector.... The [tax collector]...kept his distance, not
even daring to raise his eyes to heaven. All he did was beat his
breast and say, "O God, be merciful to me, a sinner."*

—Luke 18:10–13 (New American)

IV: Introduction to Sir Thopas

OUR TAX COLLECTOR poet and all the other pilgrims are
approaching Rochester, the town halfway to their goal, the "heav-
enly Jerusalem," the cathedral at Canterbury.[73] The Host, Christ,
who is guiding them all, turns to Pilgrim Chaucer and declares it is
the poet's turn to tell a story. Christ, who asks to hear about the
events of the poet's life, is really saying at a deeper level, "It is time
for you to make your *confession*." (Confessional tales have been rec-
ognized as coming from other pilgrims.)

As loosely organized as the *Tales* may seem, V. A. Kolve has
noted that Chaucer's personal offering forms "a structural middle as
precisely calculated as [the] beginning and end."[74] What I find
significant here is that Chaucer is the beginning, the one who is
the first on the scene; and the last at the end with his Retraction;
and here he is at the "precisely calculated" middle. The ancient di-
rective that says a story must have a beginning, middle, and end is
quietly, subtly fulfilled. Chaucer is all of them. This is a major rea-
son that leads me to believe that *Chaucer* is the story—everything
else is costumes and props.

Program notes would be an aid to follow what is about to be
divulged. Chaucer plans an unprecedented two-act performance.
The poet has provided himself with a fitting prelude, and two con-
trasting mini-dramas. These dramas are connected by a lively

entr'acte, played out during the change of scenery and lighting. What a showman!

A characterizing dialogue with the Host is the introduction that leads to the first monologue—the tale of *Sir Thopas*—a lively and varied collection of images and activities. The set on stage has a rolling background, constantly moving, designed to harmonize with the progress. The stage is brightly lighted. Then the account of the action comes to an abrupt halt. It's almost like we can hear supports snap and the background collapse. We are surprised and captivated, between the first act (*Thopas*) and the second act (*Melibee*) by an explosive outburst from the Host. (We can practically see fireworks crackling on stage.) When the verbal smoke clears, the storyteller gives a necessarily accommodating reply. Offered a chance to tell a second story, he takes it. His style now is filled with philosophy, proverbs and gospels. The previous colorful background is concealed behind a gray-brown curtain; stage lighting becomes subdued. A backdrop of muted colors moves into place as the poet begins the second monologue, which is mainly a conversation between Melibee and his wife, Prudence. The wife's ongoing prudent advice provides the major content of the script. The tale is lengthy, goes uninterrupted, and gains appreciation from the Host when its curtain comes down.

As we begin our close look at Pilgrim Chaucer's private production, be assured that what will be said is to be regarded as a *second* meaning, an underlying intention of the author—not a challenge to the surface story. There is a tantalizing allegory hidden beneath the obvious meaning, a parallel just waiting to be exposed. The allegory is concealed in the Middle English words, so in speaking of Thopas I'll give you the original words as the *primary* quotations, followed by my understanding of them. The Modern English will act as subtitles. Chaucer's vocabulary needs close attention to see the humor develop, so that you'll get the punch of the many *punch* lines.

As the poet's performance begins, the Host turns to him and says,

> For evere upon the ground I se thee stare.
> Approche neer, and looke up...
> (B 1887–88)

(Forever upon the ground I see thee stare.
Approach near, and look up...)

From the Host's comments, we understand the image the poet has chosen for himself. Chaucer is playing the scene like the publican of the gospel, like the tax collector that he is.[75] He keeps his distance from Christ, does not raise his eyes to look at Him. We find the poet's impression of this characterization by reviewing the gospel publican and his confession, as depicted by Chaucer himself in the *Parson's Tale*. (X 980–90)

The Parson first explains that confession must be "shamefast" (remorseful, recognizing one has disgraced himself), and not intended to hide or cover sin. A quote from St. Augustine follows: "The heart *travaileth* for shame of his sin." (We can wonder if Augustine was part of the inspiration for Chaucer's pilgrimage, because *travail* held two meanings: suffering, or labor; and *travel*. Chaucer may have been inspired to "travail" on pilgrimage for shame of his sins.) Augustine's thought segues to the publican, the gospel tax collector: "Such was the confession of the publican that would not lift his eyes to heaven, for he had offended the mercy of God."[76] Another Augustinian thought expresses the outcome to be hoped for, that "shamefast" folk will find forgiveness and remission of sins.

Returning to Pilgrim Chaucer, we will discover that at the close of his second monologue, several lines are added to the source he was translating, interjecting the Augustinian hope once again: "Without doubt, if we are sorry and repent for our sins...he will forgive us our sins and bring us to the bliss that never ends."[77] The publican image, adopted in this introduction to his confession by Pilgrim Chaucer, indicates a sinner in hope of God's mercy.

Christ orders the tax-collector pilgrim to come forward and lift his eyes, and then describes Chaucer's appearance.

He in the waast is shape as wel as I.

(B 1890)

(He is shaped in the waist as well as I.)

Christ finds Chaucer shaped as Christ is—the poet is made in the image and *likeness* of God.[78]

About his shape, the Host then remarks,

> This were a *popet* in an arm t'enbrace
> For any womman, smal and fair of face.
>
> <div align="right">(B 1891–92)</div>

> (This were a *popet* in an arm to embrace
> For any woman, small and fair of face.)

He is like a "popet" (a small person, a doll, or a baby), a small likeness of the Host. The picture is of a very small person embraced—not with a woman's *arms* (plural), but—as Chaucer says, "in an arm" of a woman. This begets the image of motherhood, of a child made in God's image, a *little one*. The "small and fair" face can be understood to covertly depict an infant, while the more obvious reading shows a woman.[79]

Next the Host observes that Pilgrim Chaucer

> semeth *elvyssh* by his contenaunce,
> For unto no wight dooth he daliaunce.
>
> <div align="right">(B 1893–94)</div>

> (seems elvish by his conduct
> For with no man does he act sociable.)

The Host, some say, finds Chaucer "peevish" or "mischievous"[80] (*elvyssh*), but the word (as used by one of the travelers called the Canon's Yeoman) can mean "strange; mysterious." (G 751, G 842) From Christ's viewpoint, He sees a man whose behavior is strange. While many of the other characters interact, this pilgrim does not chat, does not socialize with others in the group as they travel. Pilgrim Chaucer addresses his audience, and he exchanges words with the Host, but, once they are on the road, he never speaks to the other pilgrims, nor they to him.[81]

The Host's observations concluded, He prompts this storyteller to begin.

Sey now somwhat, *syn* oother folk han sayd.

(B 1895)

(Say now somewhat, *syn* other folks have said.)

Seen as a play on sin/since, the implication can be understood that other pilgrims also have made confessions.[82] Chaucer is ordered to

Telle us a tale of *myrthe*, and that anon.

(B 1896)

(Tell us a tale of mirth, immediately.)

Christ calls for something refreshing to follow the previous story, which was a tragedy. But "mirth," as can be understood in the Tabard scene,[83] is also heavenly bliss.

The poet responds straightway.

Hooste,…ne beth nat yvele apayd,
For oother tale certes kan I noon,
But of a rym I lerned longe agoon.

(B 1897–99)

(Host,…don't be offended
Because I certainly don't know any other tale
Except a rhyme I learned long ago.)

He moves a step backward in deference, in apology; the tale will not be mirthful, not of heaven. The Host is asked not to take offense. Chaucer knows what his story will say; a brief hope is expressed that Christ will be patient and understanding—not offended.

Surely, Chaucer has a repertoire of *many* stories, but the limitation of choice comes from the Host's general proposal. Each pilgrim is to tell about *himself* and *his own adventures* (A 795); there is only one thing the pilgrim poet knows and must say, and he learned that *long ago*. We will assume this reference to the past involves his early life. The happenings which need to be confided to Christ tell of this pilgrim's youthful days, days when indiscretions

are part of the maturing process for many people.
The Host, Christ, finds the poet's willingness "is good."

> "Ye, that is good," quod he; "now shul we heere
> Som deyntee thyng, me thynketh by his cheere."
>
> (B 1900–01)

> ("Yes, that's good," he said; "now shall we hear
> Some worthwhile thing, I surmise by his
> manner [or face, or attitude]."[84])

A worthwhile offering is expected as He surveys the storyteller's demeanor.

Pilgrim Chaucer begins his story with the next line, but we will pause before he takes the spotlight. Information on three subjects is needed to prepare ourselves for a proper (improper?) understanding of the adventures that befall Sir Thopas, hero of Chaucer's first tale. This information will clarify why the Host will censure and silence the poet's delivery. (*Drastiness* is the basis of the Host's, Christ's, objection to the adventures, and His reason for docking the tale.) First, we will clarify where the *drast* (filth) is located. Next, it is important to enunciate the poet's main theme, the basis of the action, and, therefore, the basis of the obstacle that will raise its ugly head. And, lastly, we will emphasize the genius of the risqué characteristic dominant in the lines. This characteristic has been the source of many complaints, but it has been misconstrued. What appears to be a weakness is really a strength in relation to what is described.

To begin, let's locate the drast. Does the Guide of the pilgrims get the worthwhile story He had hoped for? Hardly. Chaucer cavorts through part one of Thopas' adventures, holding nothing back—not hiding nor covering his sin—perhaps even humanly enjoying some of his recollections. He is just warming up for the second part, which, he announced, would be more of the same, when the Host—in the middle of a line—cries halt.

> "Namoore of this, for Goddes dignitee,"
> Quod oure Hooste, "for thou makest me

So wery of thy verray *lewednesse*
That, also wisly God my soule blesse,
Myne eres aken of thy *drasty* speche.
Now swich a rym the devel I biteche!
This may wel be rym dogerel,"[85] quod he.

(B 2109–15)

("No more of this, by God's dignity,"
Said our Host, "for you make me
So weary of your very *lewednesse*
That, as certainly as God may bless my soul,
My ears ache from your *drasty* speech.
Now such a rhyme the devil take!
This may well be rhymed doggerel," he said.)

The Host is fuming, spitting verbal fireworks. He can bear no more. The "lewednesse" is wearisome. The "drasty" narrative is painful to His ears. *Lewednesse* might intend "foolishness" or "lack of education" to the fourteenth-century audience, but it also indicated (just as today) "lewd" (wicked, coarse, crude). For example, Gerald Owst quotes from a medieval sermon taking to task those who "sing and boast of their own lewdness in lechery."[86] Chaucer intends this connotation in the Miller's story, as the Reeve protests the Miller's lewd, drunken harlotry—his plan to tell of the duping of a cuckold. (A 3145)

I have difficulty with reading *lewednesse* as a criticism of a lack of education—as some infer—for Pilgrim Chaucer. The reason for my difficulty is that a special vocabulary of more than twenty words is used by this storyteller within *Thopas*—the story that inspires the Host's interruption—words that Chaucer never uses in any other of his works. Dismissing the idea of lack of brain power, I believe obscene intention is confirmed when the Host redefines the lewdness as drasty speech.

Why, then, is there a problem? If a story is lewd and filthy, the point is indisputable. Telling such a tale would certainly make Christ's ears ache. The problem, however, exists because of the two interpretations of *lewd* (foolish vs. wicked), joined to the two possible interpretations of *drasty* (worthless vs. filthy). (Textbook

56

glossaries often define *drasty* only as "worthless."[87]) The MED
definition of the adjective *drasty* (*drasti*) is limited to the connota-
tions "crude, trashy, ignorant, inartistic," using only the lines from
Thopas as the example. This is a closed loop of interpretation, of
self-justification. If we venture to the previous page in the MED,
to the noun *drast*, a sense of impurity is much more vivid: "scum,"
"dirt," "iniquity," "fecal matter." These tainted images expose the
source of the Host's pain.

Christ confirms the repulsive connections when He reiterates:

> "By God," quod he, "for pleynly, at a word,
> Thy drasty rymyng is nat worth a toord!"
>
> (B 2119–20)

> ("By God," said he, "plainly, in a word,
> Your drasty rhyming is not worth a turd!")

In spite of the story's content being directly compared to fecal mat-
ter, the *Thopas* is predominantly seen as foolish, worthless, inartis-
tic. The poet's comparative "turd" is both filthy and worthless. But,
if asked, most people would doubtless declare for *filthy* before
worthless every time. The Host is stating—in a straightforward
manner—how greatly He is offended. He finds Chaucer's lewd ad-
ventures unbearable.

This problem with *lewd* and *drasty* causes a serious, and unfor-
tunate, distortion for many as they analyze the call to cease. Im-
pressions become misdirected. Instead of the language being
viewed as the honest evaluation of the *Thopas* tale, the smutty ter-
minology is seen as a characteristic of *the Host*. Misdirection of this
coarseness is one of the ways that the image of Christ, as the Host,
has remained unrecognized.[88] (An extended analysis of the con-
cealed Christic identity can be found in *Chaucer's Host: Up-So-
Doun*.) It is *not* our Host who is crude and filthy. His words simply
reflect the truth that lewdness and filth are to be found in the story
of Thopas. That the drast is actually contained *in the story* is the
first thing we need to remember.

Our second subject of preparation for comprehending the true
nature of the tale is a term repeated in various forms eight times in

eighty-three lines. *Repetition* (we learned in *Chaucer's Host*) is one of the author's tools. It is a signal which says, "Notice this. Notice this."[89] In *Thopas* the repeated signal is *pricking*. After glancing through the story, it would be difficult to deny that this is our hero's dominant activity, the ongoing theme.

In the MED, prick is said to express: "to pierce," "to penetrate," "to arouse amorous instincts," "to ride a horse, esp. at a gallop," and, figuratively, "to have sexual intercourse."[90] Today's editors who try to make the story of Thopas more accessible to modern readers will often replace the pricking with galloping or spurring. The replacement changes the basic meaning only a little, but it removes the double meaning entirely. One example will suffice. Chaucer's words

<div style="text-align: center;">

prikyng on the softe gras

(B 1969)

</div>

were transformed to

<div style="text-align: center;">

galloping over the tender grass.[91]

</div>

Gone is any hint of a naughty image. The thrust fails to hit the mark.

Without sexual innuendoes, the story loses its drast, loses its zing—becomes dull. When the story is halted with no traceable smutty undertone, the dirt-filled allusions of the Host have to be justified somehow, and, therefore, are explained as the guide's personal crudity of expression in rejecting a story that readers have perceived only as worthless. The reputed dullness of the story is well-nigh legendary. It is seen to be as "monotonous as a grocery list," "utterly worthless." There is "nothing funny about it." It's "nonsense," "debased and mindless," and it "paralyze[s] thought."[92] As an antidote to dullness, we will reinstate the pricking that originally carried the tale forward and, in the same mind-set, acknowledge that the enemy who will appear is an impediment to such recreation.

We have one last point to make before Chaucer takes the stage. This, our final piece of necessary information, has to do with the

scanning of the lines. Their metre has consistently been noted as adding to the poetic dullness because of the constant "jog-trot" rhythm. Rather than assuming this to be intentional *monotony*, the bouncing up-and-down rhythm—once the sexual intent is in place—shows Chaucer's wit. Pulsing (im)properly represents the activity.

The tale is all of a piece. The rhythm demonstrates Thopas' perseverance and indefatigability. When an enemy threatens Thopas and interrupts the *rhythm*, this enemy will be a threat to conjugal capability.

Now that the point of the story, the reason for the Host's objection, is evident, we are on the verge of reviewing what Chaucer suggests in his adventures of long ago.

I must, however, digress momentarily. I feel compelled to give a personal disclaimer before we begin. Modifying Chaucer's own justification from the *General Prologue*,

> I pray you, of your courtesy
> That you not attribute to ill-breeding
> The fact that I speak plainly...
> [A storyteller] must repeat as closely as [she] knows
> Each word,...
> Even though [she] speaks rudely and broadly
> Or else the tale is untrue,
> Or a pretense, or words new.

Frankly, if I were twenty I would be too embarrassed to divulge what I understand in his confession. The content is downright obscene, astonishingly creative, lasciviously candid, but never prurient.[93] Because *drast* is the essence of Chaucer's first story, delicacy and refinement will not always be possible. For evidence and support we will draw upon early rude tales and songs that illustrate the historical earthy tradition enjoyed by many poets. Some examples are familiar old bawdy verses collected by Robert Burns, the Scots poet, who preserved this part of his culture for posterity. We'll also sample sources contemporary to Chaucer, including fourteenth-century books of spiritual guidance, in an attempt to bring to the surface the drast rejected as not to be fathomed during the

Victorian era, and perhaps rejected for some time before. A broader grasp of Chaucer's vocabulary will prove the story to be anything but pointless.

Now that the program notes have indicated the next scene to be "X-Rated," if you would rather while away some time instead of being part of the audience, do as Chaucer recommends with the rude tale of the Miller: "whoever wishes not to hear, turn over the leaf" and rejoin us at page 138.

Only a poet with a keen sense of humor like Chaucer could occasionally transform this formalized word-play into a display of wit, sometimes subtle, sometimes coarse. In this sense he becomes a precursor of the Elizabethans.... Some of Chaucer's own puns, too, in particular his double-entendres, reflect the same colloquial background—the chit-chat of the office and the tavern, at street-corners or in the marketplace.

—*Helge Kökeritz, "Rhetorical Word-Play in Chaucer" (1954)*

V: Sir Thopas

THE POET CHOSE a type of stanza for *Thopas* that is used in medieval *English* romances. French romances of the period were refined, courtly. In contrast, English romances were "vigorous to the point of coarseness."[94] Though they were directed toward a middle-class audience, their presentations could be enjoyed by the aristocracy, as well. If we look ahead to the aristocracy of Elizabeth's day, they were inclined to liven their speech with double meanings. Angus Fletcher explains (drawing upon sixteenth-century Puttenham) "the courtier will 'never or very seldom thrive or prosper in the world' if he cannot put allegory to use.... There one can indulge in off-color and even quite obscene conceits, by a method of 'covert and dark speeches.'"[95] This "off-color" inclination is identified with the Elizabethan era because it is well documented. Kökeritz (see above) senses that Chaucer's literary expressions pre-echo the sixteenth century. Perhaps "obscene conceits" were already in vogue as early as Chaucer's day—but let's leave speculation and consider *Sir Thopas.*

One reason for choosing the *English* genre for his tale certainly could be that the adventures reported by Chaucer would be those of an *Englishman*—himself. Another reason seems that the genre and its coarseness suited what needed to be said. Ruggiers gives us the necessary attitude: "Faithfulness to one's materials

dictates the level of diction and is of greater concern to the artist than the strictures of prudes who are more conscious of the word than the deed."[96] Chaucer's caveat in the *General Prologue* (A 725–42) has prepared us for the "rude" language to come.

English romances from an oral tradition often were performed by minstrels. No doubt Chaucer had heard many. These romances probably made the rounds, but were never recorded, because secular literature (before the printing press) was not sufficiently valued to take up the time (and expense) of having scribes reproduce it. There may have been "many [Middle English] romances which have completely disappeared." Thinking of the volume of this literature that went unrecorded, "it is safe to say that if the lost poetry had been preserved, the whole history of English literature, prior to Chaucer...would appear to us in a different light."[97]

Oral tradition is a living thing. Repetition of stories continues from one generation of storyteller (minstrel) to the next; it's simple, efficient, and enduring. The tradition was so enduring that common folk in the sixteenth century were still telling stories passed down from the Middle Ages. *Thopas*, in recent years, has been seen in retrospect as appealing to common folk, an "altogether mindless entertainment which panders to the naive tastes of drab people." To see this audience as "naive" and "drab" demonstrates a quick, harsh judgment of medieval culture, a culture foreign to us. The "jog-trot" rhythm which served as a memory aid in early romances, would serve a double purpose for the poet; it would have a double intention—a double entendre for the action of his hero. The lines of this poem are "never compelled by meaning to break out of the steady beat."[98] And, in another case of seeing something in Chaucer's lines without recognizing the full potential, a reviewer says:

> The four-beat couplet followed by the shorter three-beat line creates even as a single phenomenon a pattern of climax.[99]

Exactly!

It has been said that "the rhyme is often forced, the jog-trot rhythm is unbearable to the point of distorting the pronunciation

of individual words."[100] This tells me that the pulsing rhythm is of *signal* importance. This rhythm we have already identified as the bouncing action of conjugal bliss is the primary sensation Chaucer wants his audience to notice, to feel. We might compare it to subliminal suggestion.

The tale of *Sir Thopas* is seen to have "the air of a sudden tour de force written under the influence of some special stimulus."[101] Such an impression fits the idea of the author's called-for "confession." The vocabulary and content of Chaucer's story would be in harmony with another problem of the day. It was a time in England that inspired sermons against ribaldry and coarse jesting. The preaching did not have a long-lasting effect, however. Attempts in the early 1500s were made to replace, with psalms and spiritual songs, the "foul and corrupt ballads," sung by the "youth of England."[102] (Bawdy songs get around, are preserved with very little assistance. They are surely perpetuated as part of the rite of passage. Drasty songs and stories that, when you were a year or two younger, might rate a cuff on the ear, become accepted offerings and are rewarded with a hearty laugh.)

Victorians would have another way of dealing with *drast* in literature. They often refused to admit its presence, turned a blind eye so they need not comment on base possibilities.[103] I'm sure that is a major reason that Chaucer's witty metaphors and challenging word-play were left untouched. Our detailed examination—line by line—will try to make up for what his present day audience has been missing.

Because the deciphering of allegory is not a common pursuit, a statement from Angus Fletcher's study on the subject will alert us to something of the adventure ahead:

> We shall never lightly assume that clarity is an unclouded aim of most allegory.
> The mode seems to aim at both clarity and obscurity together, each effect depending upon the other.[104]

Chaucer's ambiguities—where his duplicity lies—will prove startling at times, somewhat difficult at others, occasionally downright hilarious, but always imaginative and worth the effort. I want to

interject a practical warning given by J. Dover Wilson, to readers of *Hamlet*. Appropriately modified it is a useful caution for our Chaucerian enterprise: "Put aside all preconceived notions of [*Thopas*], derived from [Chaucer's] critics and not from [Chaucer]."[105] Now let's turn to the pilgrim poet's own story.

❦

Following the title, *Sir Thopas*, a caption reads, "The First Fit." We can understand this to mean *part one*, or *the first section of a narrative poem*. A livelier meaning, however, is lurking. A *fit* is also a happening, an experience. (MED) Elsewhere, Chaucer tells of at least two *fits* worth reviewing.

First, in the *Reeve's Tale*, John (an overnight guest and opportunist) leapt into the bed of the lady of the house. What followed was, "So merry a fit [as] she hadn't had for a long time. / He pricketh hard and deep like a madman." And, in the remarkable Prologue to the *Wife of Bath's Tale* the Wife tells of Solomon, who was "refreshed" more often than most men—said "refreshment" being provided by his many wives. "The first night," she assures us, "[he] had many a merry fit with each of them." From another source, in the time of Elizabeth I, a bawdy tune tells of a fellow who "thought to venter (impregnate) her, thinking the *fit* was on him."[106]

Although it is anachronistic to demonstrate a point in Chaucer by using an Elizabethan example, we have already met one scholar's opinion that Chaucer breathed the literary air of sixteenth century England. In addition, Donald Howard points out that "if we can find [more] recent works which call for a kind of taste or response that older works would have called for, the anachronism becomes a useful tool."[107] The tool will be used, from time to time, to tighten connections.

So, even before its first line, the ambiguous caption of the tale sets the scene for double entendre.

The story begins.

> Listeth, lordes, in good entent,
> And I wol telle verrayment
> Of *myrthe* and of *solas*;
> Al of a knyght was fair and gent

In bataille and in tourneyment,
His name was sire Thopas.

(B 1902–07)

(Listen, lords, with good intent,
And I will tell truly
Of mirth and of solace;
All about a knight fair and well-bred
In battle and in tournament,
His name was Sir Thopas.)

This "mirth and...solace" intend refreshment and pleasure which critics have taken as an inappropriate description of battle and knightly tournaments. These engagements often become mortal combat.[108] Such criticism has insight; refreshment cannot be equated with battle to the death. When Chaucer says something that seems not to apply, not to blend with the surrounding words or ideas, I ask myself "Why?" Consider, from a different point of view, if the knight's competition were an encounter with a winsome wench, the result might provide him the refreshment and pleasure (mirth and solace) he was seeking. Adjusting the image to fit the spirit of the caption, the thoughts readily merge.

This character, successful in the competition in which he engaged, was called Sir Thopas. The name, which refers to the gem *topaz*, has a number of possibilities. It has been said, for example, that the word was never a personal name before this story. Another source explains that girls wore the stone as a charm "against luxury." To clearly understand this intention, we need to know that the medieval term *luxuria* meant "lust," one of the Seven Deadly Sins. Topaz, therefore, was considered a "stone of chastity," but knightly chastity in popular romance was "unusual if not absolutely impossible."[109] Knowing that knights of the romances generally indulged in sexual conquests tells us that we should expect that Thopas would also indulge.

Some reviewers take a completely different position. Using his name and other details, they declare Thopas to be effeminate. I don't think I'm giving away any information too soon if I say that Thopas, on the contrary, will be found to be quintessentially masculine.

My conclusion about the name, the explanation that best fits the plot, comes from thirteenth-century Michael Scot, who was said by Pope Honorius III to be the "singularly gifted in science among men of learning." Scot recognized that there were "some women, as well as men, whose health depends upon frequent intercourse." Advising first that they limit sexual activity to their spouses, if this ideal situation is found to be impossible, as an alternative, he advises *topaz* should be carried to "maintain physical health."[110] This is protection recommended as a guard against harm from sexual activity. We are about to meet a character dedicated to romantic conquests. And, because of his dedication and need, he *carries* topaz (Thopas)—his name.

In the next three lines we learn where Thopas was "born." (Words of the *Tale* that are italicized will be given special scrutiny.)

> Yborn he was in *fer contree*,
> In Flaundres, al biyonde the see,
> At *Poperyng*, in the place.
>
> (B 1908–10)

> (Born he was in far country,
> In Flanders, all beyond the sea,
> At Poperyng, in the place.)

The foolishness of claiming Flanders to be a distant country is generally pointed out. Its "distance" is just across the English Channel from Dover. Chaucer knew that well. That's where the army landed when the teenage poet served with King Edward's forces in France.

To specifically name the town of Poperyng is curious. It was a small center of commerce near Calais. A suggestion has been made that the comical sound of the word makes it appropriate.[111] I was ready to settle for that, because searching for other facts—the location, the history, the economics of the place—held no obvious answer as to "Why Poperyng?" But, while checking for all the definitions of *popet* in the MED, my eye strayed and I found a new and better reason for Poperyng—*poperen*. *Poperen* means to ride a horse. The example given comes from *Piers Plowman*. In one

manuscript of *Piers*, it is said of a rider that he "poperith on a palfrey (fine horse) from town to town." In a different manuscript of *Piers*, the same phrase is presented as "*pricketh* on a palfrey from town to town." So *poperen* and *pricken* are interchangeable. Wordplay is one of the best Chaucerian reasons for Thopas to come to life at Poperyng, at poperen, at pricking. That discovery alters the feeling of the lines that precede.

"Fer" obviously means *far*, the romantic notion of a hero from a far away place. But *fer* might give us another play on words. *Fere*, a noun similar to the sound of *fer*, can indicate a traveling companion, a comrade in sin, an accomplice.[112] As an adjective *fere* can mean healthy or unspoiled. This *fer contree* begins to take on the tone of a scene from *Hamlet*. The prince converses suggestively with Ophelia, using an obscene reference to female anatomy. He offers to put his head in her lap, and continues, "Do you think I meant *country* matters? / ... / That's a fair thought to lie between maids' legs."[113] Shakespeare's turn of phrase is clever, but his choice of words had to be understood by the playgoers. We needn't think that no one had seen the erotic possibilities of *country* before the bard wrote the line for Hamlet. Such a reference could have been drawn from common speech that was unrecorded. (Interestingly, Shakespeare can add a bit to our confidence in a risqué intent for Poperyng. He alludes to a *Poperine pear* in the quarto edition of *Romeo and Juliet*, but the words have since been "suppressed." *Poperine pear* meant a penis.[114])

With all the double meanings noted, the phrase that follows Poperyng—"in the place"—is no longer what Baugh explains as "probably a mere rimetag" to fill out the line (and relate two lines later to "grace," B 1913). The phrase takes on a unique meaning. These three lines confide that Thopas came into existence in Flanders, in a healthy female, while popering (pricking) *in the place* necessary for such activity. In trying to identify "who" Thopas is meant to be, at this point Virility personified comes close. Consequently, the announcement of "his birth" becomes the declaration of a young man's first experience of the rising of generation.

The introduction of Thopas' "father" follows more or less as a formality of this genre. ("Mother" is not mentioned, is not an element of the masculine image.)

> His fader was a man ful free,
> And lord he was of that contree,
> As it was Goddes grace.
>
> (B 1911–13)
>
> (His father was a man full free,
> And lord he was of that country,
> As it was God's grace.)

This father was a free man, who had control over the *country* in question, as if it were a gift from God. If the father of Thopas is a man who succeeded in his first conquest of a maiden and sees the newfound ability as if it were a gift from God, the lines convey this neatly. This "gift" comes recommended by the Wife of Bath, as she recalls Solomon and "what a *gift of God* he had for all his wives." (D 39) Thankfulness for a similar blessing can be found in the medieval "The Minstrel and His Wares." The minstrel has an item *as a gift from God*: "without feet it can stand; / It can smite and has no hand."[115] To acknowledge the actions as a masculine "accomplishment" is a simple (if bawdy) truth.

I propose that Chaucer is describing two separate entities: a man (the father) and Thopas (his virility) that make up one person. We are about to read an outward description of Thopas in which he will gain a physical presence; he will no longer be an abstraction of virility. Thopas will function as a virile member, a phallus. There is a long history of this kind of "separate life" in both the written word and in illustration.

We'll work backward in time to meet phallic personifications. Poet Robert Burns did Scotland a service by collecting peasant songs he had grown up with and loved. Many of the songs/poems have a sense of rollicking, earthy humor. "The Ploughman," for example, has three oxen used for plowing: the one in front is "lang and sma'"; the other "twa are plump and round." And then there is Burns' "Modiewark" that shares a bed with a bride and groom. Though it be blind, if once you let its nose in, then "within a crack, it's out o' sight." Circa 1700 we find double entendres referring to a friar with a bald head, and a creature much like a mole that loves to creep in holes. In the 1600s phallic images include a dwarf, and a

vigorous swimmer who comes forth as one lame—weary, faint, and tired. In the mid-1500s there lived a lively ferret, and Tom Longe (a deliverer of merchandise), as well as a miller whose two millstones hung beside a "vyce" (screw). Moving even farther back to a time only one-hundred years after Chaucer, a woman hopes to buy a pudding that will stand "by *himself.*"[116]

The final offering is an erotic lesson-plan composed by Sir John Salusbury (d. 1612) upon finding his mistress asleep. He took the opportunity to teach his eyes to gaze at her, he taught his mouth to whisper to her, taught his arms to enfold her, taught his fingers to fondle her,

> And then I taught *my man* to wantonnise
> And in the boat of true delight to row.[117]

(21–22)

If over the centuries there have been pet names and images associated with the phallus, it seems natural, fitting, that poets of the 1400s and before would think in similar terms, create similar associations. (I'm not aware of an erotic revolution between 1400 and 1500.) If we have difficulty finding such names and metaphors in Chaucer's time and before, it may only be that they are not recognized, or not recorded. Phallic names and images with a long history may still be in use today.

Feminine counterparts are receptacle images. "She" is a miller's *mill*, a *box* in which to put an offering, a *mouse trap* used night and day. "She" is a swimmer's *fountain*, or a *mouth* to be fed that cannot bite.[118]

We've sampled a variety of *word* images. Medieval illustrators, using small figures drawn to decorate margins of manuscripts, also had a special skill in demonstrating this "separate life" at a glance. Strange little characters were depicted with a face where we would expect to see the buttocks or the groin, as if that portion of the body had a mind of its own. The popularity of these grotesques, as they are called, was at its height while Chaucer lived.

The examples on the following page are just a few that graphically demonstrate what the fourteenth-century preacher Holcot set forth as a complaint against "monstrous men having two heads and contrary

motions. For they have a body of sin joined to the natural body."[119]

A traditional fable, popular in Chaucer's day and for centuries before, lends itself to this separate-parts thinking. It's the story of the belly and its members, a moral debate between the arms, legs, belly, etc. as to which of these parts was the most important to the body. It occurred to me that "the belly and its members" could also provide an *immoral* message, by transferring the topic to the belly and its *private* members. The belly has two very different aspects: one with arms, legs, and head transacting public business of the day; the second, in contrast, represented by parts (those usually covered) functioning in private daily activities.

This concealed portion of anatomy, with its special functions, is the subject matter of bawdy poems and songs. Our generative members are celebrated in the life they lead. The fourteenth century, however, was taught to distrust this concealed area of the body. "From thy girdle to thy hose, It is vile that cometh out." In speaking directly of lechery, *The Book of Vices and Virtues* exhorts, "put the flesh under foot," and advocates foregoing simple pleasure as well as practicing stern penance to gain a higher degree of chastity.[120] Chaucer's Parson, also instructing how to avoid lechery, advises giving up undue amounts of food, drink, comfort, and sleep.

(X 950-55) These restrictions are not a satisfaction for sins committed, but the advocated means for controlling one's reproductive area. (This duality of the body could give Chaucer's *two* stories a new perspective.)

The small number of lines we've examined in the Thopas story have been fairly uncomplicated. The double meaning has been relatively easy to grasp. But Chaucer, as a man of broad experience, found inspiration for double meanings in much of medieval life and learning.[121] I could see hints of lechery (especially with the sexual connotation for *pricking*), but some particularly creative lines were reluctant to surrender their key, refused to give a reader the necessary cue—as with Poperyng/poperen.

In each group of lines so far, we have found a reference to sexual activity, first as a battle or tournament, next as word-play involving the name of his "birthplace." This pattern of variations on the theme of copulation continues for quite a while—we need to be sensitive to the ambiguities that distinguish the characteristics of each conquest, each refreshment. Our endeavors will take us to a lower level where we will attempt to expose the lewdness and drast that will eventually provoke the Host's violent opposition.

So, for Chaucer to present his hero, Thopas, as having a life of his own, functioning separately from the body he is a part of, seems a basic inspiration, perhaps an instinctive response. The action of the poet's story will be seen as a series of phallic adventures—both pleasurable and unpleasurable—as recalled by our pilgrim poet.

First we learn of Thopas' physical appearance. Details seem haphazard, unplanned. Areas described, however, have been shrewdly selected by the poet. Chaucer often has a way of presenting a collage rather than a portrait. Each item, despite a random first impression, holds significance. In reading commentators' reactions to the description of Thopas, there is a tendency to rush through all the peculiar physical attributes; get the job done. Perhaps the assumed dullness of the story creates a reluctance to linger over the lines. Rather than being in a rush, I find the intricacy of detail and complexity of the thought-patterns a marvel to be studied and enjoyed. Now, remembering the little grotesque caricatures, we are ready to meet Sir Thopas "face" to face.

Chaucer's first disclosure is,

Sir Thopas

> Sire Thopas *wax* a *doghty* swayn;
> Whit was his face as *payndemayn*.
>
> (B 1914–15)

> (Sir Thopas waxed a doughty swain;
> White was his face as *payndemayn*.)

To be a swain appropriately presents him as a servant to someone of greater importance. Three words—"pandemayn," "doughty," and "wax"—seem playfully concerned with bread, not a very heroic association. *Pandemayn* is the finest of white bread. The whiteness of the bread is unreal for the description of a face, but "face" can intend all of one's outward appearance. Too, too white could also characterize false virtue. Fals-Semblant (that is, False-Appearance, in Chaucer's translation of *The Romance of the Rose*) is precisely described as having a face black within and *white without*.[122] The word *face*, here, can be seen as a false impression. A *façade* is the basis of this kind of "face."

The second word, "doughty," means strong in battle, bold, valiant. All are manly qualities. But Chaucer could have used similarly-constructed *worthy* or *mighty*. The choice of "*dough*ty" expands the area touched by thoughts of bread.

"Wax," the third word, can allude to what we observe as the expanding, the rising of bread as it increases in size, strength, and potential. A not dissimilar increase in size, strength, and potential is also to be identified with the rising young "swain" who is eager to serve a man in lecherous transactions. Chaucer weaves a pattern of concupiscence. We will find in the Thopas tale, that a statement about language from I. A. Richards applies: "Often the whole utterance in which the co-operating meanings of the component words hang on one another is not itself stable in meaning. It utters not one meaning but a *movement* among meanings."[123]

Our poet continues:

> His lippes rede as rose;
> His *rode* is lyk scarlet *in grayn*.
>
> (B 1916–17)

73

(His lips red as rose;
His *rode* is like scarlet in grain.)

Researchers explain the "scarlet rode." This *rode* is a word unfamiliar today; it can mean complexion. And "grain" intends a special medieval process involving red dye. So the line can be drawing attention to a rosy complexion, even though scarlet seems too intense for cheeks.[124]

How are we to find a kernel of consummation here? Let's begin with "rode." *Complexion* is only one of its MED definitions; *rod* is another. A *rode/rod* can be a stick used for a particular purpose— a simple enough phallic image. Now the mention of scarlet becomes important. (It is the first of three times that the color *red* will be associated with Thopas.) His rod is like "scarlet *in grain*." *Grain* (*grayn*) is an alternate word for *seed*. Grain, then, can refer to seeds as well as to the red dye process; consequently, the word supports both levels of a double entendre. Now if we see lips *not* as part of a man, but as "his" lips by close association, they are the *labia pudendi*—the mouth "poetically" referred to earlier that is fed but cannot bite. This makes his rod *in seed* and colored *scarlet* the portrayal of the loss of a maidenhead. Introducing a *rose* demonstrates the poet's tight construction—the chosen object of proper color, the allusion to (de)flowering, and an association with Venus (as her sacred flower[125]) all in one word.

A seventeenth-century poet had a similar, though less cryptic, pattern of thought.

> Her Cherry-Cheeks and Ruby Lips,
> Doth with the Damask Rose agree,
> With other Parts which I'll not Name,
> Which are so pleasing unto me.[126]

The observation expresses a universal appeal. We return to the Thopas portrait.

> And I yow telle in good certayn,
> He hadde a semely nose.
>
> (B 1918–19)

(And I tell you for certain,
He had a seemly nose.)

These lines close this section. The density of information found in
the previous four lines is not here. The first line of this pair *seems*
superfluous—it just fills out the pattern—but it makes the nose, in
the subsequent reference, more outstanding. The uncomplicated
line acts like a drum roll preceding an event, or a lead-in to prepare
for the entrance of the star performer.

A nose, of course, can be used figuratively for something that
resembles a nose, like the nose of an airplane, for example. Recall-
ing the "separate life," and the artist's conception of a face that re-
places the lower portion of a man's abdomen, the *nose* is the most
prominent feature "for certain." Charles Owen, Jr., remarking on
these lines, finds that the description "gradually intensif[ies] to the
climactic non-information about his nose."[127] The choice of "cli-
mactic" is intended as an exaggeration, of course, but it is unwit-
tingly attuned to the humor of the tale. The "non-information"
maintains the pretense of a face; the fact that the "nose" is attrac-
tive or appropriate ("seemly") is about all that could be said about a
phallus while maintaining two levels of meaning.

A naughty nose can be found in a play called *Mankind*, which
was being performed within seventy-five years of Chaucer's death.
In one of several crude passages a character called "Nought" rec-
ommends to "Now-a-Days" that benefits will follow, if "Now-
a-Days" will put his nose in a lady's socket.[128] There is no explica-
tion for the line, but we recognize this as a "nose" of lascivious
intent.

About Thopas' physical appearance we will learn only one
more fact (having to do with his hair). We will *not* know how tall
he is, nor how old. Nor are we told of his eyes, their color or
brightness. His ears are not mentioned. It would be natural to as-
sume arms and legs—but Chaucer neglects to note them. Neither
is Thopas' voice described. Such lack of information could be due
to lack of interest on the part of the author, or lack of imagination,
but, on the other hand, he might purposefully skirt the issue. Fea-
tures that are noted *could* represent a *man*. But, as we saw with the
little bald men, or the puddings that stand by themselves, it's the

particulars that are *not* included which allow us to see and chuckle at ribald possibilities.

Chaucer continues with oddities that one could mistake for random incidentals. We no sooner learn that Thopas has a beard than our gaze is immediately directed to his shoes, then his stockings, and finally his expensive robe—questionable as equestrian garb. As we try to visualize a man, the portrait is sketchy at best; blank spaces exist where precise features would be appreciated. Changing our level of understanding to sexual activity, the lines precisely hit the mark, give the important details expected. Characteristics of the pelvic area are made public.

We see our hero's "tonsorial" endowment.

> His heer, his berd was lyk saffroun,
> That to his *girdel* raughte adoun.
>
> (B 1920–21)

> (His hair, his beard was like saffron,
> That to his *girdel* reached down.)

The poet doesn't use the typical formula of "the hair of his *head* and beard." We assume *hair of head*, but that is not what the line says. Instead, the construction can be understood as an appositive, a repetition like "John, my cousin" or "his hands, his most valuable tools." If the lower abdomen is "the face," this hair, this beard is expected. John Trevisa, translating a Latin scientific work (1398), employs this same referent, "The year of puberty…is when the nether *beard* groweth."[129]

Hair *like* saffron is a remarkable ambiguity. Saffron Walden, a town in Essex, was the source of medieval England's homegrown supply. This spice and coloring agent is produced from the delicate central structure of crocus blossoms harvested and dried. The dry filaments, used in cooking then and now, have the appearance of short, wiry hairs—an apt comparison to the hairs of this "nether beard."

Thopas' hair reaches his "girdel," a word that can mean a simple belt, or a belt which assists the carrying of a sword and purse—objects that frequently masquerade for virile equipment. Befitting our thoughts, it is the *girdel* in medieval writings, that is often central to

considerations of chastity and lechery. *Gesta Romanorum*, as one instance, refers to a person who is "gird with the girdle of lechery."[130]

A second possibility for "girdel" is a play on the word. We recognize the Biblical phrase, "to gird one's loins"—to be prepared for action, weapon ready. A man's intimate "weapon," in the fourteenth century, and for some time later, was called his ȝerde ("ȝ" sounds like "y"). To be girded could mean to be equipped with a sword, or formally given a sword at a ceremony of attainment.[131] One's sensual attainment could also be realization of the extended capabilities of one's ȝerde.

One of Burns' "Merry Songs" offers a bit of advice for capable lads, in words that echo the Middle Ages:

> Tho' the saddle be soft, ye need not ride oft,
> For fear that the girdin' beguile ye, young man.[132]

"Girdin,'" in Burns' verse, seems equivalent to *priken* and *poperen*. *A Dictionary of the Older Scottish Tongue* defines *gird* as "to ride rapidly or with force," "to draw (a sword) quickly," and also "to pierce."[133] Variations on horse riding intending sex are ubiquitous. In addition, similarities between *gird* and ȝerde would not have escaped Chaucer. To picture the nether beard reaching down to the ȝerde is an accurate pubic portrait, one more bit of entertainment for him and for us.

If ȝerde (later spelled *yard*) seems too foreign for our modern vocabulary, perhaps a sample of an early seventeenth-century poem, quite directly entitled "A Man's Yard," will help. Though explicit at times, more often it is a humorous listing of imaginative metaphors. For example,

> It is a pen with a hole in the top,
> To write between her two-leaved book.[134]

As we continue to speculate about Chaucer's performance, we will add the words ȝerde and *yard* to our assortment of equivalents for *penis*.

The surface meaning next drops a considerable distance from the beard to the shoes. Speaking suggestively, the distance is a

short "stone's" throw. What can be referred to today as "the family jewels" come in pairs. A fifteenth-century peddler says of such wares,

> I have a pocket…
> Therein are two precious stones.[135]

In 1707 the "stones" are found in the bag that hangs under a horse's chin, "'Tis the Bag he puts his Provender in." The "horse" is the yard, of course.[136]

A fourteenth-century medical treatise by Guy de Chauliac (which will be an important source a bit later) uses the phrase "the purse of the privy stones." Testicles were also known by an alternate term, *ballok*, and we find "ballok purs" or "ballok lether" to mean the *scrotum*.[137] Chaucer, however, will not present the usual medieval image of a sturdy pouch. Instead he points to

> His shoon of *cordewane*.
>
> (B 1922)

> (His shoes of cordovan.)

Cordewane refers to fine Spanish leather from Cordova. Chaucer's variation was no doubt influenced by the fact that testicles come in pairs, so he gave Thopas two *shoes of fine leather*, rather than be trite (or obvious) with the usual leather pouch or bag.

Again at the surface of the poem, we move from the shoes to the stockings; it would seem more natural to order them in reverse—but not on the level of lechery.

> Of Brugges were his *hosen* broun.
>
> (B 1923)

> (Of Bruges were his *hosen* brown.)

I returned many times to this line before the parts meshed. Questioning first what it was that was important about the city went nowhere. *Bruges*, as a word, is related to *bridge*; no help. Chaucer

was in Flanders as a youth and carried papers to the peace negotiation in Bruges. So what? And why are the stockings brown? Bruges did have a weaving industry; hosiery was woven then, not knitted. History, geography, and economics (as with Poperyng) held no answers. Finally, the word *hosen* gave the prompt I'd needed.

Part of the discovery process is knowing that in Chaucer's lifetime educated people in general were familiar with Latin. No doubt Latin equivalents came to the poet's mind simultaneously for English expressions he wanted to use. Translating English to Latin, many English words share one equivalent; whereas, when translating Latin to English, consulting the context was essential to find which of several words was the proper choice. While scrutinizing the definition of *hose* in the MED, the consummate connotation finally appeared. The first couple of definitions of *hose* deal with coverings for the legs—fabric, leather, and armor. The third definition says "something *resembling* a stocking." It's the resemblance that reveals *le différence*. Unlikely as it may seem, the word *hose* can be used for the sheath of an ear of corn. This quote, with the Latin equivalent in place, put it all together at last: "…strawe with leues (leaves) and hosen [L *vaginis*] that is ylefte (left) in the feelde…." That was it. *Hosen* is a sheath-image, and a plural form to substitute for *vaginas*. The Latin word for the sheath of a sword is also *vagina*. If surrounding circumstances encourage a double meaning, to sheath one's sword could stimulate erotic images, especially for those who know Latin. (Middle English *shethen*, "to sheath," also means "to copulate.")[138]

It is her sheath-like part that characterizes a woman for Thopas, so the line reads,

In Bruges his *women* were brown.

"Hosen" (vaginas) from "Bruges" are singled out because the poet is admitting sexual activity while he spent time there; the meaning on both levels works. "Brown," I imagine, discloses that these were not aristocrats. Instead, the women had worked outdoors and were sunburnt—the foremothers of the much joked-about "farmer's daughters." The story of a "Jolly brown Wench," as one instance, is included in the lecherous poems we've been sampling.[139]

The pair of lines that remain, the conclusion of the description of the visual image of Thopas, is an active illustration of Richards' "*movement* among meanings." Medievalists have explained the two perplexing terms here.

> His robe was of *syklatoun*,
> That coste many a *jane*.
>
> (B 1924–25)
>
> (His robe was of *syklatoun*,
> That cost many a jane.)

"Syklatoun" is our first problem. It is identified as expensive scarlet cloth. An MED quote from 1500 tells of a robe made of *red* siclatoun. (Both *scarlet* and *siclatoun* derive from the Arabic form of *sakarlat*.)[140] Having settled the problem of the red robe, how do we evaluate this use of "jane"? A jane, we are told, was a small Genoese coin worth half an English penny. An elegant scarlet robe would surely cost many half-penny coins.

I had to ask myself, however, *why* would Chaucer take his imagination all the way to Genoa to find the name of this coin? The answer came back that he had to go to that length to make the double entendre work. There was a traditional "jane" (Jane) in England. Jane, Janette, Jonet—several forms co-exist—is the easy woman, or the misused woman in plays and poetry. Chaucer's "contemporary," Piers Plowman, mentions "Jonet of the stewes (brothels)." She makes another public appearance in the Towneley Mystery Plays one hundred years later, and "Jenet" plays a part in a saucy Skelton poem of the 1480s.[141]

As part of the same thought: "cost" may be an outlay of money, but it can also describe a personal loss. The boast in the line becomes "many Janes (young women) sustained a loss (their virginity) to pay for his red robe." In a late fifteenth-century poem, when the old maid bargains for a "pudding" that will stand by itself, a chorus of young maidens pray that on a later day (despite the cost)

> We will have each of us one *whatsoever we pay*.[142]

A situation quite comparable to Thopas acquiring his "robe" occurs in another fifteenth-century poem about seduction, the subject of many comic poems of the period. This one is presented in terms of church ceremony. The woman—named "Alison" as a play on *eleison*—says, at the "Sanctus," "I paid for his coat." Finding that she is "with child" is designated as the "last blessing" of the service.[143] The "garments" and price paid represent evidence of successful conquest. It costs the woman; Janes and the Alisons pay with their maidenheads.

This is the second view of Sir Thopas encased in red; we will come to recognize it as his habit.

Chaucer provides the means to identify Thopas' major features and his consuming interest: the hair, the twin appendages enclosed in leather, the sheaths of Bruges, and the statement of how the lower class women were disadvantaged in order to envelop him in scarlet. Thus far, Chaucer has portrayed recollections of love-making: Thopas' "birth," the rosy lips, and Janes that provided his investment. We are ready now to join Thopas in the vignettes of adventures that tell of his lustful encounters. Male and female components intertwine and interact within each group of lines; the subject is always sex—only the imagery changes. A cast of play-ers—some ordinary, some unlikely, and some absurd—take the stage to amuse and amaze us.

The next eight sections are a succession of all manner of epi-sodes of strenuous exploits as well as subtler performances of the male and female figures who are waiting in the wings. We might compare a special genre of bawdy literature comprised of poems or songs celebrating basic sexual matters in a format very much like a comic review.

One such "review" is a song called "My Thing Is My Own" (1707), in which a determined young woman tells of her cherished *thing* that has many would-be invaders. (Chaucer's own outspoken Wife of Bath had talked about "my *bele chose*" (D 510)—my *lovely thing*. Time passed, and French was replaced by English, but to both women, the sought-after *thing* is the same.) The unyielding maiden of the song insists to all of her pursuers that *it* is being saved "until I be Marryed, say Men what they will." Pressure to change her atti-tude has been vigorous and persistent. She gives an account of each

attempted seduction in terms of the would-be cavalier's profession: the Haberdasher was pleasant, but she rejected his "Small ware"; a Lawyer came with "his Fee in Hand" and made a Motion that she dismissed; a Clerk was equipped with an Inkhorn and Bag to present his Warrant; a Music Teacher wanted to give her a lesson, but, she says, "my little Fiddle should not be [played] on"; a Money Lender promoted his jewels and a great store of cash, "but I would not Mortgage my little Free-hold"; a Lieutenant made a surprise attack, began to rifle and sack, but she "mustered" her spirits and forced him "to quit his strong hold"; a fine Taylor "with a Yard in his Hand" spoke of a slit above her knee, but "I'll have no Taylors to stitch it for me"; a Gentleman boasted of his horse and dogs; a young Squire offered her the same kindness "that he us'd to his Mother's Maid Joan"[144] (no doubt, another "Jane"). Similarities and differences of the encounters are strung together with clever turns of phrase.

The idea of a chain of varying lecherous innuendo might have begun with Chaucer, with *Thopas*. In contrast to the example just above, however, Chaucer does not limit his imagination to a repetitive pattern. He takes advantage of a larger range of possibility in playfully describing the generative experience.

Scenes of activity begin with the *chasseur* (Chaucer?), the hunter.

He koude hunte at wilde deer.

(B 1926)

(He could, or knew how to, hunt wild deer.)

The poet seems to embed his identity at the outset. (Was it his habit to picture himself as a hunter?) This *chasseur* is chasing many a deer. A hunter giving chase to a "deer"—and striking her with his arrow—is transparently suggestive. A sixteenth-century song tells of a huntsman bringing a doe to ground, and asks, "What do you think it means?"[145] prompting the audience to find a second interpretation. Medieval vocabulary assists the double meaning in hunting imagery, because *venerie*, the word for hunting (the chase), also meant the pursuing of lustful pleasures. *Venery* still does.

Thopas continues to hunt, now as a hawker.

And ride an haukyng for *river*
With grey *goshauk on honde.*

(B 1927–28)

(And ride at hawking for river
With grey *goshauk* on hand.)

Editors call attention to Chaucer's wording, "*for* river." Because the
line is uncomfortable, some recommend an altered, "improved,"
reading: "beside the river," or "towards the river."[146] The *goshauk* of
the second line is also an issue. Its medieval reputation is plebeian,
and therefore quite inappropriate for the knightly Sir Thopas. He
has been taken to be a person of prestige doing bumbling things,
dealing with objects and affairs beneath his station; this is the gist
of the surface story. But the second meaning of the tale has anoth-
er nature entirely. With Thopas serving as a man's generative in-
strument, we expose insinuations of drast that are beginning to
make Our Host's ears ache.

The male-female situation with the goshauk, as with the hunt-
er and his *dear*, makes the message plain. *Go*shauk gives a brief
flash of the feminine—*goose* as opposed to *gander*. *Spar*hauk would
have served the line as well, but not the double intent. Visualize
the hawk *on hand*, talons gripping the protected forearm of the
hawker. Now contrast Chaucer's covert, indelicate inspiration as
this "female" is *on hand*; that is, near by, available.

"*For* river," though it appears inept on the surface, is an essen-
tial connective in a scene of seduction. *R-i-v-e-r* functions here
not as a noun telling of water, but as a sense of the verb *to rive*, *to
pierce*. Chaucer uses this verb denoting destruction several times: in
the *Pardoner's Tale*, "I shall *rive* him through both sides" (C 828); in
the *Merchant's Tale*, "Men would *rive* him to the heart" (E 1236–
37); in *The Legend of Good Women*, "This sword through thine heart
I shall *rive*" (1793); and in the *Romance of the Rose*, "We will…*rive*
him on sharp spears." (7159–61) The words chosen, I believe are
selected for the covert level. (Sometimes, as in the case of *rive*, a
word is less than perfect in the surface reading.) The goshauk, the
female, is available; the hawker is the river, the one who pierces—
another maidenhead penetrated.[147]

Thopas, next, stands out in sports, first with bow and arrow:

> Therto he was a good archeer.
>
> (B 1929)

> (Thereto he was a good archer.)

Terms of archery easily lend themselves to risqué associations. In a poem of the early 1600s, a girl laments that she has lived so long a maid. She decides that whoever comes, she'll "deny no more, / ... / [I'le let him hit] the marke," and "A Man's Yard" advises that "every wench, by her owne will, / Would keepe [it] in her qui[v]er still."[148] *Quiver* is another variant of *sheathe*.

Archery is only one of Thopas' skills.

> Of wrastlyng was ther noon his peer,
> Ther any *ram* shal *stonde*.
>
> (B 1930–31)

> (Of wrestling was there none his peer
> There any ram shall *stonde*.)

The *ram* has been identified by scholars as a prize given for wrestling. But what does Chaucer's saucy wit disclose? If we acknowledge that Thopas' superiority in "wrestling" with *wenches* is this masculine boast, we have only to resolve "any ram shal stonde." Phallic imagery can be seen in the butting of a *ram* (sheep). But a more straightforward image is probably a battering *ram* to make a barrier (a maidenhead?) collapse. A medieval medical text speaks of feminine parts, at the time of defloration, being "corrumpid and broken," which seems descriptive of the force of some kind of ram. A similar thought comes from a poet of 1707, who says a man's yard "is a Shaft of *Cupid's* cut, / 'Twill serve to Rove (rive), to Prick, to Butt."[149] Acknowledged athletic prowess of the yard, then, includes riving and pricking, as well as being able to butt and ram.

Only one word remains a question: the ram that shall "stonde" Checking the MED, *stonde* encompasses many possibilities. This

ram shall (a) maintain a standing position, (b) shall rise from a prone position, (c) shall remain in place, (d) shall remain strong, (e) shall be fortunate, (f) shall serve, or—my favorite—(g) shall astonish or amaze.[150] Assuming that we are pondering the potential of a 3erde, all of these impressions may suit the capabilities of those functioning today. I think it safe to say that male anatomy has not changed much since Chaucer's prime. The six lines of sporting activities proclaim that Thopas is an accomplished fellow. Intimate successes are all that he could wish.

In the next episode we learn that the ladies find Thopas very appealing.

> Ful many a mayde, bright in *bour*,
> They moorne for hym *paramour*,
> Whan hem were bet to slepe.
>
> (B 1932–34)

> (Surely many a maid, bright in bower,
> They mourn for him *paramour*,
> When they were better asleep.)

Maidens long for him—when they would be better off asleep. Maidens with *bowers* are a commonplace. The MED informs us that the bower is a dwelling, or a chamber, especially a bedroom. In comparison, access to the lady's "intimate chamber" is even more limited than access to her bedroom. (The Wife of Bath refers to her pudendum as her "chambre of Venus," D 618.) A poet, in 1719, portrays a bargaining wench who says,

> For Years, for Months, for Weeks or Days,
> I'll let this famous Bow'r;
> Nay rather than a Tennant want,
> I'd let it for an Hour.[151]

Such testimony affirms the carnal, and the naturally connected reproductive, instinct of young women. The message is restated by a worldly-wise observation in "A Man's Yard,"

> The fayrest mayd that ere tooke li[f]e,
> For lo[v]e of this became a w[i]fe.[152]

There's no improving on that sentiment to understand the lack and longing ascribed to Chaucer's maids that mourn for "paramour," a word of many facets—lover, husband, a term of endearment, as well as passion or romantic love.[153]

The first three lines of this section tell how maidens feel about Thopas, and are balanced by the next three lines that give us Thopas' feelings for the ladies—but beware; be attentive.

> But he was chaast and no lechour,
> And sweete as is the *brembul* flour
> That *bereth the rede hepe.*
>
> (B 1935–37)

> (But he was chaste and no lecher,
> And sweet as is the bramble flower
> That beareth the red hip.)

If he is a pure, chaste fellow, why isn't he compared to a *lily* flower rather than *bramble*? The comparison is more than a bit odd. Brambles are associated in medieval thought with "thorns and evil weeds," with "backbiters in false detraction," with "nettles." *Evil* is said to be "more sharp than bramble or thorns."[154] Chaucer, in reporting our hero's *chastity*, is using a diversionary tactic called *antiphrasis*, describing by opposites. The same ploy is used by Mark Antony when he calls Caesar's murderers "honorable men."

Chaucer uses single lines of description elsewhere that contradict the rest of a picture he creates. For example, taken out of context, here are two single, complimentary, lines from the *General Prologue*. The compliments are contained in portraits of the most revolting pair of characters on the way to Canterbury. "A better fellow should men not find" (A 648) describes the visibly repulsive and lecherous Summoner; "He was in church a noble ecclesiastic" (A 708) speaks of the Pardoner, a hypocritical fraud who victimizes the poor. One line presented in direct contrast to everything else we know is irony, not truth. Chaucer's *bramble* says of Thopas that

his sweetness may be experienced if one is willing to be pricked. Willingness, nay, eagerness for his attention on the part of virgins has already been reported; this is the real statement of his reputation. Thopas is the arrow maids long to have in their "quiver," the visitor come to spend an hour in their "bower."[155]

The last line of this section draws attention to where his sweetness leads. Thopas is as sweet as something that "bereth the rede hepe" (bears the red hip)—*rose hip* is understood. Now consider that "bereth" and "rede" have other meanings, and a rose isn't the only thing that has hips. "Bereth" can be seen as a play on *make bare*; that is, expose to view. These hips are not only to be seen as colored *red* at the primary level, but covertly they are *ready*—prepared, ready to do something.[156] This sounds like the Thopas we recognize—an adventurer exposing hips that are ready to do something. We should not be fooled by the poet's prank that makes a pretense of chastity, because all the other evidence confirms Thopas' lechery.

Leaving the ready hips behind, Thopas will indulge his equestrian yearnings. In the next one-hundred sixty-three lines there are numerous references to pricking and to the condition of his "horse." There is no doubt that Chaucer was acquainted with the centuries-old thinking about the animals themselves and the way they served as examples for human conduct. Men and women were exhorted to be in control of the horse of their sensual nature, if they hoped to find salvation. Thomas of Citeaux sternly exhorts that "man deforms the image of God, in which he is made, by pursuing physical pleasures, behaving 'as the horse.'"[157]

In the Book of Jeremiah (5:7–8 RSV), we hear God lament over the Israelites:

> They committed adultery
> and trooped to the houses of harlots.
> They were well-fed lusty stallions,
> each neighing for his neighbor's wife.

Then there is a didactic poem of the early fourteenth century that warns women, using equine terms, not to be a source of temptation:

> And shame it is ever anywhere
> To be called 'a priest's mare.'
> Of such a one, I shall you tell
> That the fiend bears to hell.[158]

Thopas, depicted as anything but in control of his passionate appetite, is in jeopardy. The horse may have been thought of as the exemplum of man's unruly passion because the animals were seen, as far back as Aristotle, as particularly ardent with their mates. The stallion's voice has remarkable strength when the urge to breed is upon him. Both stallion and mare, it was said, "love the work of generation more than other beasts." For centuries this strong opinion restricted Scotswomen from witnessing the animal passion of horses mating; it was believed that a lady might faint away, or, even a greater hazard, she would willingly submit to *any* man's amorous advances.[159]

Neighing of the mating season is mimicked in both *Piers Plowman* and the *Canterbury Tales*. Piers scolds men who behave "as wild beasts with 'wehe'," and an unattended horse in Chaucer's *Reeve's Tale* heads for the wild mares, running "forth with 'wehee,' / through thick and through thin."[160]

Sex presented as horse-riding provides a tradition of humor as well as instruction. A confused and yet gratified Provençal poet of the twelfth century explains:

> I have two splendid horses, and can mount either.

But the "horses" are not mutually amicable. The poet laments:

> I don't know which to keep now—Agnes, or Ermensent![161]

And, like Chaucer's maids who long for Thopas, a maiden of the 1600s complains,

> If dreames be true, then Ride I can;
> I lacke nothing but a man.[162]

Sex and sex appeal have a horsy aspect elsewhere in the *Canterbury*

Sir Thopas

Tales. The Miller speaks of the comely young wife who is compared to a jolly, but unruly, colt. (A 3263)[163] And, finally, in our review of the equestrian influence on the image of human passions, a reflection in the *Romance of the Rose* credits the "horsemanship" of our parents for the fact that each of us is alive today. Riding equals intercourse when the setting fits the act.[164]

Pilgrim Chaucer stands before us, and before Christ, the Host, telling his story. We've been informed about Thopas' character—a champion in the pursuit of females, possessor of an instinctive appeal to women, and a lecher of some repute. The poet begins now to emphasize the untamed stallion image. This servant, Thopas, exists mainly for pleasure and is enthralled with the riding. We need to recognize the *pricking* in order to appreciate the extravagance of the bawdy humor.

The next pair of lines adds no information. They seem rather like phrases from a fairy tale.

> And so bifel upon a day,
> For sothe, as I yow telle may.
>
> (B 1938–39)

> (And so befell upon a day,
> Forsooth, as I may tell you.)

This more or less says—Once upon a time, and I'm telling the truth. No obvious difficulty here, but the next part is peculiar. The words don't behave well with each other, don't do what is expected.

> Sire Thopas wolde *out ride.*
> He *worth* upon his steede *gray.*
>
> (B 1940–41)

> (Sir Thopas would ride out.
> He *worth* upon his gray steed.)

Worthen means "to become."[165] How odd to say that a rider *became* on his horse. I propose that this oddity imaginatively expresses the phenomenon of engorgement, the remarkable capability of the yard

to *become* able to function sexually.

Piers Plowman uses "worth" in just such an action. He criticizes lecherous men:

> For ye live in no love nor keep any law;
> Many of you wed not the woman you share with
> But as wild beasts...*worthen up* and work
> So as to bring forth bairns that men call bastards.[166]

Worthen not only indicates mounting, but unmistakably begetting, procreating.

Returning to our view of the equestrian Thopas, the color of "his steed" as "gray" seems a suitable hue. And, in light of the process of the physical act, the *riding out* in the previous line gains added significance as describing the essential emergence of the glans of an uncircumsized yard.

We next find Thopas with a "weapon" *projecting* from his hand.

> And in his hand a *launcegay*.
>
> (B 1942)

> (And in his hand a *launcegay*.)

It is the idea of a *lance* that is important, although there is debate as to the exact type of lance that is meant. Some say the fourteenth-century "launcegay" was a short weapon; some say it was suitable for hunting rabbits. If it *is* a short implement for piercing, puncturing, it is the perfect representation of a yard; if it is used in subduing *rabbits*, that, too, is perfect because it was a medieval convention to use small, furry animals as a metaphor of a woman's pubic area. Rabbits were often called conies; the word became a familiar term for a woman's pudendum. The cheery song mentioned earlier, about the "bower to let," says that the bower is called "Cunny Hall." This is what we expect Thopas to have in mind with his "lance" in hand.[167]

Chaucer had previously alluded to the arrow and the ram in quick succession, both as models of the phallus. Here, again, he notes two weapons in a short space, both producing phallic images.

The second is a *suspended* version.

> A long swerd by his side.
>
> (B 1943)

(A long sword by his side.)

Connections have already been made between having a sword and being girded, between the word *gird* and the ꝫerde, *yard.* To sheathe means to copulate. Here Thopas is pictured as equipped with the necessary instrument to occupy a sheathe. A few lines back, the phallus was presented variously as an arrow, a ram, and a thorn; *lance* and *sword* are two more likenesses for a sexually functioning ꝫerde. The poet, I have no doubt, enjoyed collecting this assortment of images. Later writers put together such collections—but with none of Chaucer's creativity and extended wit.[168]

Equestrian adventures continue as

> He priketh thurgh a fair forest,
> Therinne is many a wilde best,
> Ye, bothe *bukke* and *hare.*
>
> (B 1944–46)

(He pricketh through a fair forest,
Therein is many a wild beast,
Yes, both buck and hare.)

Pricking *through* this lovely forest at the level of drastiness, we may conceive of something other than trees. The bawdy poems tell of "a lovely *thicket*, / wherein…[was] / raised a lively pricket"; the lady's bower has "a *pleasant Grove*, / To shade it from the Sun"; and a well of refreshment has "*Grass* that grows on the brim."[169] Hunter and forester songs, we've noted, also encourage "forest" settings as an idyllic place of copulation. Fittingly, Thopas penetrates the attractive thicket where wild creatures nestle. Naming a buck and hare is too pointedly symbolic for chance. The buck, in the year of its maturity, was called a *priket*. (See quote about the thicket, just above.) And, because bucks could renew their antlers, it was

believed they renewed their youth. The hare, in contrast, certainly shares the rabbit image (the pudendum) and could indicate fecundity, or its fame for "uninhibited mating." The hare's observable "passion," which was often likened to madness, inspired the phrase "mad March hare."[170]

We refocus on Thopas to find

> ...he priketh north and est.
>
> (B 1947)

> (...he pricketh north and east.)

It is common to find a direction, or multiple directions, incorporated with the riding, or pricking, or plowing of comic poems from the fourteenth century forward. If for no other reason, it gives an opportunity to say that a *rider* has been "in many strange *count*ries." Earthy *count*ry matters, as with Shakespeare's "*count*ry" reference, lend themselves to the prevailing suggestive inclination. And it is possible that the compass point hints at a significant formula (for position, perhaps).[171]

Surprisingly, the pilgrim's story makes a sudden, but brief, mood change. A line containing very little information is followed by the unexpected, the hint of a dark cloud in the otherwise sunny sky, the hint of a hazard on the primrose path.

> I telle it yow, hym hadde almest
> Bitid a sory care.
>
> (B 1948–49)

> (I tell you, he almost had
> Betide a distressing misfortune.)

As Thopas is pricking here and there, he experiences some kind of distress. It is speculated that Chaucer was inspired, by a romance called *Amis and Amiloun*, to interject a calamity. The hero of the *Amis* romance is riding in a "fer cuntray" when his horse, worn out, "fel doun ded" (fell down dead).[172] This would be the gravest of tragedies for Thopas. He exists to function in a riding capacity.

Our poet, at this point, however, does not elaborate on what "sory" event has occurred. It may be a spasm of pain or an injury. Only the word "almost" diminishes the anxiety. This undisclosed experience is the first inkling of a hard lesson soon to be learned.

The storyteller resumes his account of the promiscuous pursuits with two sections filled with distractions of the season. Flora, fauna, and more, proclaim that, "In spring one's fancy turns to love." The seemingly unlimited imagination of the poet casts the male and female parts in the next three lines as played by herbs and spices![173] These *herbs*, and the *ale* example that follows them, provide two of Chaucer's most absurdly creative episodes.

Here burgeoning creation disguises seduction.

> Ther spryngen herbes grete and smale,
> The *lycorys* and the *cetewale*,
> And many a *clowe-gylofre*.
>
> (B 1950–52)

> (There spring herbs great and small,
> The licorice and the setwall,
> And many clove-gillyflower.)

Medieval romances often have extensive catalogues of plants, but here just three are carefully selected to reiterate the pattern of conjugation. Let's work backwards; the end will demonstrate the means. The ultimate purpose, as always, is de*flower*ing. In this case the term clove-gillyflower holds the necessary content: the term corresponds to what we, today, call *cloves*; or a gillyflower can be the Dianthus, a clove-scented flower. Presented in two parts, the medieval word reports that many gillyflowers had been cleaved, cloven, pierced.

Participants in the action, from the line before the cleaving, are "lycorys" and "cetewale," herbs that demonstrate the sweetness of naughty Nicholas from Chaucer's *Miller's Tale*. (A 3206–07) *Lycorys* is a neat play on *likerous*—lecherous. *Cetewale* (alternate spelling: sedewalle, etc.) felicitously delivers the sound of *seed wall*, a simple way of referring to the hymen—the "wall" that prevents "*seed*" from reaching the "*feelde* of generation" (the uterus), until

that *wall* is "corrumpid."[174] The lines recount, as in previous circumstances, that propinquity of the licentious to virgins results in cloven flowers.

Looking at the first line now, green (youthful) stalks are erupting through the soil. Each one is a phallic symbol standing erect in its place. (In point of fact, *Cursor Mundi* speaks of an "erbe" in one version, and uses "ʒerde" as the corresponding word in another.) These "phalluses" come in great and small sizes. It reminds me that herbs, by predictable attributes, were designated as male and female in the Middle Ages. The male "burgeoneth and springeth sooner than the female"; the prickly sorts were, by simple observation, male; a "tufted" plant was female. Similarly predictable views were held of comparative male/female anatomy. It was thought that a woman's reproductive system was a lesser copy of a man's: her testicles (ovaries) were smaller and internal; her sperm (yes!) remained internal; and a tiny structure (a privy point) corresponded to a part of the ʒerde.[175] Woman's structures were accepted as smaller, less powerful representations of man's, so to picture great and small protrusions emerging from the soil seems a comparable metaphor of the anatomical thought of the day. Action encompasses large and small phallic structures; eager young men and maids thrill to the amorous frenzy of a medieval spring; many flowers are cleaved.

Another fourteenth-century poem expresses the same anxiousness that was endured by the maids longing for Thopas in their bowers:

> Now that sprigs are sprouting
> For love I am so sick
> That I cannot sleep.[176]

Chaucer and other poets as well present the response of human biology in terms of vegetation.

Next the poet gives his observations about ale.

> And *note*muge to putte in *ale*,
> Wheither it be *moyste* or *stale*,
> Or for to *leye* in *cofre*.
>
> (B 1953–55)

> (And nutmeg to put in ale,
> Whether it be moist or stale,
> Or to lay in a box, or coffin.)

A medieval *ale* can refer to either a beverage or a celebration. (Our word *bridal* began as *bride ale*.) Ales, drinking parties, were often preached against as encouraging carousing and fornication, the ongoing action of this tale. Chaucer's *nut* of the nutmeg gives the male factor. The "mouth that never bites" engages the nut "never used for food."[177] The nutmeg will be "put in" the ale. The beverage, we presume, is in a receptacle, a mental image that has all-purpose qualities much like the well,

> Where if you're hot you may be cool'd,
> If cold you may find heat.[178]

We are often aware of the phallic image; we must also be adept at recognizing the ever-present, and necessary vaginal correspondent. The poet goes on to say, regarding the "ale"—the female—that he's not particular. She can be moist (today, *juicy* might indicate youth), or stale (middle-aged, or much used), or on the verge of being *laid*[179] in a coffin. Opinions about ale express an undiscerning, uncontrolled attraction to women.

It's worth noting, that, with the remarkable vocabulary at the tip of his mind, Chaucer elects to repeat another word, and we've learned that that's a signal: "Notice this. Notice this." Now that he has used *leye* (lay), there will be two more variations on the word in the next fifteen lines, which deepens the lascivious tone.

From thoughts potentially inspired by a bride-ale, the storyteller turns his attention to the "briddes" themselves. Medieval spelling, with its creative inconsistencies, allows "brid" to be equivalent to our present day *bride* as well as *bird*. The fourteenth-century audience could understand both identities in the next segment.

> The *briddes* synge, it is no nay,
> The *sparhauk* and the *papejay*,
> That joye it was to heere.
>
> (B 1956–58)

(The birds/brides sing, it can't be denied,
The sparrowhawk and parrot,
 That joy it was to hear.)

"Bird" also could be a term of endearment, or one of disparagement, toward a woman.[180] We still find both in various levels of British parlance today; the relationship of the speaker to the woman addressed determines which is intended. Chaucer, here, assigns two cheerful bird companions to express their joy in song. Names, once again, have been carefully selected. It's not the visual image of the bird, nor its song that matters; it's the construction of each Middle English word that introduces the male and female required to perpetuate the love-making pattern. A glimmer of the masculine is the *spar* (thrust), of the sparhauk. The papejay contributes the *pape*, a woman's breast. The two genders make beautiful music together.

The poet next composes a line so troublesome to editors that they have generally agreed to change one of the words.[181] The modified version is

The *thrustelcok* made eek his *lay*.

(B 1959)

(The thrush also made his lay, or poem.)

It helps if you're familiar with "The Lay of the Last Minstrel," because you know that a "lay" is a kind of poem, sometimes set to music. The replacement word in the line is not "lay," however, it is *his*. Chaucer's line, which started the confusion, reads

The thrustelcok made eek her lay.

(The thrush also made her lay.)

(The Middle English *thrustelcok* is much more suggestive than *thrush* in this situation.) Scholars reasoned that a cock should not be referred to as *her*. But what if the original message of the line was misinterpreted? We will read the action now as if the male and

female interplay is continuing between the thrustlecock, the spar-hauk, and the papejay. With a *ménage à trois* in mind, the intent of Chaucer's original sequence becomes: the *sparhauk* and the *papejay* rejoiced, and then the *thrustlecok* "also made her (the female) lay."

Lay is not recorded in the 1300s as a noun denoting inter-course, at least not explicitly. But it did mean "to lay (a woman on the ground)."[182] To that end, one of the bawdy fifteenth-century poems has a servant girl daydreaming,

> Soon he will take me by the hand
> And will *lay* me on the land,
> So that my buttocks be of sand.[183]

It's no surprise that the servant girl soon finds herself in a family way.

In conversation during Chaucer's lifetime, especially men's conversation, *lay* may have taken for granted the entire sexual se-quence once the woman is "on the ground." In any case, before ed-itors changed the line, the *spar*hauk rejoiced with the *pape*jay, and then the *thrustlecock* also "made her lay."

The remaining lines about birds hold one of the several amaz-ing experiences I've had with Chaucer. The poet talks of a wood dove, but for romantic purposes think *wooed* dove.

> The *wodedowve* upon the *spray*
> She sang ful loude and cleere.
>
> (B 1960–61)

> (The wood dove upon the spray
> She sang full loud and clear.)

The bird/the bride gives full-throated expression to what she feels as she sits on the spray. When the double entendre flashed into my mind, my face turned red (I could feel it flush) and I burst out laughing. How long had it been, possibly several hundred years, since the lines were understood, and evoked a hearty laugh?

I don't want to give any false ideas. "Spray" is not pinned down as an ejection of liquid—the association a modern audience would

automatically make—but it's close. *Spray* sounds like *spreint*, a form of *sprengen*, which means *sprinkle*, *spatter*, and, more to the point, *engender*.[184] That, however, doesn't clinch it. But trust me, the laugh is not lost. I can still assert the presence of obscenity. The wooed dove is sitting on a spray, which, to the medieval mind, is an image of new growth, something that has spontaneously erupted and now projects. And that, simply stated, still puts the humor in its proper place.

In a poem called "Love in the Garden," the growing thing featured in that "garden" is a pear tree of the same variety as Shakespeare's suppressed "poperine pear." The young man who possesses it explains that

> The fairest maid of this town
> prayed me
> for to graft her a graft
> of my pear tree.[185]

In due time, the young woman produces a "pear Robert" rather than a "pear Jonet." Both a *spray* and a *graft* can serve the same purpose.

Thopas becomes our topic once again, as he is affected by observing the foregoing erotic performances.

> Sire Thopas fil in love-longynge,
> Al whan he herde the *thrust*el synge,
> And pryked *as he were wood*.
>
> (B 1962–64)

> (Sir Thopas fell into love-longing,
> When he heard the thrush sing,
> And pricked as if he were mad.)

"Wood," you'll notice, translates as a kind of madness, excitement. The love-longing, in his case, is lust-longing, caused by the *thrust*el song, and the reaction is to prick with even more energy. Thomas Nash, in 1601, relates the same excitation in a visit to "a house of Venery." His instrument, admittedly, has a problem, but

...shee raisd it from [the swoune];
And then it flewe on her as it were wood.[186]

An additional instance of passionate (summer) love is much the same: "a man and a younge maid...were [taken] in a frenzye [in the] Midsommer prime."[187] In this latter case, the madness is mutual.

With the madness upon him, we're told the condition of Thopas' trusty steed.

> His faire steede in his *prikynge*
> So *swatte* that men myghte him *wrynge*;
> His sydes were al blood.
>
> (B 1965–67)

> (His fair steed in his pricking
> So sweat that men might wring him;
> His sides were all bloody.)

These lines have been explained to say that Thopas *spurred* his steed causing it to run so hard that "it sweated blood." Nuances are stifled. A merged image obscures what Chaucer presents individually—sweat is described separately from blood. "Swatte" can mean perspire, but it's also defined as exertion or hard work. The *spurring* in modern versions, to replace Chaucer's *pricking*, eliminates the sexual aspect. Chaucer himself left the way open for the double entendre by simply not mentioning spurs as part of Thopas' equipment.[188] Recall that only shoes and hose were noted.

The first two lines tell us that the steed worked so hard at pricking that men might *wring* him. To picture a sweating horse being wrung out is not one of Chaucer's most successful images, but on the drasty level, it is eminently workable. If vigorous action is performed by a phallus having illicit relations with women, then we can picture men of their families enraged and wanting to put a crimp in this offending "intruder." By definition, the *wringing* that vengeful men might perform would cause Thopas "distress" and "pain" as they "wrench or wrest [him] out of position...by turning or twisting."[189] Such would actually be a mild form of revenge compared to all possibilities, but this lesser punishment is specified

because *wringing* can apply to both levels of the story.

His steed—the instrument of unbridled passion, the image of sinful pursuits—is bloody. This is the third time we have associated *red* with our hero. This time, however, it is unpoetically direct—not scarlet in grain, not a robe of syklatoun—specifically blood. The deflowering continues, and perhaps is increasing in frequency.

Though a gore-covered phallus is not today's usual imagery, it may have been acceptable in double meanings of early medieval centuries. Jember's translations of Old English riddles proposes "phallus" as the obscene intention of the lines

> My garment is dusky-colored, adornments bright,
> red and shining in my plunder.[190]

Such a portrayal could have been an accepted convention in Chaucer's day.

We see Thopas worn out because of his *courage.*

> Sire Thopas eek so wery was
> For prikyng on the softe gras,
> So fiers was his *corage.*
>
> (B 1968–70)

> (Sir Thopas also was so weary
> From pricking on the soft grass,
> So fierce was his courage.)

Soft grass could certainly be conducive to sexual pleasures. *Lust,* the MED informs us, is one definition of this "corage." Coital ability was often likened to courage, and inability to cowardice. For example, while a young woman was walking in a meadow, a young man's "corage shee had tamed," and another lad, Thomas by name, "had the worst courage that ever man had." Even Chaucer speaks of a lord who "had fulfilled his courage" with a lady. (E 907) But poets have no kind words for cowards. Thomas Nash flatly accuses his "faint-hearted instrument" of "Cowardice," and Skelton berates a sleepy cuckold with, "Well may thou sygh, well may thou grone, / To dele wyth her so cowardly."[191]

This fierce courage of Thopas necessitates finding consolation—for his *horse*.

> ...doun he leyde him in that plas
> To make his steede som *solas*,
> And yaf hym good *forage*.

<div align="right">(B 1971–73)</div>

> (Down he laid in that place
> To make his steed some solace,
> And gave him good forage.)

Solace for his horse gained on the soft grass is "more of the same." *Solace* is what the story is all about. The first few lines said so.

"Forage" for the steed, however, is found to be another debatable word. Some critics say that "forage" tells us that the horse was turned out to graze. If Chaucer uses "forage" to mean *eating green grass*, this is the only time it is recorded in Middle English with that connotation. But maybe *green grass* is not what the poet has in mind.

"Forage" for a horse, instead, is generally dry fodder, which gives a picture of something that is just better than nothing. Dry fodder would hardly be classified as "*good* forage." It is not something appealing and satisfying as the line seems to imply. If he had wanted to simply convey *fodder*, the poet could have structured the lines differently in order to use the word. He is, after all, master of the line as well as of the word. So the presence of *forage* is a decision made by the poet, and any difficulty with the term is only at the *surface*.

The poet's strategy, to no one's surprise, is that forage is used ambiguously. (You were advised to remember *forager* on page 33. Here is where you'll need it.) While the surface communicates the *noun* "forage" (fodder), the covert lewdness is found in the *verb* "to forage"—to plunder, to ravage. Chaucer was familiar with, was introduced as a teenager to, plundering, ravaging, foraging. It was part of his experience with the victorious English army during the Hundred Years War—"the army was allowed (encouraged?) to pillage churches, ravage women, and burn towns."[192] The foraging of

Thopas gives solace to the ravager, the plunderer, once again. This is an outstanding demonstration of what is lost by replacing the suggestion of *pricking*; you lose half the meaning; you weaken the poet's whole design.

Chaucer does with *forage* what he did with *river/river*, and with *jane/Jane*. He employs a word which moves in two very different directions simultaneously to provide both meanings. Christ, as the Host, continues to listen to all these accounts of licence and despoliation. His patience will not last forever.

The black cloud returns. We listen as Thopas, at hazard, talks to himself.

> O seinte *Marie, benedicite!*
> What eyleth this love at me
> To bynde me so soore?
>
> (B 1974–76)

> (O saint Marie, be blessed!
> What does love have against me
> To bind me so painfully, so grievously?)

His first spoken words, "saint Marie, be blessed," appear to be a momentary prayer, to be glanced at and dismissed. It is really much more. This blessing, an irreverent play on words, is directed at female essence. Phrases such as: "Seinte *marie*," "*moder*..."; "*moder mary*..."; "the *moder* that *Marie* men call..."—along with phrases like: "the *moder marriz*"; "the *marys*"; "this *moder*, that we call the *marice*,"[193] might all be taken as various addresses toward the Virgin, *mother Mary*, but they are not. The striking similarities, however, provide ample material for word-play. The first three refer to Christ's mother; the others have a different application entirely— the *uterus* (Middle English, *maris*), the essential component of womanhood. Thopas' "prayer" holds the covert intention of blessing the sexual aspect of women.

If you are thinking that a Mary/maris pun would be so offensive to the medieval "cult of the Virgin," that this idea is impossible to accept, let me explain. It is true that in the fourteenth century on the Continent, and particularly in France, there was excessive

devotion to Mary. In contrast, the focus of religious thought in England's Catholicism was Christ, especially His sufferings and death.[194] This difference of emphasis between England and France is demonstrated by the many extraordinary cathedrals of France dedicated to *Notre Dame*, while England's primary cathedral, Canterbury, the destination of our wayfarers, was consecrated as *Christchurch*.

Back to troubled Thopas. With a subtle blessing for the maris (uterus), he questions why love would afflict him so severely. Earlier we'd heard a hint of tidings of a "sory care." (B 1949) The affliction is growing serious. *Sory care* deals with the anticipation of danger or even death. Oddly enough, and we noted this at the beginning of the *General Prologue*, only thanksgiving for cure of illness is recorded as the purpose for making the pilgrimage. (A 17–18) Chaucer could have been one of those who was cured.[195] The surface story can view the crisis as humorous melodrama, but the underlying, sex-driven, plot is still developing.

The ailing hero tells us of a dream he had:

> Me dremed al this nyght, pardee,
> An elf-queene shal my *lemman* be
> And slepe *under my goore*.
>
> (B 1977–79)

> (I dreamed all night, indeed,
> That an elf-queen shall be my lover
> And sleep under my gore.)

Exciting and portentous. Chaucer's "rolling background," that enhances his narration, is no longer springlike. The ambiance becomes shadowy, threatening. Hostile figures loom.

This queen of fairies—"elves" and "fairies" are used rather synonymously—has magical powers of both good and evil. Thopas predicts she'll sleep as his lover, *under his gore*, a phrase generally interpreted as under his *garment*. But "gore" can also be defined as a *spear* or *sword*, which restates phallic conquests, now invading his dreams.[196]

What is the future of this sought-after romance? A peasant

girl, or the daughter of an innkeeper is no competition for this powerful female force. Queen of the fairies, Chaucer recognizes, is queen of the underworld, as well. (E 2311–16) Any relationship an elf-queen is willing to have with a mortal could result in his undoing—loss of life or loss of virility would be typical. Questions of ailment and constriction seem the likely stimulus of his nocturnal fantasy.

After the dream's disclosure the "jog-trot" rhythm, which has been unceasing, ceases. Four stanzas with lines of varying lengths speak of disappointments and danger. Exploits of pleasures sought and found are a thing of the past. An otherworldly chill prevails. With this change of pace, Thopas no longer functions as a perpetually successful sex-machine. He has problems.

> An elf-queene wol I love, ywis,
> For in this world no womman is
> Worthy to be my make
> In towne;
> Alle othere wommen I forsake,
> And to an elf-queene I me take
> *By dale* and eek *by downe!*
>
> (B 1980–86)

> (An elf-queen will I love, certainly,
> For in this world no woman is
> Worthy to be my mate
> In town;
> All other women I forsake,
> And to an elf-queen I betake myself
> By valley and also by down!)

Though the rhythm is irregular, sex is still a force. He will find his way to the elf-queen by "dale" and "down" (a *valley* joined to something of a *downy* texture[197])—recurrence of the receptacle image (like the *well*) surrounded not by grass, but by tufts, by *down*.

He continues his erratic pricking while reconnoitering, scouting out the territory for the female that will make his dream (nightmare?) come true.

Into his sadel he *clamb* anon,
And priketh *over stile and stoon*
An elf-queene for t'espye.

<div align="right">(B 1987–89)</div>

(He immediately climbed into his saddle,
And pricked over stile and stone
To search out an elf-queen.)

Much has been made of Thopas' "climbing" into the saddle. Critics have taken this as amusingly unheroic: "his horse seems built for comfort rather than derring-do."[198] Precisely. Again the poet's idea registers without really being understood. Remember the folk song collected by Robert Burns that warns young men to use common sense even though "the saddle be soft." Thopas, heedless of any warning or inner restraint, climbs into the fourteenth-century "saddle…soft" and pricks "*over* stile and stoon." While the surface depicts riding over steps (built for climbing over a fence) and over stones, the underlying meaning of this phrase conveys pricking "above stile (stylus or probe) and stone," that is, above a phallus and testicles. It's worth noting that a sluggish mounting seems a perceptive portrayal of an afflicted rider, a rider not in top form.

As Thopas' search continues, he arrives at a strange, wild place. No cheery birds nor soft grass.

Til he so longe hath *riden and goon*
That he foond, in a pryve woon,
The contree of Fairye
So wilde;
For in that contree was ther noon
That to him durste *ride or goon*,
Neither *wyf ne childe.*

<div align="right">(B 1990–96)</div>

(Until he had ridden and gone so long
That he found, in a private place, or chamber,
The Fairy country
So wild;

For in that country there were none
Who dared to ride or go to him,
Neither woman nor child.)

Medieval use of the word "child" was much broader than it is to-day. It could refer to a youthful knight, any person innocent or im-mature, and more. Mention of "wife nor child" can be understood as "neither wives nor young women" were interested in the ride.

Our adventurer is in magical fairy country. Atmosphere has al-tered. Rather than a blessing, the power here could be a curse. The first line recounts that he had "ridden and gone" for a considerable length of time. A few lines later the expression is repeated, but now no one *dared* "ride or go" to him. Repetition requires scrutiny; the poet was not at a loss for words. One result of the repeated phrase is to draw attention to the development of negative attitudes.

As if getting a general cold shoulder were not enough, enter the enemy.

Til that ther cam a greet geaunt,
His name was sire *Olifaunt*,
A perilous man of *dede*.

(B 1997–99)

(Until there came a great giant,
His name was Sir Elephant,
A man of dangerous deeds.
or, A dangerous man of the dead.[199])

Aside from noting the mammoth size of Sir Elephant, the poet de-clines the colorful project of bringing a real giant to our mind's eye. One descriptive detail, but only one, will be given later. For now, the giant's name and the words he says must be all we *need* to deci-pher his identity, or the description would have been expanded. Another way to judge this scant portrait is that the more complex the description, the more difficult it would be to have the complete picture work on more than one level of the story. Sir Elephant's single given characteristic tells us that it is perilous (fatal?) to be confronted by him.

The giant's first action, sadly enough, is to confront Thopas, swearing by a pagan god as he does so.

> He seyde, "*Child*, by *Termagaunt!*
> But if thou prike out of myn haunt,
> Anon *I sle thy steede*
> With mace..."
> (B 2000–03)

> (He said, "Child, by Termagant!
> If you prick out of my special place,
> Immediately I'll slay your steed
> With a weapon...")

Addressing Thopas as "child," with the multiple uses of the word noted earlier, simply points out that he is a *young* man. For example, the age of "twenty winters," to the medieval mind, could denote a child.[200] The giant's presumed origin is the Middle East. Crusaders had returned home with stories of "Termagaunt," believed to be a god of the Arabs. With an allusion to Thopas' pricking, the giant is prepared to retaliate against him by using a weapon to slay his *horse*. Not many lines back, men might have injured the horse by wringing "him." It is the horse—Thopas' ability to ride—that is at risk.

Sir Elephant continues,

> "Heere is the queene of Fairye,
> With *harpe* and *pipe* and *symphonye*,
> Dwellynge in this place."
> (B 2004–06)

> ("The queen of Fairies is here,
> With harp and pipe and harmony,
> Dwelling in this place.")

Thopas has located the queen of fairies, but his dream will not be fulfilled. Nevertheless, beautiful music is being made without his participation. Sexual harmony prevails: the *pipe* is recognizable

from an old song where the refrain encourages, "Strike home thy pipe, Tom Longe." The harp is one of the stringed instruments— like the "little Fiddle" of the independent lass who resisted her many suitors, or like the "Lute well in Tune" of a young wife whose old husband had lost his "musical" skill.[201] Chaucer's "instruments" are stand-ins for the yard and pudendum as they perform together; harmony produced is celebrated by *sym-phonye* (a blend of sound).

The giant has spoken his piece. Young Thopas, the child, gives prompt reply.

> The child seyde, "Also moote I thee,
> Tomorwe wol I meete with thee,
> Whan I have myn armoure;
> And yet I hope, *par ma fay* ,
> That thou shalt with this launcegay
> Abyen it ful sowre.
> Thy mawe
> Shal I percen, if I may,
> Er it be fully *pryme of day*,
> For heere thow shalt be slawe."
>
> (B 2007–16)

> (The child [Thopas] said, "As I must[202] prosper,
> Tomorrow will I meet with thee,
> When I have my armor;
> And yet I hope, by my faith,
> That with this *launcegay* thou shalt
> Buy it bitterly.
> Thy belly
> I shall pierce, if I may,
> Before it is nine in the morning,
> For here thou shalt be slain.")

Thopas is quick to challenge, "As I must prosper." He expects to overcome his *sory care*. Many have commented on Thopas' declining an immediate battle, apparently because he lacks armor.[203] His hesitancy may seem unmanly on the surface, but a reference to

armor is needed to provide anticipation for the special "arming" scene soon to come.

Our hero promises that, when he is armed, a short lance will slay this enemy; the giant will "buy it." Sir Elephant's vitals will be pierced with the lance by 9 A.M. tomorrow. This is a peculiar scene. Time is an unexpected factor. The passage of days, weeks since the beginning of the story is a haze. The geography of travel is also a haze. Where Thopas and the giant debate is a mystery. If they are near the Queen of the Fairies, they could be in the underworld. But "tomorrow by 9 A.M." is not hazy; it is specific, like a planned appointment. Actually it *is* a planned appointment. Thopas makes the foolish-sounding promise that a small lance will be able to end the life of this giant simply by piercing his body. It seems too fantastic to be possible. On the surface it isn't possible. But once we understand who the players really are and what the killing of the giant entails and intends, it will make good sense.

Now that the scene is set, the challenge given, and Thopas' determination recorded, Chaucer returns to the bouncing rhythm. It's almost like returning to the real world from a fantasy or dream state.

> Sire Thopas drow abak ful faste;
> This geant at hym stones caste
> Out of a fel staf-slynge;
> But faire escapeth child Thopas,
> And al it was thurgh Goddes gras,
> And thurgh his *fair berynge*.
>
> (B 2017–22)

> (Sir Thopas drew back very quickly;
> This giant cast stones at him
> Out of a terrible sling-shot;
> But child Thopas fortunately escaped,
> And it was all through God's grace,
> And through his proper conduct, etc.)

Sir Elephant continues to menace our hero by flinging stones, but Thopas retreats unharmed. (For reasons which will become obvious

later, we will assume the stones are large.) Thopas escapes by God's grace, a split-second mention of God's mercy. Credit for well-being is also given to the equestrian's "fair berynge." "Berynge" is a multidirectional word here. It refers to *conduct*, to *piercing*, to *carrying something*, and to the ability to *endure suffering*.[204] Conduct and piercing have been demonstrated, as well as the reason our hero *bears* (carries) the name *topaz*. The need to *endure suffering* is close at hand. It is the price Thopas must pay to "escape" from his enemy.

We're given a surprising sense of closure in being told that Thopas did escape harm by God's grace and his own qualities. It's a prophecy like "and he lived happily ever after." We already know the outcome—but the story isn't over. I can feel this finality because I know (and Chaucer knew) "the future"—the giant will never return.

Many reviewers allude to a fight with the giant. When I read the story the first time, I got to the Host's interruption, and wondered how I could have missed the talked-of battle scene. So I went back to where Sir Elephant comes on stage, and carefully, almost one word at a time, went through the remainder of the story a second time. No duel. No combat. Chaucer captivates us with his sleight of word. He entertains with scenery, adventures, even conversation. And we are so pleased with what is offered that we remain oblivious to what is held back. As he performs, we are patient with his method, expecting we will learn all things in due time. Then, when the story is over (the "First Fit" is over, in this case), we applaud his creativity and wouldn't think of demanding more. At some point, the poet has spread a thin layer of smoke over the surface and thinks, "Maybe they won't notice what's missing"—and we don't. My realization that the plot involving Sir Elephant was an incompleted fantasy made me take a closer look at the tricks played here by our storyteller.

In a plot of sexual activity, what or who would be the enemy, the cause that would prevent activity from continuing, the cause that would prompt women to not dare "ride or go" with Thopas? Our instinctive answer is Venereal Disease.

When I came to that conclusion, it meant a trip to the library to search among books about medieval illnesses. We need to know names of illnesses and to understand how people of the Middle

Ages viewed afflictions to their bodies. I had learned a harsh reality sometime earlier: *any* disfiguring skin condition was assumed to be leprosy—and the afflicted person was legally declared dead, as were all actual lepers.[205] I wondered if genital ailments would also be viewed "generically."

I took several books off the shelf and sat down to page through them, knowing what I would find, but not knowing what I was looking for. As I turned the pages dedicated to venereal disease, the medieval attitude toward VD proved to be as I had suspected. If any problem touched a man's genitals, a woman had to be the source. No other cause on a physical level—lack of cleanliness, contact with inflammatory substances, bites of insects—was considered primary in the event of phallic failure. Retribution, on a spiritual level, was linked to "foul women."[206] God would punish a man who had participated in sex outside of marriage. How more appropriately than to allow the sinful portion of his anatomy to suffer?

Back to the library books. What clues do we have for the search? The name "Sir Elephant," the fact that he's very large, and that his background is Arabic because of his calling upon "Termagaunt." That's all. So I carefully considered each entry before going on to the next. Then it happened. In Erwin Ackerknecht's *History and Geography of the Most Important Diseases*, he was there, Sir Elephant: "for a long time [the disease] was known in Europe as *Elephantiasis Arabum*."[207] Right there in the library, I almost cheered.

Crusaders had learned about elephantiasis—an affliction resulting in giant enlargements. Some may have contracted it. What the Middle Ages understood only as an act of God, modern science has analyzed. Microscopic parasitic worms, that thrive in tropical climates, have been identified as the cause of the condition. They invade the human lymph system through the bite of a host insect that carries the larvae. Enlargement of the victim's legs and feet often follows, but it is also known to target the genitals. Onset among the native population, for some unknown reason, is slow, sometimes taking years. In complete contrast, visible symptoms in newcomers manifest rapidly with blockage of lymph vessels, and swelling of tissue.[208] Of course, after the scientific analysis

has been accepted, a fellow might still see his trouble as the hand of God allowing the catastrophe to overtake him.

In another book I found a photo of a man grievously afflicted. These enlargements can weigh one-hundred pounds or more.[209] (The stones Sir Elephant flings can be *very* large.) Ability to copulate had long been sacrificed; to ambulate could require

a wheelbarrow as transport for the grossly exaggerated scrotum. Chaucer's selecting this image as the personification of Venereal Disease is as grotesque as introducing a live medieval Frankenstein monster. He may have seen such a man, heard stories, or become acquainted with *Elephantiasis Arabum* through his "keen interest in great medical treatises."[210] For this enemy to use "stones" as the means of his attack is a clue. It is not the victim's feet or legs that are threatened.

Now that we have met the enemy, let's continue with the poet's adventures, with what is substantially a prophetic interlude. Forward movement of the tale is halted in order to forecast what will soon be demonstrated. Besides the foreknowledge of his "escape," a "merry" element comes as an additional pleasant surprise.

Yet listeth, lordes, to my tale
Murier than the nightyngale,
For *now I wol yow rowne.*

(B 2023–25)

(Yet listen, lords, to my tale
Merrier than the nightingale,
For now I will tell how this happened,
or, Now I will speak to you in confidence.[211])

Chaucer will confide in his audience. He may be about to give personal information not generally known to his contemporaries.

Thopas, once again, will be coming to town. (I suspect that the medieval "coming to town" is much like our "going to town," that is, becoming very active.) In spite of threats made by a formidable enemy, Pilgrim Chaucer's Thopas will manage to resume his favorite pastime. The storyteller is about to disclose

How sir Thopas, with *sydes smale,*
Prikyng over *hill and dale,*
Is *comen agayn to towne.*

(B 2026–28)

(How Sir Thopas, with sides small,
Pricking over hill and dale,
Is come to town again.)

These "sides small" have brought ideas of effeminacy to some. One critic ridicules Thopas because of his small *waist,* but Chaucer never mentions a waist.[212] Like the unmentioned spurs that are taken for granted, "waist" will not perform on two levels; it is inappropriate for a phallic image. If Chaucer is referring to a man's yard, small sides seems fit. "Small" may also foretell a reduction in size, a return to a normal contour from an afflicted condition. And, to halt the thought of effeminacy, the use of the word *pricking* only needs to remain as his dominant action to see Thopas' function at the opposite end of the gender scale from the feminine.

Thopas is (or soon will be) pricking over "hill and dale." In the

"bower to let" poem, there is a similar location. The bower is "seated in a Pleasant Vale, / Beneath a rising Hill." The pilgrim poet's allusions to "hill and dale" might be called a commonplace, because it was so often used to refer to a woman's abdomen and her desired receptacle.[213] So Thopas, in his pricking, is about to "come to town again." Renewed activity is just beyond his next adventure. As the interlude of prediction comes to a close, the poet resumes his account of the action.

Suddenly the stage is filled with extras. In typical medieval fashion, the distraction of a troupe of minstrels has been called upon.[214]

> His myrie men comanded he
> To make hym bothe game and glee,
> For *nedes moste he fighte.*
>
> (B 2029–31)

> (He commanded his merry men
> To make both game and glee for him,
> Because he must fight.)

Thopas must prepare himself for the fight. There is confusion among reviewers because this fight *never occurs*. In an attempt to tie up this loose end, one critic has identified the fight with the giant's stone-throwing and Thopas' retreat that have already taken place. It could be seen that way if the story ended there; one might assume this was prudent (or cowardly) avoidance of battle. Another commentator, in an offhand manner, simply refers to the burlesque of the "arming of Sir Thopas [and] the fight with the giant" without attempting to locate where in the story the elusive action takes place.[215] In Chaucer's time-frame, his words in this third line make it clear that the battle has yet to occur. The solution to this dilemma is that a "battle" does take place, but it is not a physical conflict *between two persons*, as the primary plot would demand. The clever resolution will soon occupy the stage.

While props are set up behind the curtain, the poet holds the interest of the audience by revealing the final detail about the enemy. Thopas must fight

With a geaunt with *hevedes three,*
For *paramour* and *jolitee*
Of oon that shoon ful brighte.

<div align="right">(B 2032–34)</div>

(With a giant with three heads,
For *paramour* and *jolitee*
Of one that shone very brightly.)

An adversary with three heads! How amazing, even for a giant. Why didn't Chaucer draw attention to this shocking fact at Sir Elephant's first entrance? It's surely as important, perhaps it is more important than the fact that he is a giant. Chaucer, in his wisdom, wanted us to focus on a giant Arab named "Sir Elephant." Three heads would have been a distraction: which one spoke? did they recite in unison? did the heads actually have three different names? We were not to be distracted by non-essentials. The foe has been identified as Venereal Disease—and now is the proper moment to demonstrate what *type* of venereal disease is afflicting Thopas.

Heads, though a humble word, is another of Chaucer's brilliant ambiguities. The poet has revealed that the phallus is threatened by three *heads*, three apostemes; that is, three boils. Grim. The second and third lines can be interpreted to read that one head is there because of *passion* (paramour), one because of *fornication* (jolitee), and the third is especially swollen (shoon ful brighte).[216] What does a man in the fourteenth century do to rid himself of three inflamed heads threatening his yard? He accepts a physical challenge. It is this "battle" that calls for the earlier mentioned *endurance of suffering*. The "battle" to be waged against the "opponent" is staged in a doctor's quarters, fulfilling all that has been said. The three heads will be done away with—with a *small lance*—by 9 A.M. tomorrow morning. A real life medical/surgical experience could be the inspiration for the one purpose listed as reason for pilgrimage—cure of illness.

So Thopas, speaking for himself once again, commands

"Do come," he seyde, "myn mynstrales,
And geestours for to *tellen tales,*

Anon *in myn armynge,*
Of romances that been roiales,
Of *popes and of cardinales,*
And eek of love-likynge."

(B 2035–40)

("Do come," he said, "my minstrels,
And reciters of adventures to tell tales,
Continually during my arming,
Of romances that are royal,
Of popes and of cardinals,
And also of love-liking.")

He wants to hear all the stories while he is "arming," which—on the covert level—will be the preparation for, and enduring of surgery. The patient's plan shows an urgent desire for romantic recollections to make the pain more bearable. He wants to dwell on how it will be to participate in the pursuit once more. Perhaps the line about the clergy asks for spiritual guidance, bravery in the face of agony (there is bound to be agony), or perhaps there is an undiscovered, covert intention for *popes* and *cardinals*. In any case, the procedure to eliminate the three heads of the enemy with a small lance—and other equipment—is about to begin. It is good to know, as we already do, that Thopas will be "victorious." The medical battle *will slay* Sir Elephant, as our hero has boasted, and our storyteller has confided.

This arming passage, we are about to examine, is outstanding. It is not surprising that the descriptions have caused conflicting statements among scholars. For example, it has been said that we are to take the arming sequence seriously as details of a precise ritual; or, we should see this as ridiculous and meant to make fools of the Flemish (because of Thopas' "birth" in Flanders); or, we are to recognize Pilgrim Chaucer here as a dunderhead in matters of armor.[217] What we will find is the surgeon's procedures conveyed in terms of a medieval soldier preparing for battle. The scene is unique in all of the poet's writing.

Its uniqueness comes partly from vocabulary. Within the whole of the tale of *Sir Thopas*, there are twenty-three words that

Chaucer uses here and nowhere else.[218] The many strange-looking and unfamiliar terms were a primary reason for my doing a word-by-word reading the second time through. I had to be "sure" of the intention of each line. The poet has something special, something personal, to say in his own story. Within the arming/medical maneuver, which covers thirty-two lines, he uses ten of these once-in-a-lifetime words.

The surface understanding of this sequence and selection of equipment has been thoroughly studied, and found nonsensical insofar as real knightly garb is concerned. Covertly, it is medical technique that masquerades as Thopas donning pieces of clothing and armor. We must realize, of course, that items named are inventive approximations of medical procedures and equipment. As a pretense of actually being outfitted with armor, the process becomes redundant and perplexing. The sham is only meant to conceal the doctor's activities and patient's reactions so as to continue to provide a double meaning.

In all the tantalizing little vignettes we have seen, from the beginning of the Thopas story until the onset of this problem, just a few lines were devoted to each subject. Chaucer, now, collects many knightly objects and materials that in some way imitate surgical necessaries. Because of the number of lines, it almost seems that the poet made a list of every possible ambiguous object, and challenged himself to use them all. It must have been quite a feat intellectually and creatively—a word game to play and try to win. Confusion for readers results from his effort, because he attempts to tell the entire story—from infirmity to health—in one analogy. Centuries later, I. A. Richards would say that "there is no whole to any analogy, we use as much of it as we need; and, if we tactlessly take any analogy too far, we break it down."[219] The pilgrim poet's ploy is almost stretched to the breaking point.

Chaucer's presentation of the activity in a surgeon's rooms may be the earliest such literary creation. But in the 1700s an account of surgery was musically transcribed by Marin Marais. The title of the work is "Operation for the Removal of a [gall] Stone." It is made up of many recollections; descriptive titles guide the listener: Trembling at the sight of the apparatus, Decision to mount the operation chair, Apparatus lowered, Solemn thoughts of family and

death, Tying down of arms and legs, Incision made, Forceps insert-
ed, Stone removed, Patient faints, Blood flows out, Bindings
loosed, Transported to bed, and Convalescence.[220] Though the
eighteenth-century outline deals with an *internal* condition, it sets
a proper mood for the challenge Thopas faces. The fourteenth-
century surgery will be external; therefore, the procedure will be
simpler, but medical techniques are not as "advanced."

Pilgrim Chaucer said that one aid to Thopas' escape from his
attacker was his *berynge*, his "ability to endure distress." Medieval
candidates for surgery needed courage. Doctors also had to be cou-
rageous in order to have the confidence to subject patients to hor-
rendous procedures in hope of a cure.

How does our hero prepare for the ordeal? His minstrels cater
to his whims.

> They fette hym first the sweete wyn,
> And mede eek in a *mazelyn*,
> And roial *spicerye*.
>
> (B 2041–43)

> (They brought him first the sweet wine,
> And mead also in a bowl made of maple,
> And royal spices.)

Good food and wine and eating of "kene spicis" was thought to en-
courage lechery, and abstinence from such tasty fare to be a lecher's
proper penance. A medieval cleric, concerned with aphrodisiacs,
asks, "Hast thou smelled anything…Of meat or drink or spicery
that thou hast after sinned by?" A medical book by Lanfranck,
which was well known in the thirteenth century, forbids "wine, and
flesh and all manner of sweetmeats" to a man with apostemes of
the yard, and that "personifies" Thopas. In spite of general medical
wisdom, servants fetch wine, mead, and spices to please him. This
has the flavor of a last fling. Chauliac, concerned with afflictions of
the yard, talks of eating spices to aid the ȝerde to "stand up."[221]

The storyteller's subsequent choice of words is suggestive of
conquests, even if only contemplated.

> Of *gyngebreed* that was ful fyn,
> And *lycorys*, and eek *comyn*,
> With *sugre* that is *trye*.
>
> (B 2044–46)

> (Of preserved ginger that was very fine,
> And licorice and also cumin,
> With sugar that is tried, tested, select.[222])

The surface indicates preserved ginger and other sweets, but the reappearance of "lycorys" (likerous, i.e. lecherous) causes suspicion. Word-play with lecherous is balanced by *comyn*—a play on *commun*, promiscuous.[223] Chaucer, elsewhere, reviles "common strumpets." (*Boethius*, I, pr. 1) Even today "common" can be a slur directed against a woman.

With this sexual innuendo, let's take a second look at the "gyngebreed." As a compound word, the second half addresses breeding (MED, "breden"), reproduction. *Cursor Mundi* says of a woman "she breeds two for one...twinlings." (3444–45) The first syllable, "gynge," is part of the Middle English verb *gangen*, "to be" or "to become." To "child gangand" is "to be pregnant." The MED tells of a steward who is a father-to-be, "gret *ging* hys wyf."[224] So Chaucer's spicy "gyngebreed" in one direction points to tasty food, but "gyng breed" in another points to the result of copulation.

Sugar, the last item of food, is a sweetener for recipes, of course, but even in the fourteenth century it also meant sweet words—"sugared flattery."[225] Thopas is being entertained with erotic tales filled with sweet, well-chosen (tested, select) words, the romances he had requested.

And now Thopas' attire becomes the center of interest.

> He *dide* next his *white leere*,
> Of *clooth of lake fyn and cleere*,
> A *breech* and eek a *sherte*.
>
> (B 2047–49)

> (He donned next to his white *leere*,
> Cloth of lake fine and clear,

A breech and also a shirt.)

Dide is part of the verb *to don*. Thopas donned *something* next to his "white leere." John Matthews Manly has found this to be the only example where *leere* means "skin of the body"; it usually means cheek. Of course, if we go back to Thopas' original description—his white face and seemly nose—white cheeks also belong to this lower "face." *Lira*, the suggested source from Old English, refers to the "fleshy part of the body."[226] Chaucer, acquainted with many forms of English, chooses and positions his words with purpose.

The *something* that is placed next to these "cheeks" is a cloth of *lake* which, we are told, is a kind of linen. ("Lake," then as now, also meant a body of water.) If we hadn't been told that *lake* meant *linen*, "cloth of lake fine and clear" would have reverberations of cloth that is *wet* from a "lake fine and clear." The covert level of this part of the pilgrim's story is a medical adventure where wet cloth is important. Such fabric is recommended by Lanfranck when treating apostemes of the ȝerde—the *heads* that will be dealt with. Wet linen is laid about the ȝerde and balloks. Chauliac, the outstanding medical man of the fourteenth century, lists cotton and linen cloths as necessities. These fabrics are doctor's standard supplies. The poet, here, is giving the particulars of the preparation for the "battle," the cure of the affliction. The breech and shirt are added next. This is additional cloth, dressings for parts to be treated—some specifically for the breech, some above it. *Breech* also has a special medical connotation: surgical girdle.[227]

Critics point out the unreasonable sequence of several items that follow.

> And next his sherte an *aketoun*,
> And over that an *haubergeoun*
> For percynge of his *herte*.
>
> (B 2050–52)

> (And next to his shirt, a padded garment,
> And over that a jacket of mail
> For piercing of his heart.)

It is said that the padded cotton aketoun worn over a shirt is an "absurdity." But, as a layer of padded cotton, it seems just what the doctor would order. Over this is a haubergeoun, "a coat or jacket of mail...often worn under plate armor."[228] Because metal plate will be the next medical object to deal with—a defense for uninvolved portions of the anatomy—the haubergeoun preceding the plate is the logical order. Strangely enough, the poet says this "garment" will aid in piercing of his heart. One would expect that it is protection *against* piercing of Thopas' heart that is required, but that's *not* what Chaucer's words say. The double meaning lends itself well to saying the haubergoun aids in piercing of *his*—the giant's—heart (the *core* of the boil). This is essential.

All that has gone before are preliminaries—the cleansing, and the protective and absorbent padding—for medical procedures to come. The "battle" is at hand. Thopas is wearing the haubergeoun,

> And over that a fyn hawberk,
> Was al ywroght of *Jewes werk*,
> Ful strong it was of *plate*.
>
> (B 2053–55)

> (And over that a fine hawberk,
> Was wrought of Jew's work,
> Very strong it was of plate.)

The "plate" and "Jew's work" are clues. Jews were rarely associated with making armor, but they were prominent as medical men of the time. A metal *plate* was surgical equipment, used as a guide for the surgeon, and protection for the patient in the technique of cauterization. Lanfranck instructs: "Take a broad plate of iron and make a hole in it, and lay that plate where you will make thy cautery. Then thou must have an iron made long and small and hot, and put it in that hole of the plate. This plate will save the place so that the cautery shall be no more than you will."[229]

Next is applied our hero's "coat-of-arms," his identifying insignia.

> And over that his *cote-armour*
> As *whit as is a lilye flour*,
> In which he wol debate.
>
> (B 2056–58)

> (And over that his coat-armour
> As white as is a lily flower,
> In which he will contend.)

Though this garment has been ridiculed as "blank," it needs to be viewed from a different perspective.[230] Chaucer was aware of insignias elaborately embroidered to identify a combatant's allegiance. This *is* what the poet presents with this unadorned design. The garment is not "blank," but meaningfully *white*—as a *lily flower*. His earlier comparison was to a flower that pricks (B 1936), but now, surrounded with white, he appears as a lily. The picture properly illustrates the transformation: life, for the moment, is nothing but pure. Purity and sexual abstinence are his "coat-of-arms" for the nonce. This is how he will meet his foe, enter the "fight" against venereal disease.

As we would expect with surgery, prevailing color makes a change from white to red.

> His sheeld was al of *gold so reed*,
> And therinne was a *bores heed*,
> A *charbocle* bisyde.
>
> (B 2059–61)

> (His shield was all of gold so red,
> And therein was a boar's head,
> A red gem beside.)

It was common in the Middle Ages to speak of *gold* as "red" (and *silver* as "white"). Chaucer says elsewhere that "blood betokeneth gold." (D 581) Blood on armor is poetically spoken of as "gilt." Thopas' shield is predominantly red; it is stained by the blood of surgery. The carbuncle, a boil-like inflammation, is also the name of a *red* gem which the Middle Ages believed glowed in the dark.

The alternate image, the infected carbuncle, contains its own vibrant heat and was said to "burn as a coal."[231] Atmosphere in these lines is suddenly red, glowing, filled with intense heat.

The "bores heed" is the spectre of the cautery iron. The *head* is the tip; the *bore* is the hole bored into the metal plate to guide the surgeon's iron. When the operation is completed, having used a lance to remove the infected portions of the yard, the bleeding must be stopped. Cautery was considered the best means to seal a wound.[232]

Chauliac, often more detailed than Lanfranck, describes preparing for cautery. We hear the doctor's concern for the one who is ill, as well as his personal desire to assist recovery. First he advises that information should be given beforehand about the goodness and sureness of cautery in hopes that the ailing soul may endure it better. But, if need be, the sick person is strongly held or bound. Two or three cautery irons (or "as many as shall be needful") are heated until they become red, for then they are better. They are slyly brought to the surgeon, so the patient does not see them. The irons are thrust, one at a time, into the hole with a rolling motion so they cleave not to the flesh. The procedure continues until the irons lose their redness, and is repeated as often as necessary.[233]

Enclosed in an atmosphere of blood, heat, and pain, what does our hero do?

> And there he *swoor on ale and breed*
> How that *the geaunt shal be deed*,
> *Bityde what bityde!*
>
> (B 2062–64)

> (And there he swore on ale and bread
> That the giant shall be dead,
> Betide what shall betide!)

No more spices and wine. Our hero swears on simple penitent and convalescent fare of a hospital—bread and ale—that, whatever is necessary, his enemy will no longer exist. Venereal disease will no longer be a factor. His vow, at the height of distress, is human and timely, comparable to a woman's sincere, but soon forgotten, promises made

in the throes of labor. As the surgeon completes his work, a covering for the wounded area is put in place, captured in the poet's terse, "*be tied* what shall *be tied*." Chauliac carefully explains the special method of bandaging in the groin area. Bindings, with a division and a roll that is cut in two parts in the middle, often hold medications. For the purse of the privy stones a coif is made; for the ʒerde, a bag is bound—*be tied what shall be tied*—to the breech, the surgical girdle.[234]

The pilgrim storyteller continues his considerations of protection. A yard recovering from surgery and cautery would welcome these precautions.

> His *jambeux* were of *quyrboilly*,
> His *swerdes shethe* of *yvory*,
> His *helm of latoun* bright.
>
> (B 2065–67)

> (Armor for his legs was of *quyrboilly*,
> His sword's sheath of ivory,
> His helmet of shiny brass.)

Jambeux means leg or shin guards. *Quyrboilly* is leather processed to facilitate contouring of fitted protectors. An alternate spelling, *cureboile*, makes word-play more visible. The message communicated is that venereal disease is forced to relinquish its hold on Thopas. The onslaught of Sir Elephant (elephantiasis) against legs has been resolved. Limbs are no longer at risk; cure of the boils removed the threat. And to match the lily white "coat-of-arms," the "sword's" sheath is also white (ivory). The sheath is purity itself; medically, the yard is swathed in more linen, typically soaked in a soothing concoction.

A helmet of "brass" is inadequate for knightly battle equipment; it is too soft to wear as a defense against swords and cudgels. But, medically speaking, a helmet-like guard was used to ward off accidental encounters with swishes of hands or blankets, or from one's own movements while asleep. What a blessing! Chauliac tells of such an implement. After an aposteme has been removed, ivy leaves would be laid on the wound, then a covering of three layers

of cloth, and finally a guard made of brass (or leather) atop.[235] This brass defense surely could correspond to a kind of helmet in the poet's imagination.

Equipment, for the riderless "horse," is the next topic.

> His *sadel* was of *rewel-boon*,
> His *brydel* as the *sonne shoon*,
> Or as the *moone light*.
>
> (B 2068–70)

> (His saddle was of whalebone *bone*,
> His bridle as the sun shone,
> Or as the moonlight.)

The saddle is of bone; once again, it is white. There is, however, a peculiar twist to these words. "Rewel" is whalebone, which makes "boon," as *bone*, redundant. *Boon*, however, also means prayer. In addition, *rewel* can be a play on *ruel*, the space between a bed and the wall. (MED) Then *reul-boon* is a prayer offered beside one's bed. Thopas, at the moment, would be no competition for the fifteenth-century lad who did "gallopp" until he made "both bedsides cracke.[236]

His saddle can be seen as figurative. One medieval author counsels, "the saddle of thine horse shall be patience and meekness,"[237] the "horse" being man's animal nature. In Thopas' case, he is saddled with prayer beside his convalescent pallet. The bridle (another word often used figuratively), his restraint, is a preventative while the "sun shines" and in the "moonlight"—day and night. One would expect that a wounded patient would experience a period of limitation. He is not up to "unbridled passion," an equestrian phrase we still use today.

A positive prognosis is forthcoming. Recovery is nearly complete, indicated by the condition of his "spear."

> His *spere* was of fyn *ciprees*,
> That bodeth werre, and nothyng pees,
> The *heed ful sharpe* ygrounde.
>
> (B 2071–73)

> (His spear was of fine cypress wood,
> That bodes war, and not peace,
> The head was well sharpened.)

Those who know weaponry tell us that cypress wood is a poor choice for a spear to be used in battle, and that our hero—on the surface—appears foolish again.[238] The underlying intent, however, is right on target. "Cypress," is a play on *Cypris*, an ancient name, one which Chaucer uses in *Troilus* (3.725) and in *House of Fame* (518), as a reference to Venus. Thopas is making ready to fight in her war with chastity,[239] as alluded to in *The Romance of the Rose*. (3698–99) This "spear" is dedicated to erotic skirmishes, and its ambiguous "well sharpened" head has recovered the ability to pierce. Thopas has won the battle; he "escapeth," as Pilgrim Chaucer foretold. (B 2020)

A wise observation from the fifteenth century counsels: "You took a malady from excess of venery and thereby, if your health is restored, you will never sheath (copulate) afterwards as easily as you did before."[240] Is Thopas touched by sober wisdom such as this? Will this revitalized "warrior" be sensible, prudent in his actions? Apparently not. His "spear" is once more in good condition; that signals the stage lights to brighten. Threatening shadows vanish. His gray steed has returned and is carefully on the move.

> His steede was al *dappull gray*,
> It gooth an *ambil in the way*
> Ful *softely* and *rounde*
> > *In londe.*
> Loo, lordes myne, *heere is a fit*!
> > > (B 2074–78)

> (His steed was all dapple gray,
> It went at an amble in the way
> Full soft and round
> > In land.
> Lo, my lords, here is a fit!)

The pace is an amble, easy going; the rhythm, just for these few

lines, irregular. The surface image, of a rider on a soft and round horse that is moving "in land" (from what?), is provocative. If we look at the lines again, perhaps it is "the way" that is soft and round. It reminds me of our bawdy songs again, that tell of a place "when you once are enter'd in, / You cannot lose your way"; or the lane that is straight and goes not far.[241] The "steed," in good physical condition for "his" first venture, takes a pleasant path and heads in land.

If the storyteller's intention is not completely understood, he adds an exclamation about the *fit*! Do we understand this to be an experience that refreshes, the definition of *fit* we learned at the beginning of the pilgrim's performance? Do we understand, because there are only two more lines left to this part of the story, that this is a declaration of the ending of this first portion of the story, this "First Fit"? Or are we to understand that a sheathing has taken place and the accommodations were a proper match (fit)? I imagine the poet intended all three.

At the close of this first "fit," addressing his listeners directly, Pilgrim Chaucer leaves the continuation in the hands of the udience.

> If ye wol any moore of it,
> To telle it wol I *fonde*.
>
> (B 2079–80)

> (If you will [have] any more of it,
> To tell it will I strive.)

The performer is agreeable to continue, if his listeners will it. "I will *fonde*" he tells us; he will *strive* to please us. Though "strive" is usually given as the explanation of "fonde," the word has multilevel relevance. Checking other possibilities of *fonde*, I was astonished. The additional, perfectly attuned, definitions were a revelation. I spent several minutes just contemplating their effect. They still give me pause. *Fonde* can mean, "to tempt to evil." A legend tells of a young man who was often and sorely "I-fondet" by a woman's hot flesh.[242] And, *fonde* can mean, "to try the patience of God." Could this final word have more potential? Knowing the identity of the

Host as Christ creates this second level of powerful significance.

Christ, attentive to Chaucer's shameful offering, allows him to continue. The poet assumes his listeners want more of the same, and so will begin the "Second Fit." And we, as his audience, know by this recent declaration that he will continue to *fonde*—to tempt us into evil ways and to try the patience of God.

The First Fit is concluded. The pilgrim performer steps back, and the curtain closes ever so briefly. Applause encourages our storyteller to give us the second installment as offered. And here he is again, ready to lead us farther down this path filled with medieval obscenery.

The backdrop for The Second Fit conjures a different mood. Gone are sporting and hunting, grasses and herbs, birds and rabbits—topics of the great outdoors that filled the youthful adventures of Thopas. He is now a successful survivor and a "man" of the world. As the storyteller comes forward, the open curtains expose panels with stylized figures, regal decor, lush colors. There are knights with their ladies, towers and torches, heroes of romances and visions of *chivalry*, a term not mentioned in the story before this.

The opening lines are similar in message to those of The First Fit, but the tone now is confident, with a hint of familiarity. While the previous opening had said only "listeth, lords," the poet has become very sure of himself.

> The Second Fit
> Now holde youre mouth, *par charitee,*
> Bothe knyght and *lady free,*
> And herkneth to my spelle;
> Of bataille and of chivalry,
> And of ladyes *love-drury*
> Anon I wol yow telle.
>
> (B 2081–86)

> (Now hold your mouth, for goodness sake,
> Both knight and lady free,
> And harken to my report;

Of battle and of chivalry,
And of ladies' flirtations
Shortly I will tell you.)

We can't help but be surprised at the narrator's boldness, instruct-
ing the royal audience—both knight and lady—"hold your mouth"
and "harken." Practically speaking, however, each listener might
need to place a hand over his or her mouth to muffle a laugh in or-
der to be able to hear. They could still be reacting to moving far-
ther "in land" for a good "fit."

The poet speaks to those who are *free*. With what has gone be-
fore, it is safe to assume this has to do with amour. Chaucer's
words from the *Romance of the Rose* explain.

For wel wot ye that love is free,
And I shall loven, sith that I will,
Who ever like it well or ill.

(3432–34)

(Wel ye know that love is free,
And I shall love whom I will,
Who ever like it well or ill.)

Love that is free is spontaneous, not subject to control. Ladies of
the Second Fit are women of nobility who can also be lovers, not
just "love" objects. "Ladyes love-*drury*," hints at flirtation and en-
couragement of illicit relations. An MED entry speaks of "these
proud ladies, that love druries, and break [their] spousing."[243]
Adultery will be part of this encore performance.

Battle and tournament were announced as topics for the first
part. Battle will continue as an interest, but now coupled with
chivalry. To confirm the new importance of chivalry, the word is
repeated only nine lines later. The common link among similar
words (chevalier, cavalier, cavalry) is the mental picture of mounted
horsemen. That part of the action will not change.

The next group of lines seems almost forbiddingly literary and
formal as it catalogues names of six—seven, with Thopas—heroes of

medieval works. Are we to be impressed with Thopas by association?

> Men speken of romances of *prys*,
> Of *Horn* child and of *Ypotys*,
> Of *Beves* and sir *Gy*,
> Of sir *Lybeux* and *Pleyndamour*,—
> But sir Thopas, he *bereth the flour*
> Of roial chivalry!

<div align="right">(B 2087–92)</div>

> (Men speak of romances of prize,
> Of Horn child, and of Ypotys,
> Of Beves and sir Guy,
> Of sir Lybeux and Pleyndamour,—
> But sir Thopas, he carries, or pierces, the flower
> Of royal chivalry!)

Chaucer used many elements from medieval romances, but he could be very selective—there was such variety to choose from. Selecting carefully, he tells his own unique story. The "romances" named here come with special problems. (Chaucer never makes things easy or obvious.) The biggest problem is *Ypotys* because the content is no romance at all, but the propounding of Christian doctrine as a dialogue. *Pleyndamour* is a different matter; it is an unknown work. All are said to be "romances of prys." A *prys* (prize) can be a reward, a prize, victory, or fame, but the word began in hunting jargon as *a thing taken by right of seizure*.[244] That sounds like the guiding philosophy of Thopas' romance. His searches now include the elite; he pierces *royal* flowers.

Considering the word games played before, I wondered about the names as words. No full title of a romance is used, only an identifying word; and then the pairing needs to be considered. Why balance *Horn* with *Ypotys*? or *Beves* with *Gy*? "Horn" makes a fine representation of a phallus. "*Ypotys*" led me to *pot* (plural in Middle English, *potes*)—a receptacle, potential sheathe to match the associated potential phallus. *Beves* and *Gy* hold girl and boy identities: "Beves" as *bevys of ladies* and "Gy" as *gie*, their guide. "Pleyndamour," even if an unknown hero, has a name that says "to

play (pleien) amorously," which the MED tells us is to "engage in intercourse."

"Lybeux" is difficult. The only sex-related word I could find with a hint of the sound (lib you), is *libbing*—gelding.[245] A libber, a gelder, could be assigned to carry out an act of retribution against a perpetrator of lustful conquests. The catalogue concludes with a boast that, despite the famous above-mentioned romantics, our recovered swain is the last word, the consummate achiever, the best at what he does. His accomplishments surpass those of legendary lovers.

Next Thopas gives a truly brilliant performance in the saddle.

> His goode steede al he bistrood,
> And forth upon his wey he *glood*
> As *sparcle* out of the *bronde*.
>
> (B 2093–95)

> (His good steed he was astride,
> And forth upon his way he glided, or glowed
> As sparks out of the torch, *or* the firebrand.)

Here again, we find an unsuitable, unstable, description of horsemanship. I think of Richards, once again, and the "*movement among meanings*." A man on a horse does not function like sparks released from a torch (bronde)—but a phallus does. A "bronde" (firebrand) is also associated with both Cupid and Venus to signify the arousal of passion. The line before the firebrand says that "he *glood*," a word both ambiguous and non-equestrian. "Glood" is *glided* (smooth, continuous movement), hardly the action of hoofs beating the earth. The verb, however, can also express *to glow*, as an ember, or be inflamed with emotion, setting the mood for the sparks and torch that follow.[246]

As the poet continues, he reveals concern.

> Upon his *creest* he bar a *tour*,
> And therinne *stiked* a lilie flour,—
> God shilde his *cors* fro *shonde*!
>
> (B 2096–98)

> (Upon his crest he bore a tower,
> And therein stuck a lily flower,—
> God shield his body from shame!)

Our hero's personal insignia, his crest, bears the image of a tower—appropriately phallic. This symbol holds memories for him of lilies that were "pierced" (stiked), "thrust with force."

The concluding line is a surprise, but better late than never. A prayer is said regarding the future. Christ, the Host, hears this prayer: "God shield his body from *shonde*!" The Baugh text defines *shonde* as harm, but the MED brings us closer to the pattern of the typical fourteenth-century prayer, with connotations of disgrace, dishonor and ignominious ruin. Many variations of the popular prayer coexisted to plead,

> Shield me today from sin and shame.

> Shield me from world's shame.

> Shield me from the fiend.[247]

Chaucer inserts this serious note. Will Thopas continue to have a reputation unsullied? The medieval *Secreta Secretorum* warns that fleshly delight "brings a man to shame and his destruction."[248] Sir Elephant's attack has not deterred continued risk-taking. It is so human to forget quickly.

The end of the story is near. Ten lines remain. What does the poet find important to tell us, knowing how soon it will be over? There are a few more identifying clues, a few more creative presentations.

> And for he was a knyght *auntrous*,
> He nolde slepen in noon hous,
> But liggen in his *hoode*.
> > (B 2099–2101)

> (And because he was a knight adventurous,
> He would sleep in no house,

But lie in his hood.)

We learn of his adventurous life, his day-to-day living. Anxious for exploits, he refuses the comfort and security of a house. Stoic. Stupid! What he does instead is lie in his hood, hardly sufficient protection for a *grown man*. But if we recognize the covert image, not as a man, but, as an uncircumcised yard, this is where "he" would spend "his" off time. *Hood* can be applied to "something resembling a hood," something that protects and conceals, such as the prepuce, the foreskin. Chauliac calls the foreskin a "small cape." Modern day physicians often refer to the "sleeve" of the penis. *Hood*, in the MED, gave no hint of this physical equivalent. So I tried another tactic, the reverse—hood*less*. That did it. In a fifteenth-century poem, a virile member not covered by the foreskin is described as a rascal standing "hoodless."[249]

So Thopas lies in his hood.

> His brighte *helm* was his *wonger*,
> And by hym *baiteth* his *dextrer*
> Of herbes fyne and goode.
>
> (B 2102–04)

> (His bright helmet was his pillow,
> And his war horse was baited by him
> With herbs fine and good.)

"Wonger" is one of Chaucer's once-in-a-lifetime terms, already obsolete in the late Middle Ages. The poet works with great spreads of time as well as great geographical distances to find properly ambiguous words. "Wonger," glossaries tell us, is equivalent to *pillow*. The MED has not reached "W" and cannot assist with details of usage, but the OED says that Chaucer's old word was explained as indicating a pouch or a leather bag in the 1600s and 1700s.[250] If the poet wanted to utilize a word that means pillow as well as pouch, he could have chosen another medieval term—*cod*. But that choice would have made the third connotation—*scrotum*—obvious. The pilgrim storyteller, in his most devious fashion, is providing Thopas with an ambiguous "cushion" for his relaxation.

The "steed," now regarded as a war horse (because of outstanding service in the war against chastity?), is baited with fine herbs. Suitable herbs were believed to enhance generative prowess. *Baiten* also carries with it the significance of "inciting." The hero of *Troilus and Criseyde*, for example, was concerned for young knights in his company whose eyes "baiten" on women. (1.190–93) Thopas' charger is maintained at the ready.

A final comparison of our hero is made to yet another legendary figure of a romance. Why is this knightly figure mentioned separately?

> Hymself drank water of the well,
> As dide the knyght sire *Percyvell*
> So worthy under *wede*.
>
> (B 2105–07)

> (Himself drank water of the well,
> As did the knight Sir Percival
> So worthy under garment.
> *or*, So worthy when aroused.)

We must study these lines. They hold the last thought Pilgrim Chaucer will be allowed to express. Something that is said taxes the Host's patience beyond its limit.

The "well" is the much-repeated pleasing receptacle; it would hardly be more likely to offend here than before. Perhaps it is the name of the knight that holds the key. We saw the many associations derived from the construction of "Cecilia." What could be said about "Percyvell," the knight of the Grail Quest? An obvious thought is that the name begins with *pierce* and ends with *evil*—or is it *veil*? And then Percyvell is said to be "worthy under wede"—strong, powerful, or distinguished under a garment, or when aroused. This "wede" can be related to the *wood* used earlier (B 1964) as indicating a form of *madness*. Refreshment at the well, we are told, both knights have enjoyed. Is it the likening of the lecherous Thopas to dedicated Percyvell? Is it the offense of a slur against a knight of the Grail?

Oblivious to what is about to occur, the storyteller continues,

Til on a day—

(B 2108)

(Until one day—)

but the Host will not even allow him to finish the thought. We have arrived at the interruption we talked about in the tale's introduction. (pp. 55–56)

> "Namoore of this, for Goddes dignitee,"
> Quod our Hoste, "for thou makest me
> So wery of thy verray lewednesse
> That,...
> Myne eres aken of thy drasty speche.
>
> . . .
>
> "By God, " quod he, "for pleynly, at a word,
> Thy drasty rymyng is nat worth a toord!
>
> . . .
>
> Sire, at o word, thou shalt no lenger ryme."
>
> (B 2109–22)

Christ cannot bear the continuing filth that is painful to His ears.

A similarly offended Christ appears in a medieval legend. The Christ-image on a crucifix was seen "to loose his hands from the cross" so that He could cover His ears to avoid hearing words that were offensive to Him.[251] It is what fourteenth-century man would imagine. As for Pilgrim Chaucer, his distressing words, his boastful lewdness, must cease. Debauchery will no longer hold forth.

This story has long been seen as foolish and worthless (*lewed* and *drasty*). But hidden beneath that interpretation is the spectacle of an uncontrolled lifestyle that is truly vulgar and filthy (also expressed as *lewed* and *drasty*) as declared by the Host. The poet's skill with ambiguous words and images is a triumph of double entendre.

The *Tale* has come to a sudden end. The covert storyline, spread over so many pages, calls for a brief synopsis.

The story begins with the caption of a First *Fit*, an exciting, pleasurable experience. Our main character is introduced as capable in conquests, and bears the name *Thopas* (topaz), a stone believed to protect those with a need for frequent intercourse.

The "birth" of Thopas, expressed as an initiation into sexual activity, came at *popering* (a synonym for *pricking*) while in Flanders. (Chaucer, the poet, had been there as an adolescent member of the victorious army of Edward III.) A physical description of Thopas uses images and terms to put us in mind of a special category of grotesques where the tiny medieval illustrations characterize a man's genital area as having a mind of its own. The *nose*, in such an image, serves as the most prominent member, the phallus, or, in fourteenth-century English, the ʒ*erde*. The "face" is *too* white, as if it is falsely white to conceal a blackness within.

A drasty little pageant follows, as the poet shows his creativity in expressing sexual matters under many guises: expensive clothing, athletic achievement, equestrian appearance. "Vener"-ability is portrayed with wild game, sprouting herbs, singing birds, excess of physical exertion, and a pastoral setting. The whole sequence puts me in mind of Annie Dillard's vignettes describing *writing*. Whether she is giving details of the courting of butterflies, the rowing of a boat, the construction of a piece of jewelry, or the harrowing gyrations of airplane stunts, her real topic is always the writing process.[252] Expressed with comparable variety, the real topic of Chaucer's Thopas is always the daring enterprise of a phallus.

A hint of crisis appears. Tone and tempo change. Sexual trouble is brewing. Mention of a fairy queen, as consort, may foretell loss of virility. A fearful enemy appears, Sir Elephant, who portrays Venereal Disease. He threatens to slay the hero's horse, eliminate Thopas' ability "to ride." The boastful "youth" claims a small lance can slay this monster who has three heads. The enemy retaliates by flinging stones (an image of testicles) in an attempt to injure Thopas.

Now we prepare for the showdown, set for "tomorrow morning." Thopas is surrounded first by linen and cotton as a doctor, who will complete the curative strategies by 9 A.M., begins to move against the venereal attack—three inflamed heads that besiege the ʒerde. The small lance and other medical equipment,

involving surgery and cautery, come into play in pretense of white clothing, armor, and knightly outfitting. The pure white of sexual abstinence, the red of blood, and heat of inflammation and cautery make for a colorful scene.

Soon, announcement of recovery is understood when Thopas' "spear" has been sharpened, and he's ready "to ride."

The First Fit concludes with a promise to continue trying God's patience and leading the audience into sin.

The second exciting experience (fit) begins in a different atmosphere. Chivalry and literary heroes are prominent. Thopas is in the saddle and performing like sparks issuing from a torch; aptly put. A prayer for his safety is uttered. A couple more images—one of an uncircumcised ʒerde, the other of a scrotum—continue to demonstrate Thopas' identity as a virile member.

With the next reference to intercourse (drinking from the well) comes the Host's order to stop. The last few lines, the mention of the Grail Knight, Percyvell, must hold the clue to interpreting the specific motivation for the Host's (Christ's) definitive move.[253]

It is as if the Host takes the naughty storyteller by the verbal shoulders and shakes him. "Enough! Have done with it!" This interference is Christ's answer to that brief prayer to save Thopas from ruin. (B 2098) The judge of the stories refuses to allow such a tale to continue. The covert significance of the Host's opposition, however, deserves a closer look.

Chaucer did not need to finish the tale; what he wrote
accomplishes what he needed to accomplish.

—*Donald R. Howard, The Idea of the Canterbury Tales (1978)*

VI: The Link Between Sir Thopas and the Tale of Melibee

WE CANNOT lose sight of the fact that Chaucer is the star and director of this production. What happens on stage is *his* scenario, the chain of events meaningful to the author. So what is accomplished in the scenario by the interruption? To begin with, Thopas' progress is halted in an entertaining, and totally unexpected fashion. The Host makes a simple maneuver on the surface, but the double meaning, the covert purpose, is complicated and surprising.

To understand what is concealed, we need to recall the poet's method of introducing the travelers in the *General Prologue*. They were cardboard-like figures who took life from his imagination only while the spotlight was on them. As he moved to the next character, the previous pilgrim became a paper figure once again. Consider that the Host in the surface story is one of these figures—though he occupied a featured spot as the last introduced—and bides his time until activated by the poet's creativity. But the covert level is *not* imagination, not simply entertainment; it is an expression of reality regarding the poet's life.

At the covert level, the pilgrim poet's offering—from his being called upon for his first story until the very end of his appearance in the spotlight at the conclusion of his second story—is continuous as narrator, conversant, and then reformed narrator. The "Host" is one of Chaucer's creations, but the omnipresent Christ,

whose identity is hidden, is not. The sudden action of Christ is as much a surprise to the poet as to his audience. What we witness here is Chaucer's representation of God's intervention in his life. The Host, beneath the surface, is actually *Deus* without need of *machina*. The scene dramatizes a moment precious to medieval man—the moment when the Infinite touches our world and changes destiny. Some such moments are individual realizations, some universal transformations. We heard of such events (as instant personal conversions) in the life of St. Cecilia; it was the effect she had on those she touched.[254] The Good Thief, dying on a cross next to Christ, was similarly touched. The *Corpus Christi* plays, so important in Chaucer's day, commemorate and glorify many such events of dramatic consequence—the Creation, the Flood, the Crucifixion, and more. Rosemary Woolf affirms that "in the early Middle Ages, examples of repentance were always sudden and striking."[255] In the *Canterbury Tales*, Chaucer is recording a personal event when, touched by God, his life changed and his destiny was altered. He abandoned venery for virtue—by the grace of God—in the blink of an eye. The Host's, Christ's, interruption was the poet's plan in narrating the confession of his sinful life. It is not a whim of inspiration; it is a representation of covert reality.

Then, asked by Christ for prose containing mirth (the atmosphere of heaven) or doctrine, the poet immediately complies. "Gladly, by God's sweet pain!" is his response, a direct reference to the Crucifixion, the source of salvation. He *will* oblige, is now *able* to oblige, by acknowledging this profound reparation for his life. A "little thing in prose" will be forthcoming, but he has qualms. Perhaps this Host is too "daungerous," *difficult to approach*.[256] His hesitancy toward God whom he has offended is reasonable. Then, as if to demonstrate his conversion, he expresses a relationship between the story he is about to tell and the Gospels.

His allusion is not to the Gospels in general, however, but remains centered on Christ's Passion and Death. (Devotion to Christ's Passion was a recommended "antidote" to temptations and "particularly lust.") The poet notes that each Evangelist had his own way of telling the story, "but doubtless the sentence is all one."[257] "Sentence," here, is understood as the true meaning, authoritative teaching, or significance. Repeated incorporation of the

word (five times in seventeen lines) announces, signals, that the *sentence* is of prime importance.

As he closes the comments on the accounts of Christ's Passion, alluding to recollections of Christ's death, he makes a direct link to the story he will tell. Variations, he reminds his audience, are capable of producing the same Truth (sentence). When the prose he will offer is seen to differ from the source, he gives assurance that the *sentence* is not changed. (The story of Melibee and Prudence, which follows, was popular among readers of French.) He explains that he may add more proverbs and change some of the words. These changes are intended to "reinforce the effect of [his] subject matter."[258] Chaucer's *Melibee* is to be "more so" than the original. In the humble publican image, he places all his listeners on a plane above him as "lordings all," and then beseeches their understanding, that they not find fault with his effort.

Lastly, as this segue to *The Tale of Melibee* closes, he pleads, "Allow me to tell all of my tale, I pray."[259] At the surface, he is simply asking not to be interrupted again. But covertly he prays to be given sufficient time to repent, and to provide a new enlightenment which will amend the influence of his sinful past upon his audience.

Now, finished with his necessary introductory message, Pilgrim Chaucer is fidgeting at the curtain's edge, anxious to begin his moral presentation, to declare his sentence, to make known his reinforced subject matter.

VII: The Tale of Melibee

AS SOON AS the poet's alter ego accepts the Host's offer to have him tell a second story, a prop box labeled in French *Le Livre de Mellibee et Prudence*, is moved onto the stage of his mind. While the action between the pilgrim and his Guide goes on, the contents of the box is set up for the second half of his production. When he lifts out a book with the French title, he lays it aside. He'll work from his own translation, and displays an identifying placard that reads in English "The Tale of Melibee" (omitting Prudence).

A backdrop sketched with black chalk depicts a large gathering. Many faces are crowded together; few have distinguishing features. The box also contains several carved wooden figurines (like those the poet had seen at entertainments on the continent). There is a man and a woman each about two and one half feet tall; he places them at center front stage. An adolescent girl, just a bit smaller, is set close by the woman. Three men, only half as tall as the other figures, are in a group to one side. (These must play lesser roles because medieval artists often illustrated importance by the height of a figure. Ordinary folk, for example, were small compared to a king or bishop.) The last item from the box is a wooden plaque to suspend above the setting—a black chalk drawing of God the Father.

As the scene gets under way stage lighting is muted. We can

just make out the set arrangement. A small spotlight illumines the characters spoken of as we review the cast. First we see the wooden man with colorfully painted regal attire. His name is Melibee, which means "a man who drinks honey." (B 2600) The name signifies many things: he has been blessed by the honeycombs of *wholesomeness* that give sweetness to the soul (B 2300–05); he has been deceived by the sweetness of *flattery* and *falsehood* (B 2360–70), and has experienced *excesses* of physical delights (B 2600–05); he has also been nourished by the traditional honey of *Scripture*.[260] This is a young, rich, powerful man, who went "into the fields" to play, leaving his wife and daughter in the house with doors securely locked.

The spotlight next moves to the image of the woman, also in royal garb. This is Prudence just like the virtue. She has the power to survey the past, evaluate the present, and visualize the future.[261] The doll's facial expression has been altered to show her nobility. (The French Prudence had been concerned with gaining respect.) Three enemies (the small figures) saw Melibee leave home, and took the opportunity to place ladders against the windows, and enter the house. Noble Prudence was beaten.

Next our attention is directed to the barefoot daughter. She has a non-speaking part. Her clothing is simple, refined, but stained with blood. Melibee's enemies wounded her in five places—her hands, her feet, her ears, nose, and mouth—and left her for dead. The palms of her hands are turned outward so that we see the wounds. Red paint marks her injuries. Her face is pale. The French daughter was left nameless, but Chaucer adds a dimension by calling her Sophie, which means *wisdom*.[262] (The "recovery" of wisdom is part of the plot.)

We get a quick look at the three enemies, as the narrator describes what they have done. These smaller statuettes had been colorfully painted in the French production, but Chaucer has stripped their color, and left them a neutral tone.

Our narrator sets the scene, telling about off-stage events (Melibee's excursion and the attack) which have already taken place.[263] Action begins when Melibee returns home. Enraged by the injuries to Prudence and Sophie, he weeps and wails and tears his clothes. Prudence cautions him not to carry on; suffering must be borne

with patience. (She is an endless stream of good advice as the story unfolds; sometimes, when his masculinity doesn't get in the way, he even listens to her.) She suggests calling wise friends together to counsel him about action to take against his enemies. (B 2190–95)

Cued by her suggestion, the back lights come up. We see the faces of the crowd clearly now. Melibee's invitation, unfortunately, was general, not selective. A motley group has responded: doctors, old men, young men, enemies (who claim to be Melibee's friends), neighbors who respect him, flatterers, and men wise in the law. They debate, offer advice, and sometimes get noisy and disruptive, shouting "War! War!" A few give opinions, but no agreement is reached. (B 2200–40)

When the crowd scene is over, the faces are obscured once more, and Prudence, along with Melibee, reclaims the light. Their dialogue is extensive. Chaucer inserts a characterizing proverb into the woman's script: "In wicked haste there is no profit." (B 2240–45) Melibee is ready to go to war; she says stop and think. He protests; he doesn't want to be called a fool for taking advice from a *woman*, and adds that Solomon says all women are wicked—he never found a good one. (B 2245–50) She responds that Solomon may never have found a good woman, but many other men have. And if *all* women were wicked, Christ would never have been born of a woman. (B 2260–70)

Prudence knows her ideas are good. How can she persuade Melibee to cooperate? (Her strategy impresses us as preposterous, but who are we to deny the power of virtue?) She tells Melibee that if he will trust her advice, she will restore the well-being of the seriously injured daughter. (B 2300)

He agrees to listen, and during the course of her lengthy counseling she reviews his sinfulness in terms of the honey that provides his name:

> Thou hast drunk so much honey of sweet temporal riches, and delights and honors of this world, that thou art drunk, and hast forgotten Jesus Christ thy creator. Thou hast not done to Him such honor and reverence as thou ought.[264]

(Did Chaucer see *himself* as a man "drunk" with worldly recognition

and out of touch with the path of salvation?)

She continues by identifying Sophie's wounds with the wounds of Melibee's (Chaucer's?) spiritual life:

> Thou hast done sin against our Lord Christ; for certainly, the three enemies of mankind…the flesh, the devil and the world, thou hast suffered to enter into thine heart willfully by the windows of thy body, and hast not defended thyself sufficiently against their assaults and their temptations, so that they have wounded thy soul in five places.[265]

This might serve as an examination of conscience.

Melibee wavers between her advice and his determination that "men have to avenge wrongs!" (B 2650–55) She eventually convinces him to let her (Prudence) deal with the enemies. (B 2910–15) The back-and-forths are finally resolved as Melibee decides in favor of the skill and reasonableness of Prudence. When we hear him say, "I will do your will and put myself completely under your guidance,"[266] we know the daughter's condition will be righted. As if by magic (or disappearing paint) the "blood" of the wounds on the wooden daughter fades until it has completely disappeared. There is rosiness in her cheeks and a sweet smile on the doll's face.

I must mention now something that has been happening throughout this performance. We noticed our narrator reach up and touch the picture of God repeatedly with what appeared to be a slender object. Lighting was inadequate to evaluate the action. Those familiar with the source story, however, knew that his movement, each time, coincided with the French author's use of the name of God. The action was noticeable but not distracting. Now as the story comes to a close we discover the purpose.

A thin curtain has been drawn concealing all of the set except the figure of Melibee and the image of God. Lighting now reveals that the narrator's movements have enhanced the original chalk drawing. The "slender object" was actually a brush used to apply touches of powdered gold to the holy picture. The result—a gilded luminescent icon.

Beneath the luminous portrait of God, Melibee recites the ending of the French translation. We learn that he has decided to

forgive his enemies who are now contrite because of the influence of Prudence. To this end, he affirms, "God in his mercy will, at the time of death, forgive guilts trespassed against Him in this wretched world."[267]

The all-knowing Host, Christ, watches as the penitent storyteller immediately steps out from behind the curtain with a hand raised for silence. He lifts the figurine of Melibee. Holding it so that it faces the audience, the pilgrim takes a deep breath and then delivers his *own* final thought:

> Doubtless, if we are sorry and repent of the sins which we committed in the sight of our Lord God, he is so generous and merciful that he will forgive our guilts and bring us to the bliss that never has an end. Amen.[268]

With the "Amen" Pilgrim Chaucer bows his head, indicating that now his special performance is concluded. From the Host, and the audience as well, applause brings a fitting close to the narration.

Pilgrim Chaucer's announced intention was to "reinforce the effect of [his] subject matter." He managed his intent with small but significant adjustments to his source: adding, deleting, modifying.[269]

French Mellibee, who left home to find his entertainment, becomes English Melibee, who went into "the fields" for his. The pastoral setting is added by Chaucer and corresponds to the favorite get-away of the rowdy Wife of Bath. We understand her purpose to be sexual; Prudence confirms as much about Chaucer's Melibee. (B 2590–2620)

Prudence, of the source, is not what Chaucer has in mind; she wants to be praised. (Fr. 1063–65) In shaping the dialogue, Chaucer "translates somewhat more freely...altering the sense."[270] He ignores the human desire and instead sets reconciliation of hostile factions as the aim of his heroine's efforts. (B2950–55)

The poet adds the daughter's name, and its significance gives an importance to the message that is absent from the French. The original story dealt with deciding what action to take against enemies who had injured "a daughter"—a hostile challenge to a man, and how he resolved it. Naming the child, however, introduces the

fact of a man's wisdom that was left behind, damaged (inoperative) while he traveled the world without benefit of that wisdom. The name also provides an observation about Melibee's behavior. What was originally a securely guarded French wife and daughter takes on a double intent. On one plane Melibee appears as protective householder. In the added dimension he is self-indulgent, refusing to be accompanied by his virtues. Recovery and revitalization of wisdom touches a realm of meaning far beyond the return to health of a daughter.

Chaucer also adjusts by deleting *human* qualities a number of times. This entails "behavior" modifications in the adversaries, and the elimination of physical imagery. For example, the French work describes enemies *on their knees and in tears*. (Fr. 1124) Chaucer removes the physical details. Again, when the French Prudence says the enemies would *do honor and reverence* to Melibee. (Fr. 1149) Chaucer deletes the phrase. For sinfulness "to do honor and reverence" would be incongruous. The phrase does not function on a second level.

In general, palpable or material references found in the French source are dismissed. In parallel (French-English) passages, Chaucer omits indications of strength (Fr. 275–76) and allows only an emotion (anger) to be a force. (B 2310–20) Elsewhere, he ignores a reference to "great expense" in a discussion of defenses (Fr. 560), and concludes that the love of one's subjects and neighbors is the best defense a man can have. (B 2525–30) Lessening of the physical or the concrete increases ambiguity.

In the French version it is the *law* that forbids making a profit by harming another person. (Fr. 864–65) Chaucer claims it is *Nature* that forbids such action. (B 2770–75) The poet "enforces" an all-encompassing authority higher than man-made law.

What the poet/translator has done with the name of God lifts and expands the story he adapted. Though it may seem trivial, it is actually a subtle imparting of worship. It isn't often a topic associated with Geoffrey Chaucer, but Elizabeth Barrett, the poet, said of him that "with all his jubilee of spirit and resounding laughter, [he] had the name of Jesus Christ and God as frequently to familiarity on his lips as a child has his father's name."[271] It is loving "familiarity" that is evidenced in the *Melibee* translation.

Our poet embellishes the text with eight references to God where the original had none. And where the French writer addresses *Nostre Seigneur*, Chaucer will say "Our Lord Christ" or "Our Lord Jesus Christ." Where the French is content with many repetitions of *Dieu*, Chaucer expands and diversifies with various forms as they come to mind—"Our Lord," "Our Lord God," "Jesus Christ," "the High God," "Almighty God," "Our Lord God Almighty," or "Lord God of heaven." The variety seems a spontaneous response to each encounter with the name of God, and the embellishments a heartfelt reinforcement.

When Melibee had delivered the last lines of the French story, Chaucer stepped in to add the *final* thought, a personal message for his audience. If a "tale's strength" is its ending, as the poet claimed, then the "long religious sentence"[272] he adds must have a *strong* message. The surface gains one more grammatical unit; but the sentence (the underlying meaning) conveys an explicit confidence that sinners who repent of their past life (recounted in both *Thopas* and *Melibee*) will find mercy and forgiveness, and enjoy God's everlasting kingdom. This final added statement appears to be the pilgrim poet's ultimate "reinforcement."

Now, if we take a position which will give a panoramic view of Thopas and Melibee, their tales can be seen as integrated. Words link the two stories the poet awarded "himself," and actions or images create a sense of *déjà vu*—but the relationship goes deeper than that. *Melibee*, a story popular in the Middle Ages,[273] is quite different from *Thopas*, but maybe this *difference* was its appeal—a well known story as a follow-up to the highly imaginative personal tale.

At the outset, the titles of his narrations are a basic clue to a two-part plan. First, *Sir Thopas* announces as its subject one male figure. The second title deletes "Prudence" from the source—even though she has the dominant role—and "Melibee" stands alone as another individual male.

As *Melibee* begins, the poet imparts a bit of *Thopas* immediately. Who can forget Thopas gaining solace "on the soft grass"? As a comparable image, Chaucer adds a similar view with Melibee "in the fields" at his diversion.

The Host relegated Thopas' perseverance in sin to the *devil*: "such a rhyme the devil betake!" Altering the French produces an echo of Thopas. The French of Melibee alludes to the "enemy," but Chaucer changes the word to "devil." As a result, Melibee's condemning statement: "To persevere at length in sin is the devil's work,"[274] seems an observation about Thopas.

An image common to both stories is Christ's distressed ears. When Christ scornfully refuses to go on listening to *Thopas*, it is because His ears ache from this turd-like story. Later, Prudence (who has the power to see the past), proposes to Melibee, "Perhaps Christ is scorning thee, and hath turned away...*his ears of mercy*."[275]

Prudence is a perfect foil—better yet, a perfect corrective—to dominate the tale that succeeds Pilgrim Chaucer's first story. As a balance for Thopas' tale of uncontrolled carnal nature, she is the virtue credited as the *control* of that nature.[276]

Though Thopas' wrong-doing is more obvious—his account more outspoken than Melibee's—both characters had sinful beginnings. Prudence indicates to Melibee, "Thou hast been punished in the manner that thou hast trespassed."[277] That holds true for both characters. Thopas is put upon by bodily anguish for physical transgressions. In contrast, Melibee is afflicted with mental anguish over the damage to his prudence and wisdom.

A substantial connective is found in Melibee's counsel:

> He is truly worthy to have pardon and forgiveness of his sin, who does not excuse his sin, but *acknowledges* it and repents, asking indulgence.... There is remission and forgiveness, where confession is, for confession is neighbor to innocence.[278]

If he who openly confesses his sin and repents will find forgiveness, Thopas is on the right track. The *Thopas* tale is a confession without excuses—a bright, lively straightforward *acknowledgment* of misdeeds. Melibee's guilt, on the other hand, is subtly noted. But he too *acknowledges* his sinfulness (prompted by Prudence). (B 2890–95) Forgiveness is anticipated for both.

What about continuity in Pilgrim Chaucer's entire offering? Not

only can we find common elements here and there in the two parts of this performance, but I believe that we are to understand Pilgrim Chaucer's complete personal narrative as *one unit*. He never relinquishes the stage from his tax-collector entrance until the "Amen" that concludes the added prayer of the Melibee story.

Unity can be visualized in a number of ways. We can simply look at *Thopas* as "the past," while *Melibee* gives us the present and alludes to the hoped-for future. We could say that the pilgrim storyteller leaves *Thopas* (his confession) behind, and continues his program with *Melibee* as public testimony of his transformation.

Another possible plot description is to recognize *Thopas* as "Part One," the first episode; the interruption as the "cliff-hanger"; *Melibee's* opening lines as the flashback recalling the first episode; and the remainder of *Melibee* as the sequel, Part Two—including a happy ending.

Or we can view Pilgrim Chaucer's performance as a physical-spiritual dichotomy. A well known medieval genre, debate of body vs. soul, can be seen to influence Chaucer's dual production. Two main images were used in the Middle Ages to express this debate. "One is that of horse and rider: The Body, as horse, took the bit between his teeth and bolted; and the Soul, as rider, failed to control it." Though we can *see* Thopas in that description, we can also *hear* Prudence chiding Melibee for his lack of defense against his enemies. (See p. 144 above.) A second depiction "more philosophically subtle [with] more literary reverberations, is that of Soul and Body as husband and wife."[279] Pilgrim Chaucer took the stage with an inexhaustible rider to disclose (confess) that in his youth desires of his body dictated his actions. In the subsequent offering, a husband and wife gave a lesson that restored wisdom and brought hope in the mercy and forgiveness of God. Both presentations were grounded in fourteenth-century thinking.

A final integrating scheme recalls the little grotesque figures we identified with Thopas as the personality "below the waist," the genital area with a mind of its own. Melibee, then, is the upper or elevated portion of the whole character—the portion dominated by the mind or soul—that necessarily has the mouth filled with honey. Together they are the dual nature of one man.[280]

☙

A sentence from Chaucer's translation of Boethius encapsules what I believe the double performance says:

> Ye that been encumbered and deceived with worldly affections, come now to this sovereign good, that is God.[281]

Rejection of the world's deceptions and turning toward virtue, and in so doing turning toward God, is the subject matter Chaucer has enforced in his second narrative.

Another observation from Boethius has a strong Melibee-an flavor:

> Honey is the more sweet, if mouths have first tasted savors that are evil.... Thou, beholding first false good...withdraw...from...earthly affections; and afterward the true goods shall enter into thy heart.[282]

The "honey-eater's" story may have provided the contrast with Thopas that Chaucer needed for a fitting statement and closure.

Melibee, who knew the honey of "temporal riches and delights, and honors," seems a possible (perhaps an obvious) image of the poet himself—international diplomat, administrative servant, and entertaining performer to the English kings and court. This *upper* honey-filled portion could portray the public life of our poet; the *lower* prickster component, his private life. *Thopas* and *Melibee* together can be seen as accounts of sensual and spiritual transgressions in need of God's forgiveness. Seeking God's forgiveness may be the point of Pilgrim Chaucer's journey. It *is* the point of poet Chaucer's Retraction.

I find it wholly appropriate that Chaucer the pilgrim—perhaps, too,
Chaucer the poet—should himself be moved to formal penitential
posture: to examination of conscience, to a confiteor that admits to
sins of cogitatione, verbo, et opere and to expiative retraction of
whatever may have offended—even unwittingly—over the course of
a long and mixed career.

—Rodney Delasanta, "Penance and Poetry in the
Canterbury Tales" (1978)

VIII: Chaucer's Retraction

NOTHING CHAUCER offers in the *Canterbury Tales* has been
more difficult for scholars to accept than the ending, which they call
"Fragment X." (This, the tenth section, is alternately designated as
"I." We will use option "X" because it is clear; "I" could be mistaken
for the abbreviation of "line" or the numeral "one.") It may come as
a surprise that the *Tales* exist only as a collection of medieval frag-
ments, a few tales linked together in separate groups. There is no
complete, connected manuscript. The several parts have no overall
outline of the order the poet intended. This lack of an indicated se-
quence has been a source of debate over the centuries.

Despite a lack of prescribed order, there are two parts, Frag-
ment A and Fragment X, that we can be confident are as Chaucer
planned. Fragment A (the *General Prologue* followed by the first
five tales) unquestionably constitutes the beginning; and Fragment
X (the *Parson's Tale* and Chaucer's Retraction) is assuredly the con-
clusion. This final section is deeply religious. The religiosity was
unacceptable to a number of early scholars attempting to confirm a
proper succession to the tales. They would have excluded Fragment
X from the rest of the work on the basis of its being completely
uncharacteristic. John Masefield, as late as 1931 in a lecture at
Cambridge, hoped the Retraction was "forged" and recommended,
"in any case let us ignore it."[283]

One opinion for exclusion questioned "whether Chaucer himself was responsible for the choice" of the material translated for the *Parson's Tale* and for the "melancholy Retraction." There is "some doubt [of] the genuineness of the Retraction"—a "morbid passage" resulting from "an hour of reaction and weakness." Some reviewers said that the spiritual content demonstrated that Chaucer had "fallen into monkish clutches."[284]

Allusion to "monkish clutches" refers to the fact that in December 1399, about ten months before his death, Chaucer rented a house on the grounds of Westminster Abbey. The Abbey sojourn, his final residence, has been assumed to be a time when God's plan for Chaucer "is hastening to an end." The poet "was about to die."[285] These judgments, we must realize, are made from *hindsight*. We have no information of what, if anything, afflicted Chaucer in these months. He may have moved there to gain the quiet of the chapel garden for his writing. The poet could have died of an unexpected heart attack in October, 1400, having enjoyed less than one year of his lease.[286] At best, this prayerful closing is seen by some readers, on the one hand, as a conventional gesture; by others as an "act of piety" defended as legitimately "heartfelt," the poet's surroundings notwithstanding.[287]

Another opinion of Fragment X is that the texts are sincere—but a totally unexpected contrast to everything that has gone before. To hold this opinion, to be unprepared for a spiritual ending of a *pilgrimage*, many ambiguities need to be overlooked. "To the medieval mind the allegorical implications of a pilgrimage were obvious...this life is but a pilgrimage—from birth to death or from earth to heaven, the Celestial City to which every Christian soul aspires."[288] Ideas and expressions uttered at the closing by the Parson were foreshadowed in *Thopas* and *Melibee*. We will examine them shortly. (No doubt additional correspondences with other tales are to be found, but we will limit our remarks to Chaucer's personal stories.)

Those who find the religious ending inconsistent also have a second complaint: the spiritual intensity has "short-circuited the promise of a jolly feast" back at the Tabard.[289] There is much more to Chaucer than the ever-jolly poet, and much more to the *Tales* than just a prelude to a jolly feast. There is no broken promise, no

inconsistency. Spiritual ambiguity, from beginning to end, indicates that this reference to a "feast" would function equally well as the *celestial banquet*—the successful end to the earthly pilgrimage. Rather than *disappointment*, the spiritual achievement is the pilgrim's ultimate desire. There is no sudden change at the end of the poet's plan—"pilgrimage" has been implied with every step, and spoken of directly thirteen times. In Fragment X, it just becomes dominant—embracing the total message of the plan, radiating its essential significance.

Some reviewers claim that Chaucer has "altered" the time scheme so that only *"at the end"* can we understand the journey to Canterbury as symbolically representing "Chaucer's own life."[290] This fails to take into account Chaucer's early statement (A 20–22) that the *Tales* are to be the story of *Chaucer's own pilgrimage* before any of the other travelers have joined him.

But finally, there are those who have recognized that the sermon and retraction are part of Chaucer's grand design. Donald Howard, in *Writers and Pilgrims*, warns that "those who *must* have their genial, ironic Chaucer must avert their eyes from these earnest and severe elements at the end."[291] Baldwin's "The Unity of the *Canterbury Tales*" sees the Retraction as an indissoluble link, "no random appendage." Bernard Huppé finds the Retraction as "a reminder...of the necessity to read the *Tales* for its sentence" (for an "underlying meaning in accord with Christian truth"). V. A. Kolve values this portion "in providing so authoritative a sense of closure, but also, we may believe, in witness to the deepest beliefs of the author himself."[292]

Though specific sources have not been found for the sermon on Penitence, and treatise on the Seven Deadly Sins that make up the *Parson's Tale*, the humble clergyman presents topics that echo *Thopas* and *Melibee*. The Thopas part of Chaucer the pilgrim must deal with the statement: "And yet you are more foul for your continuing in sin and your sinful habits, for which you are rotten in your sin, as a beast in its dung." Remaining in sin is compared to excrement by the Parson as it was by the Host, apparently a pattern in Chaucer's thinking. One important question for both Thopas and Melibee is "How long hast thou continued in sin?"[293] Sinful involvement over a period of time demonstrates a hazard-

ous persistence in evil.

In addition, when the Parson consoles his audience with the words "God will rather illumine and enlighten the heart of the sinful man to have repentance," it happily recalls Pilgrim Chaucer's enlightenment, when Christ, the Host, brings a halt to the sin-filled first story. Illumination produces the wished-for repentance and renewed hopes of salvation. Sophie's five wounds, identified with spiritual wounds to Melibee's senses, are a subject also touched upon by the Parson. He quotes Augustine: "Sin is every word and every deed, and all that men covet, against the law of Jesus Christ; and this is for to sin in heart, in mouth, and in deed, by thy five senses, that are sight, hearing, smelling, tasting or savoring, and feeling."[294]

The conclusion of *Melibee* refers to all trespasses being "in the sight of God." Similarly, the Parson confirms: "A man should think that God sees and knows all his thoughts and all his works; to him may nothing be hidden or concealed." And when the Parson encourages his audience to pray for "respite a while to weep and wail [for] trespass"—that is, to pray for adequate time for repentance—it reiterates Pilgrim Chaucer's hope for sufficient time to tell *all* of *Melibee*, his account of conversion.[295]

At the conclusion of the Parson's teaching, only one message remains, Chaucer's Retraction. Ruggiers notes that the poet's "final emphasis…is not social but private, a withdrawal from the 'we' of the *Parson's Prologue* to the 'I' of the Retraction in a final individualized *exemplum* of the method by which salvation and the kingdom may be attained."[296] Chaucer began this work indicating "*I* lay, / Ready to wend on *my* pilgrimage" and ends with a personal declaration, as well.

So what is it that the poet, late in his life, wishes to "retract"? He names several of his books, parts of the *Canterbury Tales* (those tales that have to do with sin[297]), and writings that seem not to have survived, including many songs and lecherous poems. For these he asks Christ's forgiveness. A thanksgiving follows for his many edifying translations: Boethius, saints' legends, homilies, and devotions. Chances are that not all of these have survived, either. The basis for telling of *Tales*, we know from the end of the *General Prologue*, was the anticipation of the Host's judgment. The Retraction, then, "is in

perfect keeping with the motif of Judgment ...[and] we should hear [Chaucer's] last words—his very last words in the *Canterbury Tales*—as a prayer for benign sentence" that he may be among the Saved.[298]

Let's hear, now, from Chaucer himself. He has just finished the voice-over for the *Parson's Tale* and steps out from behind the curtain. After the audience's welcoming applause, he stands unpretentiously in a spotlight for the last time at center stage, and says to us:

> Now I pray that all who hear or read this little treatise, if there be any thing in it that you like, thereof thank our Lord Jesus Christ, from whom proceeds all wit and all goodness. And if there be any thing that displeases you, I pray that you attribute it to my faulty skills, and not to my will, that fain would have said it better if I had the knowledge. For our book says, "All that is written is written for our doctrine" and that is my intent. Wherefore I beseech you meekly, for the mercy of God, that you pray for me that Christ have mercy on me and forgive me my guilts, and namely of my translations and writings of worldly vanities which I revoke.[299]

He goes on to list the writings we've noted above. Then, hat in hand, he genuflects. Kneeling on one knee, the spotlight a warmer tone, he concludes:

> I thank our Lord Jesus Christ and his blissful Mother, and all the saints of heaven, beseeching them that they from henceforth unto my life's end, send me the grace to bewail my guilts, and to study the salvation of my soul, and grant me true penitence, confession and reparation to do in this life, through the benign grace of him that is king of kings and priest over all priests, that bought us with the precious blood of his heart; so that I may be one of them at the Day of Judgment that shall be saved. *Qui cum patre et Spiritu Sancto vivit et regnat Deus per omnia secula. Amen.*[300]

The spotlight dims. When the house lights come up, the stage is empty. After a moment of respectful silence, the audience responds to the performance with enthusiastic applause that culminates in a standing ovation. Beyond the curtain, Geoffrey Chaucer is smiling.

This book is concerned with...the life that poems have in the mind. It is interested in the way a poem by Chaucer engages the literary and visual culture of its time...and in its public life thereafter, as it is experienced by an audience and thought about when it is over.

—V. A. Kolve, Chaucer and the Imagery of Narrative (1984)

IX. A Review of the Performance

THE CURTAINS are closed. The theatre is dark. What can we say now about the performance? As a one-man show, it has probably never been surpassed. (A number of years ago Alec Guiness gained many kudos for playing eight roles in one production—but Chaucer had out-Guinessed Guiness centuries before.) The Canterbury sets, the costumes, the script, the special effects all deserve special awards.

The opening set of the *General Prologue* was a lovely spring day in England. A lively scene with food, drink, spirited conversation, and merriment at the Tabard (a comfortable hostel) closed as a grand entourage set out on the road. A very different setting was part of the story of St. Cecilia, from the mysterious Second Nun, who told of the holy woman living in ancient Rome. The poet's own story of Thopas began in Flanders, and included glimpses of other areas of his contemporary Europe. The locale of Melibee's tale was surreal, nebulous. Finally, the poet's concluding monologue, without any backdrop, was simple and intimate. His purpose, it seemed, was never to use a background a second time.

Costumes were a prominent element in characterizing each pilgrim, making for their uniqueness. Garb was also vital to the adventures of Thopas, adding to the ambiguous intent and reflecting the point of the tale. Clothing served to describe and categorize

more than to act as bodily coverings.

The script took us through many moods, many visual experiences in our mind's eye, and provided many surprises with multilevel turns of phrase. The bright, outdoorsy *General Prologue* as the curtain rose, and the penitential Fragment X could not present a more diverse comparison. Chaucer, famous for producing images for his audience, was in top form. The contrasting ambience from *Thopas* to *Melibee* was striking. In *Thopas* we were confronted by wildly imaginative mental pictures; multilevel words enticed us to seek a spicy underlying sense. The experimental medical sequence—from padding, to blood and cautery, to bindings that "betide," to protective equipment and recovery—was a poetic first. Content of the scene (as with many experimental offerings) has stimulated controversy. A special recollection, for me, is the word *fonde* (strive, tempt into sin, try the patience of God) in *Thopas*, where all three definitions function—an impressive demonstration of the poet's genius. The naming of Sophie and other minor vocabulary adjustments in *Melibee* provided ambiguity as well as edification.

And then there were the special effects, including the poet's skill as a quick-change artist. Obvious and colorful were the animated vignettes—so alive, so different one from the other, so full of personality. More subtle was his ability to dismiss our sense of time and place. We accepted fantasy without objection and settled back to enjoy the performance.

As director/producer, Chaucer was sequestered before and after the account of his personal adventures at a vantage point behind the scene, as he provided authentic accent, vocabulary and timbre, to simulate each storyteller in turn. These stories often involved another special effect—the flashback. They are all understood to be remembrances of a previous undisclosed time, but some are a flashback within a flashback. The plan is amazingly complex, but somehow the writer/producer/director makes it all work. (I wonder if he kept a production log.)

A unique excitement to the entertainment was an awareness that the structure of the performance grew and developed before our eyes. Chaucer took the stage as the author (he would say "maker") of a poem about the English spring. But soon it was evident

that he was a poet about to become a pilgrim and a narrator as well, because he informed us that he would tell us of a pilgrimage about to get under way. Next, while acquainting himself with the other pilgrims, he became interviewer and reporter. Later he added the role of storyteller, and, ultimately, humble penitent—the role we now know had been his aim from the start. It was *his* pilgrimage we witnessed, and, in the Gregorian sense, we were his fellow pilgrims.

Though the poet's multiple identities have been analyzed and re-analyzed, the several roles given the Chaucer character causes me no difficulty. The poet/craftsman informed us in a very creative way. I take all thoughts and opinions to be his. Complications result from our attempts to understand his method, but the problems are ours. Donald Howard, for example, says that we may perceive his "ambiguities as ironic, but the irony is *in us*."[301] Perhaps the poet intended little or no irony. In any case, it appears to me that there is a level at which no irony exists.

Similarly, statements in the poetry may seem confusing, disconnected, but it is our confusion and our inability to follow. The poet said of the account he was about to present that, "I yow devyse" (A 34), that is, "I *contrive* for you."[302] The author/narrator was being ambiguous about the technique to be used. A covert meaning that must be sought after—the pleasurable fourteenth-century recreation—is what we should expect him to devise, to contrive.

In the *General Prologue* Chaucer creates a collage, a cluster of the last five pilgrims—all rogues—and places himself with them. We asked why he would surround himself with these public sinners. In reviewing details of his life through the exceptional activities of Thopas, we can understand that he was apparently stating that he, too, was a rogue. He knew his spiritual condition before he took up his pen, but we were not informed until the confessional aspect of *Thopas*. Having initially declared, "*I* am ready to make *my* pilgrimage," we should not be surprised at the inclusion of autobiographical material; we should expect it. An epiphany from his real life—at the middle of his journey (the middle of his life)—brought a radical change. Heavily religious prose pieces that follow "throw into relief the literary, theatrical, and 'storial' quality of the

poetical prologue, frame and tales."[303]

For those who feel that the work was left unfinished, since no connected manuscript with a tale from each and every pilgrim exists, perhaps Baldwin's statement will console: "For though the *Canterbury Tales* is incomplete, it cannot be properly called unfinished. The ending is as neatly calculated as the beginning." Ruggiers sees the plan in much the same way: "What is disjointed and fragmentary...is given anchorage within the completer vision which the beginning and end morally imply."[304] Chaucer proves here that he lived by his maxim that the end of a tale is its strength. While parts of the *Tales* are left unfinished—stories without endings, stories left without a connection to show proper sequence—the *conclusion* is in good order. The Parson's words and Retraction must have been more important to the writer than tidying up portions of the middle that have been left suspended. As it stands, the creation is like a picturesque building where several staircases have been left unconstructed; one can certainly enjoy, perhaps even be awed by, the structure. One just needs to minimize concern over the non-existent connectors.

In this prodigious work, the essential character, the role which could never be dropped without removing the essence, is that of the poet himself—"narrator" par excellence. It is his memory, his imagination, his creativity, his personality, that is the *Canterbury Tales in toto*. His ubiquitous presence, however, makes the plan difficult to grasp. Or, in Howard's terms, among the pilgrims, "the slipperiest of them is Chaucer himself...who appears in his own works as observer, speaker, and writer...we never know positively which we are hearing, and are not meant to know."[305] I think that's the key: we need not know, we need not differentiate between the parts he plays, just accept that it is Chaucer communicating with us from behind the curtain, or in planned conversations, or alone at center stage.

This fluid impression of his role takes the sting out of an accusation, such as, "he has disappeared into the group [at the *Parson's Prologue*], to reappear with a provoking self-centeredness in the Retraction."[306] The whole poem is centered on the poet, but his presence is never "provoking." It is as if he has transformed his whole life into a work of literature; then, as he asks forgiveness for

his *sinful* writings, he is, in effect, asking forgiveness for the sins of his life. With this point of view, we can recognize the Parson as the facilitator preparing for the Retraction, the final act of contrition.

An assumption of fluidity relieves the frustration of pinning down a persona who, it is said, the author "does not employ...very consistently"; where "the point of view shifts back and forth between...a first-person Narrator with restricted vision and that of an omniscient author." The narrator has been seen as "little more than a shadowy extension of the poet himself"; his "outlook is almost indistinguishable from Chaucer's own"; and his "voice... might as well be Chaucer's own."[307] What is needed is to relax and allow that the narrator's outlook *is* Chaucer's outlook; the voice *is* Chaucer's voice.

To say, however, that the ideas expressed are all "Chaucer's" does not solve all problems. After much scholarly effort—opinions forming in one direction and then reversing—there has surfaced "a sort of universal rule of thumb that nothing in Chaucer is what it seems."[308] Though that appears to avoid the difficulties, it could still be a solution—at least for the present.

Skelton, about one hundred years after Chaucer, must have had an artisan like the fourteenth-century poet in mind when he wrote:

> I, calling to mind the great authority
> Of poets old, which, full craftily,
> Under as covert terms as could be,
> Can touch a truth and cloak it subtilly
> With fresh utterance full sententiously.[309]

It is our poet's "subtle cloak" that previously has not been penetrated, or better said, not made transparent.

After our enjoyable experience in the theatre of Chaucer's mind, we come away with a grand impression of his seemingly inexhaustible creativity; in a short time, however, questions begin to form. We know he did not proclaim the happenings as they occurred; events were collected somehow at sometime—he never makes clear how or when the knowledge was acquired. Where or when does the pilgrimage actually take place? How could he make

friends so quickly and know so much about his fellow journeyers in such a short time? Shall we attribute all the noticeable quirks (his presumed disappearing and reappearing, etc.) to the use of an *inconsistent* persona of which he is accused? It seems much more likely, with all the evidence of his genius, that the basis of *consistency* has not yet been recognized. Lack of recognition is *in us*.

What if the consistency we desire is not in the *surface* story? Chaucer may not play according to our "rules." What if ambiguous words are chosen for their usefulness and vitality at the *covert* level while performing properly, or peculiarly, or merely adequately on the surface? Choosing and placing words of such potential could have been a challenging amusement for the poet.

An underlying consistency may actually exist. It appears to involve the allegorical dimension of the "sondry folk" that are his companions. This dimension will be the subject of book three—*Chaucer's Pilgrims: the Allegory*—my final volume in explication of the *Canterbury Tales*.

NOTES

PREFACE

1. Miri Rubin, *Corpus Christi: The Eucharist in Late Medieval Culture* (1991; repr., Cambridge: Cambridge Univ. Press, 1993), 348.

2. Bernard F. Huppé, *A Reading of the Canterbury Tales*, rev. ed. (1964; Albany: State Univ. of New York, 1967), 233, 235.

3. "Aventures that whilom han bifalle." All citations of Chaucer's poetry (unless otherwise noted) are to *Chaucer's Major Poetry*, Albert C. Baugh, ed., (New York: Appleton-Century-Crofts, 1963). Modern English renditions are mine.

4. Ralph Baldwin, "The Unity of the *Canterbury Tales*," *Anglistica* 5 (Copenhagen: Rosenkilde and Bagger, 1955): 32.

I: INTRODUCTION

5. V. A. Kolve, *Chaucer and the Imagery of Narrative* (Stanford: Stanford Univ. Press, 1984), 369.

6. Huppé, *Canterbury Tales*, 233–34.

7. R. M. Lumiansky, "The Meaning of Chaucer's Prologue to 'Sir Thopas'," *PQ* 26 (Oct. 1947): 316–18.

8. Bertrand H. Bronson, *In Search of Chaucer* (Toronto: Univ. of Toronto Press, 1960), 28.

9. Donald R. Howard, *The Idea of the Canterbury Tales* (1976; repr., Berkeley: Univ. of California Press, 1978), 370; Huppé, *Canterbury Tales*, 21.

10. Howard, *The Idea of the Canterbury Tales*, 149.

11. Donald R. Howard, "Chaucer's Idea of an Idea," *Essays and Studies*, vol. 29 (London: John Murray, 1976), 52. Italics added.

12. In "Medieval Popular Literature: Folkloric Sources," Bruce A. Rosenburg makes the limiting assumption, "We never assume that any medieval author invented his own story, but always borrowed it from tradition." *The Popular Literature of Medieval England*, ed. Thomas Heffernan (Knoxville: Univ. of Tennessee Press, 1985), 66.

13. W. T. H. Jackson, *The Literature of the Middle Ages* (New York: Columbia Univ. Press, 1960), 355.

Huppé presents ideas from Augustine and Boccaccio to illustrate the high regard for the inner meaning, the *sentence*. (*Canterbury Tales*, 8–9)

II: THE GENERAL PROLOGUE

14. The hooly blisful martir for to seke,
 That hem hath holpen whan that they were seeke.
 (A 17–18)

15. In Southwerk at the Tabard as I lay
 Redy to wenden on my pilgrymage
 To Caunterbury with ful devout corage.
 (A 20–22)

16. Baldwin, 32. Author's italics.

17. At nyght was come into that hostelrye
 Wel nyne and twenty in a compaignye,
 Of sondry folk, by aventure yfalle
 In felaweshipe, and pilgrimes were they alle,
 That toward Caunterbury wolden ryde.
 (A 23–27)

18. And shortly, whan the sonne was to reste,
 So hadde I spoken with hem everichon
 That I was of hir felaweshipe anon.
 (A 30–32)

19. And made forward erly for to ryse,
 To take oure wey ther as I yow devyse.
 (A 33–34)

20. Me thynketh it acordaunt to resoun
 To telle yow al the condicioun
 Of ech of hem, so as it semed me,
 And whiche they weren, and of what degree,
 And eek in what array that they were inne.
 (A 37–41)

21. Ther was also a Reve, and a Millere,
 A Somnour, and a Pardoner also,

A Maunciple, and myself—ther were namo.

(A 542–44)

22. Baldwin, 53.

23. Now have I toold you shortly, in a clause,
 Th'estaat, th'array, the nombre, and eek the cause
 Why that assembled was this compaignye.

(A 715–17)

24. But now is tyme to yow for to telle
 How that we baren us that ilke nyght,
 Whan we were in that hostelrie alyght.

(A 720–22)

25. And after wol I telle of oure viage
 And al the remenaunt of oure pilgrimage.

(A 723–24)

26. But first I pray yow, of youre curteisye,
 That ye n'arette it nat my vileynye,
 Though that I pleynly speke in this mateere.

(A 725–27)

27. Also I prey yow to foryeve it me,
 Al have I nat set folk in hir degree
 Heere in this tale, as that they sholde stonde.

(A 743–45)

28. ...and to reste wente echon,
 Withouten any lenger taryynge.
 A-morwe, whan that day bigan....

(A 820–22)

29. The pilgrimage as Christ-centered is the subject of *Chaucer's Host: Up-So-Doun*, the first book of three. Dolores L. Cullen (Santa Barbara, CA: Fithian Press, 1998). This, *Pilgrim Chaucer: Center Stage*, is the second book of explication.

III: A PORTRAIT OF CHAUCER

30. Legouis and Robinson associate the family name with the French *chaussier* and see a strong connection to "shoemaker." In *Thopas*, however, we will see Chaucer demonstrate his name as a form of *chasseur*, "hunter." The pronunciation of *chaussier* loses the final "r."

Chausseur (with the "r" intact) seems the more inviting choice. Emile Legouis, *A History of English Literature*, trans. Helen Douglas Irvine, rev. ed., 2 vols. in 1 (1927; New York: Macmillan, 1930), I: 137; F. N. Robinson, ed., *The Works of Geoffrey Chaucer*, 2d ed. (1933; Boston: Houghton Mifflin, 1957), xix.

31. Edward Wagenknecht, *The Personality of Chaucer* (Norman: Univ. of Oklahoma Press, 1968), 10. It is remarkable for the poet to rest in the Abbey. The honor was bestowed on him despite his being a commoner.

32. Desmond Seward, *The Hundred Years War* (New York: Atheneum, 1978), 97–8; Alfred H. Burne, *The Crecy War* (London: Eyre and Spottiswoode, 1955), 326–33.

33. Burne, 335.

34. *The Middle Ages: A Concise Encyclopædia*, ed. H. R. Loyn (1989; New York: Thames and Hudson, 1991), s.v. "Hundred Years' War."

35. Burne, 335.

36. T. F. Tout, *The History of England* (New York: Longmans, Green, 1905; New York: Haskell House, 1969), 395.

The English did not attack the city because Edward felt he could not prevent his men from "running amok" once they breached the French defenses. Such chaos hardly would be the fitting prelude to the king's anointing by the archbishop and subsequent coronation. (Burne, 338)

37. *Chaucer's World*, comp. Edith Rickert, ed. Clair C. Olson and Martin M. Crow (New York: Columbia Univ. Press, 1948), 294; Burne, 333.

38. Burne, 339–43; Herbert J. Hewitt, *The Organization of War Under Edward III* (New York: Barnes and Noble, 1966), 133–4.

39. *Letters from Petrarch*, ed. and trans. Morris Bishop (Bloomington: Indiana Univ. Press, 1966), 196; Hewitt, 132.

"Canterbury Cathedral" by Kenneth MacLeish, in *National Geographic* (March 1976) contains the following paragraph about King Edward and the war:

> This daring commander gained fame during the Hundred Years' War for his adroit use of longbowmen

against mounted French knights at the Battles of Crécy and Poitiers. Yet he showed a grim side of chivalry at the conquest of Limoges. There the citizens knelt before him to beg for mercy, but Edward was "so enflamed with yre that he toke no hede to theym.... mo than thre thousande men, women, and chyldren were slayne and beheeded that day...." (376)

This horror was also part of Chaucer's background.

40. Philippa came from a prestigious family. Her position was not that of a simple domestic. See Baugh, xii–xiii.

41. Tout, 421.

42. Baugh, in his note for B 61 explains, "This is not a device of Chaucer's for calling attention to his other works, or at least his only purpose. He omits some of the most important. The emphasis is on stories of virtuous or wronged women."

43. For he hath toold of loveris up and doun
 Mo than Ovide made of mencioun
 In his Episteles....

 (B 53–55)

44. Though I knew that the problem is not often spoken of, I was still surprised that Derek S. Brewer, in writing the authoritative Chaucer entry for the *Encyclopædia Britannica* (1968), did not give a hint of it. Generally, if a commentator is bold enough to bring up the subject, it is opened and closed without light ever falling on the details. For example, in the new Chaucer essay in the 1974 *Britannica*, R. M. Lumiansky devotes only two sentences to the incident and suggests that Chaucer was not guilty as charged.

 All subsequent *Britannica* citations are to the 1968 edition.

45. P. R. Watts, "The Strange Case of Geoffrey Chaucer and Cecilia Chaumpaigne" *The Law Quarterly Review* 63 (Oct. 1947): 491–515. This article is my main source for general legal information. He quotes Furnivall on p. 492.

 Robert Dudley French, *A Chaucer Handbook*, 2d ed., (F. S. Crofts, 1927; New York: Appleton-Century-Crofts, 1947), 61–62; George H. Cowling, *Chaucer* (1927; repr., Freeport, NY: Books for Libraries, 1971), 23; Watts, 494.

46. Watts, 500.

47. Watts, 502–03.

48. Watts, 492–97.

49. Watts, 502.

50. The debt was apparently paid a short time later, because a nota-tion of July 2 crosses out the recognizance entry, and a note in the margin indicates money paid. (Watts, 493)

51. Watts, 502.

52. Christopher Cannon, "Raptus in the Chaumpaigne Release and a Newly Discovered Document Concerning the Life of Geoffrey Chaucer," *Speculum* 68 (Jan. 1993): 75.

53. Watts, 507; Cannon 90, 92, 93, 94.

54. Cannon, 92–93. Possible self-accusation was referred to when he included himself with "rascals." See p. 27 above.

55. Watts, 504.
 There is further speculation to complicate the Chaucer mar-riage. Some have proposed that Philippa may have been John of Gaunt's mistress, and that Chaucer's eldest son, Thomas, may ac-tually have been Philippa's son by Gaunt. The evidence used to promote this theory is the nobleman's considerable interest in, and assistance given to, the career and marriage of this child of Philippa. See Baugh, xix.

56. *A Concordance to the Complete Works of Geoffrey Chaucer*, ed. John S. P. Tatlock and Arthur G. Kennedy (Carnegie Institution of Washington, 1927; repr., Gloucester, MA: Peter Smith, 1963); *The Golden Legend of Jacobus de Voragine*, trans. Granger Ryan and Helmut Ripperger (New York: Longmans, Green, 1941; repr., Salem, NH: Ayer, 1987).

57. "Another Nonne with hire hadde she, / That was hir chapeleyne." (A 163–64)
 If you are considering that *nun* in Shakespeare's writing could intend a prostitute, this may not be true in Chaucer. The OED has a 1770 entry indicating a *nun* to be understood as a courtesan (s.v. "nun," 1. c.); after 1593 there are references to a *nunnery* as a bawdy house (s.v. "nunnery," 1. b.). *The Compact Edition of the Ox-ford English Dictionary*: Complete Text Reproduced Micrographi-cally, 2 vols. (1884–1928; Oxford: Oxford Univ. Press, 1971).
 In the MED, however, there are no such connotations. (S.vv.

"nonne," "nonneri(e.") *Middle English Dictionary*, ed. Hans Kurath and Sherman M. Kuhn (Ann Arbor: Univ. of Michigan Press, in progress 1956–).

58. G. H. Gerould, "The Second Nun's Prologue and Tale" in *Sources and Analogues of Chaucer's Canterbury Tales*, ed. W. F. Bryan and Germaine Dempster (Chicago: Univ. of Chicago Press, 1941; repr., New York: Humanities Press, 1958), 664–67.

59. MED, s.v. "lust," 2. (c), sexual gratification. For *lust* with sexual inference in the *Canterbury Tales* see D 611, D 927, X 840–45.

Please note: For clarity, the "X" option will be used to identify quotations from the *Parson's Tale*, instead of "I." The "I" could be misinterpreted for the number "1" as part of the source identification; or for the letter "l," as meaning "line."

S. K. Davenport, "Illustrations Direct and Oblique in the Margins of an Alexander Romance at Oxford," *Journal of the Warburg and Courtauld Institutes*, (1971): plate 29, fig. c; Lilian M. C. Randall, "Exempla as a Source of Gothic Marginal Illumination," *The Art Bulletin* (1957): fig. 2. The female figure is identified as a "matron," but individual matrons (because of the style of dress) resemble individual nuns, so ultimately it's the viewer's decision. See also Kolve, 246, and n. 47, p. 460.

For songs, see Richard Leighton Greene, *The Early English Carols*, 2d ed., revised and enlarged, (1935; Oxford: Clarendon, 1977), #461, #461.1.

60. Yet preye I yow that reden that I write,
 Foryeve me that I do no diligence
 This ilke story subtilly to endite.
 (G 78–80).

61. Huppé, *Canterbury Tales*, 228.

62. This refers to the empyrean layer. It was thought that the highest heaven was a realm of pure fire.

63. And right so as thise philosophres write
 That hevene is swift and round and eek brennynge,
 Right so was faire Cecilie the white
 Ful swift and bisy evere in good werkynge,
 And round and hool in good perseverynge,
 And brennynge ever in charite ful brighte.
 Now have I yow declared what she highte.
 (G 113–19)

64. Gerould, 669.

65. Kolve, 297; Rodney Delasanta, "Penance and Poetry in the *Canterbury Tales*," *PMLA* 93 (March 1978): 243.

66. MED, s.v. "hoten," v. 1, 3a. (a) To give a command. Ex., from *Piers Plowman*: "In...swynke þou shalt...labouren for þi liflode, & so oure lord hiȝte."; (e) To give an order to somebody. Ex., *Piers Plowman*: "To wynchestre...I was sent...as my maister me hiȝte." Chaucer uses "hiȝte" to express *to name*, or *to command* in *Romance of the Rose*. (Robinson, 2803)

67. Cowling, in considering the wronged woman in the *raptus* case, proposes, "Possibly it was for her that Chaucer wrote *The Life of St. Cecile*." (24)

68. See Baugh's discussion, pp. 212–15.

69. Caroline F. E. Spurgeon, ed., *Five Hundred Years of Chaucer Criticism and Allusion 1357–1900*, 3 vols. (Cambridge: Cambridge Univ. Press, 1925; New York: Russell and Russell, 1960), I: 39, 42, 10.
 "Ditties" was an accepted word for "songs." See Chaucer's *Boethius* (V, m. 2). All citations to Chaucer's prose are from Robinson.

70. "Many a song and many a leccherous lay; that Crist for his grete mercy foryeve me." (X 1085–90)

71. F. C. Gardiner, *The Pilgrimage of Desire* (Leiden, Netherlands: E. J. Brill, 1971), 48–49.

72. Philippa probably died in 1387, when Chaucer was 47. See Baugh, xvi.

VI: INTRODUCTION TO SIR THOPAS

73. Hans Jantzen, *High Gothic*, trans. James Palmes (Hamburg: Rowohlt Taschenbuch, 1957; New York: Minerva, 1962). Jantzen makes the unqualified statement that "all mediaeval authors are agreed that the church, as a building, represents the City of God, the heavenly Jerusalem." (178)

74. Kolve, 369.
 John Speirs, in *Chaucer the Maker*, underestimates the significance of the placement by asserting that "a Portrait of the Artist

is inserted into a corner of the Canterbury Tales." (London: Faber and Faber, 1951), 180.

75. There have been many surface impressions to explain why the Pilgrim poet is staring at the ground: George Lyman Kittredge said he intended to be a conscientious reporter and didn't want to miss a word: *Chaucer and His Poetry* (1915; repr., Cambridge: Harvard Univ. Press, 1946), 184; John Matthews Manly finds it a reaction to the solemn tale which had just ended: "Sir Thopas: A Satire," *Essays and Studies* 13 (Oxford: Clarendon, 1928), 56–57; Lumiansky sees the poet scheming to put the Host at a disadvantage. (*PQ*, 318–19)

76. And herof seith Seint Augustyn: "The herte travailleth for shame of his synne"; and for he hath greet shamefastnesse, he is digne to have greet mercy of God. Swich was the confessioun of the publican that wolde nat heven up his eyen to hevene, for he hadde offended God of hevene; for which shamefastnesse he hadde anon the mercy of God. And therof seith Seint Augustyn that swich shamefast folk been next foryevenesse and remissioun. (X 980–90)

77. For doutelees, if we be sory and repentant of the synnes...he wole foryeven us oure giltes, and bryngen us to the blisse that nevere hath ende. Amen. (Conclusion of *Melibee*.)

78. Baldwin notes the influence of the teachings of Gregory of Nyssa: "The traditional monogenism that held that man was made in the image of God was, again, a *fourteenth-century assumption...* 'the whole of human nature from the first man to the last is but one image of him who is.'" (38) Italics added.

79. Under Augustine's influence the student "will learn that figurative words have one meaning in one context but may have a different, even an opposite, meaning in another context." Bernard Huppé, *Doctrine and Poetry* ([Albany]: State Univ. of New York, 1959), 23.

80. Baugh, n. B 1893; Lumiansky, *PQ*, 319.

81. An overall picture of the Canterbury Pilgrims will be the subject of Book III in this explication, *Chaucer's Pilgrims: the Allegory.* That "picture" will demonstrate a better understanding of Chaucer's plan.

82. The Pardoner and Wife of Bath, in particular, are often said to make confessions.

83. See Cullen, 108–09.

84. MED, s.v. "chere," n. (1).

85. *Doggerel* and related words, about one-hundred years after Chaucer's death, can be found in print as referents to foul and obscene language. (OED s.vv. "dog," "doggerel," "doggery.") "Dog rimes" were filthy verses. Though "doggerel" in the MED is defined as "poor, worthless," similar words (such as, "dogge" and "dogged") have abusive intentions.

Beryl Rowland, in detailing animal associations through the centuries, gives a number of medieval exempla for religious instruction (1100s and later) that connect the dog with promiscuity, incest and hell. *Animals with Human Faces* (Knoxville: Univ. of Tennessee Press, 1973), 59–60.

Chaucer's lines, which immediately precede *doggerel*, contain both "drast" and the "devil" and, therefore, seem to me to intend a complaint regarding filth and sinfulness.

86. The word *lewdness* is a problem because of its primary non-licentious connotation. Baugh's note to the line has it as "ignorant"; David Wright "translates" it as "drivel." *Geoffrey Chaucer: The Canterbury Tales*, trans. David Wright (Oxford: Oxford Univ. Press, 1985; repr., World's Classics, 1986), 173; Skeat considered it, in this context, "foolish talk." *The Complete Works of Geoffrey Chaucer*, Walter W. Skeat, ed., 2d ed., 7 vols. (1900; repr., Oxford: Clarendon, 1924), V: n. B 2111; Robinson's Glossary offers a balanced selection of possibilities. (S.vv. "lewed," "lewednesse."); MED, s.vv. "leued," "leuednes(se."

"Thei…synge and make bost at ther owne lewdnes in lechery." Gerald R. Owst, *Literature and Pulpit in Medieval England*, 2d rev. ed. (Cambridge: Cambridge Univ. Press, 1933; Oxford: Basil Blackwell, 1961), 439.

87. Baugh indicates "wretched," but parenthetically adds "(*lit.* filthy)"; Pollard specifies "worthless" in *The Works of Geoffrey Chaucer*, ed. Alfred W. Pollard (New York: Macmillan, 1904); Speirs avoids characterizing the interruption. (181)

88. Saintsbury claims we don't know why the story was stopped! George Saintsbury, *A History of Criticism and Literary Taste in Europe*, 3 vols. (New York: Dodd, Mead, 1900), I: 451; Donaldson's opinion is that the story "gets out of hand, and is publicly censored as unworthy of continuation." *Chaucer's Poetry*, ed. E. T.

Donaldson (New York: Ronald, 1958), 880; David M. Zesmer credits the interruption to an "impatient Harry Bailey" in *Guide to English Literature* (New York: Barnes & Noble, 1961), 249; Legouis says the Host finds it "silly and a waste of time." (179); D. Wright reaches a new level of vulgarity with his concept of the Host. (173)

89. Cullen, 39–40.

90. MED, s.v. "priken" See also "prikel"; "priking(e."

In the first decade of this century a comparison was made of vocabulary common to both *Sir Thopas* and to *Sir Guy*, another medieval romance. The number of uses of "pricking" in each was counted, for example. The incidence of the term in *Sir Guy* was said to be "suggestive" as the influence on Chaucer, but the connotation intended was "resemblance," "model," and "imitation." Double entendre was not mentioned. See Caroline Strong, "Sir Thopas and Sir Guy. II," *MLN* 23 (April 1908): 102–06.

91. D. Wright, 169.

92. Huppé, *Canterbury Tales*, 233; Kolve, 295; Donaldson, 936; French, 243; Howard, *The Idea of the Canterbury Tales*, 215, 274.

93. Alexander Smith, in *Dreamthorp*, finds, "There is...a single-heartedness and innocence in Chaucer's vulgarest and broadest stories...an absence of any delight in impurity for impurity's sake." (London: Oxford Univ. Press, 1914), 202.

V: SIR THOPAS

94. M. Dominica Legge, *Anglo-Norman Literature and Its Background* (Oxford: Clarendon, 1963), 6.

95. Angus Fletcher, *Allegory: the Theory of a Symbolic Mode* (1964; Ithaca: Cornell Univ. Press, 1970), 328–29.

96. Paul G. Ruggiers, *The Art of the Canterbury Tales* (Madison: Univ. of Wisconsin Press, 1965), 33.

97. E. K. Chambers, *The Medieval Stage*, 2 vols. (1903; repr., London: Oxford Univ. Press, 1967), I: 65–68; Legge, 370–71; Donaldson, 934–35; R. W. Chambers quoted in R. M. Wilson, *Early Middle English Literature*, 2d ed. (1939; London: Methuen, 1951), 296.

Derek Brewer, dealing exclusively with comic tales, tells of

their widespread popularity and yet there was no impulse to record them. (137) Tales that were told and finally recorded in the 1500s may have survived from a much earlier century. "The International Medieval Popular Comic Tale in England," in *The Popular Literature of Medieval England*, ed. Thomas J. Heffernan (Knoxville: Univ. of Tennessee Press, 1985), 131–47.

98. R. M. Wilson, 295; Howard, *The Idea of the Canterbury Tales*, 273; French, 243; Zesmer, 248; Thomas R. Lounsbury, *Studies in Chaucer*, 3 vols. (New York: Harper & Bros., 1892), II: 201; Charles A. Owen, Jr., "Thy Drasty Rymyng...." *SP* 63 (July 1966): 540.

99. Owen, 539.

100. Zesmer, 248.

101. Laura Hibbard Loomis, "Sir Thopas," in *Sources and Analogues*, ed. W. F. Bryan and Germaine Dempster (London: Routledge and Paul, 1941; repr., New York: Humanities Press, 1958), 490.

102. Owst, 336, 363, 372; MED, s.v. "lecherous," 1. (d) *Piers Plowman*, "Ich had lykynge to lauhe of lecherye tales"; Greene, n. 457, p. 493.

 Brewer assures us of natural preservation of "low comedy": "No doubt comic dirty stories circulated among adults of all classes, as they always do." (137)

103. Saintsbury, 477.

104. Fletcher, 72–73.

105. J. Dover Wilson, *What Happens in Hamlet* (1935; Cambridge: Cambridge Univ. Press, 1956), 110–11.

106. So myrie a fit ne hadde she nat ful yoore;
 He priketh harde and depe as he were mad.
 (A 4230–31)

 As wolde God it were leveful unto me
 To be refresshed half so ofte as he!
 Which yifte of God hadde he for alle his wyvys!
 No man hath swich that in this world alyve is.
 God woot, this noble kyng, as to my wit,
 The firste nyght had many a myrie fit
 With ech of hem.
 (D 37–43)

Thomas Percy, *Bishop Percy's Folio Manuscript*, ed. John Frederick J. Furnivall, 3 vols. (London: Trübner, 1868), III: 4. Italics added.

107. Howard, *The Idea of the Canterbury Tales*, 61.

108. Owen, 539.
Such "solace" is also spoken of in "The Land of Cokaygne," a poem about an earthly Paradise (early 1300s). Rossell Hope Robbins, *Historical Poems of the XIVth and XVth Centuries* (New York: Columbia Univ. Press, 1959), #48.

> he schal hab, wiþ-oute danger,
> xii wiues euche ȝere,
> al þroȝ riȝt & noȝt þroȝ grace,
> for to do him-silf solace.
>
> (169–72)

"Merlin's Prophecy," which precedes "Cokaygne," also mentions this "solace"—"lechery callyd pryve solace." (#47)

109. Skeat, *Complete Works*, V: 183; John Matthews Manly, ed., *Canterbury Tales by Geoffrey Chaucer* (New York: Henry Holt, [1928]), n. B^2 1907 ; Donaldson, 935.

110. Lynn Thorndike, *Michael Scot* (London: Thomas Nelson and Sons, 1965), 1, 87; Lynn Thorndike, *A History of Magic and Experimental Science*, 8 Vols. (New York: Columbia Univ. Press, 1923), II: 331.

111. William Witherle Lawrence, "Satire in *Sir Thopas*," *PMLA* 50 (March 1935): 86.

112. MED, s.vv. "fer," adj (1); "fere," n. (1) 1. (c).

113. Act 3, Scene 2.

114. The *Macmillan Dictionary of Historical Slang*, ed. Eric Partridge, [based on revised and enlarged, *A Dictionary of Slang and Unconventional English* 1961] (London: Routledge and Paul, 1937), 2 vols. in 1, abridged, Jacqueline Simpson (New York: Macmillan, 1974), s.v. "poperine pear."

115. Rossell Hope Robbins, ed. *Secular Lyrics of the XIVth and XVth Centuries*, 2nd ed. (1952; Oxford: Clarendon, 1955), #7; Greene, #416.
Greene's note: "*jelyf*" jelly; here slang for penis, rather than the

suggestion in O.E.D.: 'perh[aps] in imitation of jolif, archaic form of jolly.'" (p. 462) One might compare this "jelly" (*jelyf*) to the "pudding" of another poem.

> Podynges at nyght and podynges at none;
> Were nat for podynges the world were clene done.

The subject stated quite suggestively is "a podyng that will stand by hymself." (#460.1) Italics added.

The Hieatts diminish the spice of the line by changing one word: "What a gift from God he had *with* all his wives!" Solomon's "gift" was *for* each wife; it was something she received from him. *The Canterbury Tales by Geoffrey Chaucer*, ed. A. Kent Hieatt and Constance Hieatt (1964; New York: Bantam, 1981).

116. John S. Farmer, ed., *Merry Songs and Ballads* (New York: Cooper Square, 1964), 270, 272–73, 205, 10, 81; Percy, 85, 112–13; Greene, #460, #460.1.

117. *Poems by Sir John Salusbury and Robert Chester*, ed., Carleton Brown, EETS e.s. 113 (London: Paul, Trench, Trübner, 1914), 7–8.

Vicary, surgeon to Henry VIII, personifies the phallus (which he calls the "yard") with male referents. Speaking of "this member" which is "the yard" he says, "through *his* consecration the spermatike matter is the better and sooner gathered together, and sooner cast foorth from the Testicles: for by *him* is had the more delectation in the dooing." Thomas Vicary, *The Anatomie of the Bodie of Man*, ed. Frederick J. Furnivall and Percy Furnivall, EETS e.s. 53 (London: Oxford Univ. Press, 1888), 82. Italics added.

118. Greene, #460, #456.1; Farmer, 81, 204.

Beryl Rowland is credited by Kolve with informing us that *molere mulierem* describes sexual relations "the husband being the miller who grinds the wife the mill." (Kolve, 363)

119. D. W. Robertson, Jr., *A Preface to Chaucer* (1962; Princeton: Princeton Univ. Press, 1969), 155–56.

120. MED, s.v. "girdel," 1. n. (b); "put þe flesche vnderfote." *The Book of Vices and Virtues*, ed., W. Nelson Francis, EETS o.s. 217 (London: Oxford Univ. Press, 1942), 226–27.

121. Lowes comments on the genius of Chaucer to merge "at one stroke the two most powerful influences that made him what he was—his immersion in affairs, and his absorption in his books."

John Livingston Lowes, *Geoffrey Chaucer* (Boston: Houghton Mifflin, 1934; Bloomington: Indiana Univ. Press, Midland, 1958), 39.

122. *The Romance of the Rose*:

> And Fals-Semblant, the theef, anoon,
> Ryght in that ilke same place,
> That hadde of tresoun al his face
> Ryght blak withynne and whit withoute.

(7330–33)

123. I. A. Richards, *The Philosophy of Rhetoric* (London: Oxford Univ. Press, 1936), 48. Author's italics.

124. Walter Skeat (n. B 1917) said that the phrase is more properly expressed as "*with* grain." (*Complete Works*, vol. V) Chaucer's choice, however, is "*in* grayn."

125. MED, s.vv. "rod(e," n. (1) (b); "rod(de" (also "rode"), n. 2.; MED, s.vv. "grain," n. 2.; "sed," n. 1a. (a). "The grain or ovule of a plant"; also, 2. (a) "Semen, sperm."

 Chauliac (physician to the Pope), writing in 1363, confirms the term for procreative *seed*: "Sperma forsoþe is þe seed...of mankynde." *The Cyrurgie of Guy de Chauliac*, ed. Margaret S. Ogden, EETS o.s. 265 (London: Oxford Univ. Press, 1971), 67.

 Barbara Seward, *The Symbolic Rose* (New York: Columbia Univ. Press, 1960), 11–12.

126. Farmer, 153.

127. Owen, 539–40.

128. "Mankind" in *Specimens of the Pre-Shaksperean Drama*, ed. John Matthews Manly, 2 vols. (New York: Ginn, 1897), I: 320.

129. MED, s.vv. "berd," n. (1) 1. (a); "her," n. 1. and 2; MED, s.v. "shar(e," n. (2) (a). "þe ȝere of pupberte...is when þe neþir berd her (hair) growiþ."

130. MED, s.v. "girden," v. (1) 4. *fig.* "Gyrd with the gyrdell of lechery."

131. OED, s.v. "Yerd, ȝerd, etc.: see Yard." Under "yard, sb.², " the definitions deal with variations of a twig, a rod, or a symbol of office, until entry 11.: "The virile member, penis; also = PHALLUS"; MED, s.v. "girden," v. (1) 3.

 The letter "ȝ," called "yogh" (YAWCH, *not* like a sneeze, but like

clearing your throat) has disappeared from our alphabet replaced by "g" or "y."

132. "Tho' the saddle be saft, ye needna ride aft, / For fear that the girdin' beguile ye, young man." (Farmer, 253)

133. S.v. "Gird," v. 1 *Dictionary of the Older Scottish Tongue* contains words "from the Twelfth Century to the End of the Seventeenth," ed. Sir William A. Craigie (London: Oxford Univ. Press, [1937]).

134. "It is a penn with a hole in the toppe, / To write betwene her two-leued booke." (Farmer, 10)

135. "I haue a poket for the nonys; / Therine ben tweyne precyous stonys." (Greene, #416)

136. Farmer, 193.

137. MED, s.vv. "purs(e," n. 4. (a) ; "ballok," n. 1.

138. MED, s.vv. "hose," n. 3. (a); "shethen," v. (b).

139. Farmer, 197.

140. MED, s.v. "siclatoun," n. (a); OED, s.v. "ciclatoun."

141. *John Skelton: The Complete English Poems*, ed. John Scattergood (New Haven: Yale Univ. Press, 1983), 56.
 A satire by David Lyndesay has a character named "Fund-Jonet" (that is, "Fiend Jonet") who initiates prostitutes. *Ane Satyre of the thrie Estaits*, ed. F. Hall, EETS o.s. 37 (London: Trübner, 1869), 387.

142. Greene, #460.1. Italics added.

143. Greene, #457.
 The explanation given by Brewer, regarding popular comic stories of seduction, no doubt gives the perspective of the times. The plot generally focuses on "the amused contemplation of seduction of more or less willing girls by smart-alec young men. It is natural; it is wrong; it should not happen; it does go on; and possibly tragic outcomes are ignored." (145)

144. Farmer, 194–96.

145. Greene, #466.1; notes, p. 500.
 If the poet had thought his name meant "shoemaker" (the opinion of some scholars as mentioned earlier, n. 30) the story

might have been about an eager foot slipping into one shoe after another!

146. See the notes of Baugh and Skeat to B 1927, and Robinson for line 737.

Altering Chaucer's words distresses me. If his chosen vocabulary causes a problem, then the point in question needs to be carefully examined and possibly solved. All such problems may not be solvable, but rewording the line removes possible future insight and solutions.

147. "I shal *ryve* hym thurgh the sydes tweye" (C 828); "Men wolde him *ryve* / Unto the herte" (E 1236–37); "This swerd thourghout thyn herte shal I *ryve*" (Robinson, *LGW* 1793); "We wole / ... / hym on sharpe speris *ryve*" (Robinson, *RR* 7159–61). Italics added. MED, s.vv. "riven," v. (2); "river," n. (a).

Robbins' *Secular Lyrics* records "A Betrayed Maiden's Lament" as a *riving*:

> he leyde my hed agayn the burne,
> he gafe my mayden-hed a spurne
> and *rofe* my kell[ey] (maidenhead).
>
> #25 (6–8).

148. Farmer, 82–83; 11. See MED "quiver," (b). The *Wyclif Bible* warns of daughters who open their quivers to every arrow.

149. MED, s.v. "matris," (a). Farmer, 204. Editor's italics.

150. MED, s.vv. "stonden," v. (1) 1a. (a); 5. (a); 19. (a) (b); 22. (a); 26. fig.; 30a; "stonden," v. (2).

151. MED, s.v. "bour," n. 1 (a) and 2 (a); 3. *fig.* indicates the use of "bower" for the *womb* of the Virgin Mary; Farmer, 218.

Chaucer's "bright in bower" is expressed by Thomas Nash (1601) as, "The verye chamber that includes her shine." (Farmer, 20)

152. Farmer, 11.

153. MED, s.v. "paramour(e," n. 1. (b), (c), 2. (a).

154. MED, s.vv. "brembel"; "brember."

155. The face we've heard described in terms of red and white, along with a mention of "sydes smale" (B 2026) have resulted in Thopas being promoted as effeminate by modern editors. This is in opposition to the stated amorous appeal to the opposite sex. I do not

believe Chaucer would devise a plan that works at cross purposes.

156. MED, s.vv. "bar" (also spelled "ber"), adj. 1. (a); "beren," v. (1) 1. (a), 4. (a), 5. (a), 6. (a); "redi" (also "rede"), adj. (3) 1a.
Skelton (late 1400s) offers a poem filled with suggestive equestrian imagery. One line in particular parallels Thopas as Skelton's "rider" announces, "myne horse (whore's) behynde is bare." (p. 43; p. 394, n. 20)

157. Thomas wrote in the twelfth century. Leonard Barkan, *The Gods Made Flesh* (New Haven: Yale Univ. Press, 1986), 141.

158. *Robert of Brunne's "Handlyng Synne"*, Part I, ed. Frederick J. Furnivall, EETS o.s. 119 (London: Paul, Trench, Trübner, 1901), 253.

> And shame hyt ys euer aywhare
> To be kalled 'a prestës mare.'
> Of swych one, y shal ȝow telle
> Þat þe fendë bare to helle.
>
> (7979–7982)

159. "And whanne þe hors bigynneþ to gendre þanne here voice is grettere, and so fareþ þe mares also and loueþ þe werk of generacioun more þan oþere bestes." (Bartholomeus citing Aristotle in Kolve, 245); Rowland, 111.
Both Rowland and Kolve are very informative about horses as sexual and moral imagery.

160. Piers: "As wilde bestis with 'wehe.' " William Langland, *The Vision of Piers the Plowman II Text B*, ed. Walter W. Skeat, EETS o.s. 38 (London: Trübner, 1869), Passus VII, (l. 91).
Chaucer's Reeve: "And whan the hors was laus, he gynneth gon / Toward the fen, ther wilde mares renne, / And forth with 'wehee,' thurgh thikke and thurgh thenne." (A 4064–66)

161. Kolve, 246.

162. Percy, 55.
The "riding" image was a common one. For example, a woman several times widowed foregoes looking for another husband,

> And bycause she loued rydynge,
> At the stewes (brothel) was her abydynge.
>
> (399–400)

"The Boke of Mayd Emlyn" (ca. 1520), in *Remains of the Early*

Popular Poetry of England, ed., William Carew Hazlitt, 4 vols. (London: John Russell Smith, 1866; New York: repr., AMS, 1966), 4: 96.

163. An assortment of equine terms were in use to indicate the precise quality of a woman—jade, hackney, mare, etc. Frequent hitting on the tail indicated generous distribution of favors.

164. Kolve, 245; MED, s.v. "riden," v. 9. To copulate.
 Beryl Rowland goes so far as to say that "in every language *riding* is a commonplace term for coitus." (105) Author's italics.

165. Baugh, "got on (*lit*. became on)" (B 1941); Robinson, "got upon; lit. 'became upon.'" (751)

166. Skeat, *Piers*, Passus VII.

> For ȝe lyue in no loue · ne no lawe holde;
> Many of ȝow ne wedde nouȝt · þe wommen þat ȝe with delen,
> But... · worthen vppe and worchen,
> And bryngeth forth barnes · þat bastardes men calleth.
>
> (ll. 89–92)

167. Baugh, B 1942; Robinson, n. 752; Manly, *Canterbury Tales*, n. B[2] 1942; Skeat, *Complete Works*, V: n. B 1942; Farmer, 218.
 Skelton alludes to a lance as a phallic image. (57) Skeat's note gives a lengthy history of Chaucer's word.

168. The poem, "A Man's Yard," presents a dozen or more images. "My Pretty Maid, Fair Would I Know" explores another set of comparisons. (Farmer, 10–11; 204–5)

169. Farmer: "There growes a louely thickett / wherin 2 beagles trambled, / & raised a liuely prickett." (80); "There's round about a pleasant Grove, / To shade it from the Sun." (218); "Then catch hold of the Grass that grows on the brim." (193) My italics.

170. Rowland, 100; 93. There are many examples of rabbits (the hare's cousin) used as allusions to women. The prevalent word—because of its similarity to the basic word for the genital area—was *cunny* or *cony*.
 The term was well known and accepted in the best circles. At the wedding pageant of Prince Arthur and Katharine of Aragon (1501), rabbits and doves were released in the hall as emblems of sexual and spiritual love. The description reads: "They cast ought many quyk conys, the which ran abought the halle and made very

great disporte." *The Receyt of the Ladie Kateryne*, ed. Gordon Kipling, EETS o.s. 296 (Oxford: Oxford Univ. Press, 1990), 76.

171. Farmer, 32, 85, 154, 271; Greene, #440, #451.

Jember, renders "from below," in a new translation of an Old English riddle, as meaning "from the south." The proposed obscene solution to the riddle (a counterpart to innocent possibilities) is a *phallus*. Gregory K. Jember, *The Old English Riddles* (Denver, CO: Society for New Language Study, 1976), #62.

172. Loomis, 511 (977–82); Skeat, V: n. B 1949; Manly, *Canterbury Tales*, n. B^2 1948f.

173. Baugh informs the reader that "these 'herbes' would naturally not be found growing in Flanders." (B 1951) This fact is a confirmation that the story is not *about* Flanders; Flanders is just where the activity begins.

174. Vicary, 78. Italics added.

175. *Cursor Mundi*, ed. Richard Morris, EETS o.s. 59 (1875; repr., London: Oxford Univ. Press, 1966), l. 9329.

MED, s.v. "male," n. (1) 2. (a). The entry (b) also declares that some stones were considered either male (hard) or female (soft). MED, s.v. "herbe," n. 3 (a) explains that the "Carduus is a male herbe ful of prikkes." In addition, a "cristofre male" is mentioned as well as a "*tufted* cristofre female."

Chauliac, 66–67.

176. "[Nou] spri[nke]s the sprai; / Al for loue icche am so seek / That slepen I ne mai." (Greene, #450)

177. H. S. Bennett, *Life on the English Manor* (1937; repr., Cambridge: Cambridge Univ. Press, 1974), 264–66; MED, s.v. "note," n. (2) 2. (c).

178. Farmer, 218.

179. Farmer offers a song about an old man who married "a Juicy brisk Girl of the Town." (167); MED, s.v. "leien," v. (1) 1a., 3. (b).

180. MED, s.vv. "brid," n. 1a.; 3b. (a) and (b); "brid(e," n. (1); "birde," n. (1).

181. Manly, *Canterbury Tales*, n. B^2 1959. Baugh incorporates the change, but fails to note the alteration.

182. MED, s.v. "leien," v. (1) 2. (a).

183. "Sone he wolle take me be the hond, / And he wolle legge me on the lond, / That al my buttockus ben of son[d]." (Greene, #452)

184. MED, s.vv. "sprengen," v. (a) and (g); "sprai," n. (1).
An Anglo-Saxon Dictionary, ed., T. Northcote Toller, 2 vols. (Oxford: Clarendon, 1882) defines "sprengan (III)" as "to burst, crack," and compares it to springing a leak.

185. "Þe fayrest mayde of þis toun / preyid me, / for to gryffyn her a gryf / of myn pery tre." Robbins, Secular Lyrics, #21.

186. Farmer, 14; 19. The poem is "Nash His Dildo," the second line being a joke at the poet's own expense. At this point, however, he has not yet resorted to pretense.

187. Farmer, 75.

188. Manly, Essays and Studies, 68–9; MED, s.v. "sweten," v. (1) 1. (a), (g). Loomis explains that, when Chaucer omitted equipping Thopas with spurs, this "cannot be considered a special absurdity" because there were other romances where the main character does his riding (pricking?) without spurs. (526, n.1) That might bear investigation.

189. OED, s.v. "wring," v. I. 2., 5., 6.

190. Jember, #11.

191. Percy, III: 4, 116; Farmer, 22; Greene, #459.

192. And see pp. 33–34, and 49 above. The OED ("forage," v., 1. and 2.) says the term is especially used "of soldiers in the field."

193. MED, s.vv. "moder," n. 3. (a); "maris." Italics added.

194. Cullen, 81–2.

195. See page 23, above.

196. MED, s.v. "gore," n. (1) weapon. The variation "gor(e," n. (2) 3. (a) deals with phrases like "gropen under gore," which denotes amorous fondling, and "stingen under gore," which refers to intercourse.
An early fourteenth-century verse, "Old Age," is a man's lament, which says in part,

Ihc ne mai no more
Grope under gore
thog mi wil wold gete.

Reliquæ Antiquæ, ed. Thomas Wright and James Orchard Halliwell, 2 vols. (London: William Pickering, 1843), II: 210.

197. Farmer, 207.

198. Donaldson, 935.

199. MED, s.vv. "dede," n; "ded," adj. as n.

200. Skeat, *Complete Works*, V: n. B 2020.

201. Percy, 112–13; Farmer, 195, 167.
 Chaucer's Wife of Bath uses *instrument* to mean the ꝫerde (D 132) and later the pudendum (D 149).

202. "Moote" is generally said to intend *may*, although both *may* and *must* are possibilities. See MED, s.v. "moten," v. (2). The "2b" entry in the definition specifies: "To be compelled by destiny or the nature of things (to do or be sth.), must." Heroism (or mock heroism) seems called for as the "young romantic" threatens a *giant*.
 Two Chaucer "destiny" examples are quoted in the "2b" entry: *Troilus*, 1.216 and *Canterbury Tales*, E 1862.

203. "The hero, [who is] already armed, defers battle until he has more armor." (Loomis, 531) I would distinguish between *arms* and *armor*. Thopas has weaponry, but no body armor is mentioned. That is what is described in the scene of arming yet to come.

204. MED, s.v. "beren," v. (1). An unexpected echo of "bering" is found under "beryhing" (also spelled "bering"); it means "salvation."
 Using this "unexpected echo," the three lines become prayerful:

 But child Thopas fortunately escaped
 And it was all through God's grace,
 And through his salvation.

205. Otto L. Bettmann, *A Pictorial History of Medicine* (Springfield, IL: Charles C. Thomas, 1956), 90; *The Cambridge World History of Human Disease*, ed. Kenneth F. Kiple (Cambridge: Cambridge Univ. Press, 1993), 274; Danielle Jacquart and Claude Thomasset, *Sexuality and Medicine in the Middle Ages*, trans. Matthew Adamson (Presses Universitaires de France, 1985; Princeton: Princeton Univ. Press, 1988), 183–85.

206. Lanfranck in *Lanfrank's Science of Cirurgie*, ed. Robert v. Fleischhacker, EETS o.s. 102 (London: Paul, Trench, Trübner, 1894), 288; Donald J. Campbell, "The Venereal Diseases," in *The History*

and Conquest of Common Diseases, ed. Walter R. Bett (Norman: Univ. of Oklahoma Press, [1954]), 180–81.

Here is a medieval "morning-after" plan for men: If after lying by a woman, "he haue ony suspecioun of vnclennes, þan he schal waische his ȝerde wiþ coold water medlid with vinegre." (Lanfranck, 289)

207. Erwin Ackerknecht, *History and Geography of the Most Important Diseases* (New York: Hafner, 1965), 135.

208. *Cambridge History of Disease*, 726; *Gould's Medical Dictionary*, ed. R. J. E. Scott, 3rd ed. (Philadelphia; P. Blakiston's Son, [1931]).

209. *Anomalies and Curiosities of Medicine*, ed. George M. Gould, M.D. and Walter L. Pyle, M.D. (Philadelphia: W. B. Saunders, 1901), 800–03.

210. Lowes, 117.

Avicenna wrote an encyclopedia of medicine that was very influential in the Middle Ages. Chaucer refers to him twice in the *Tales*. (A 432, C 889) According to Atkinson, "There seems to be little doubt that...Chaucer became acquainted with the names of these Arabian celebrities of medicine and was regarded as the greatest authority in England on the subject." Donald T. Atkinson, *Magic, Myth, and Medicine* (New York: World Publishing, 1956), 59.

211. MED, s.v. "rounen," v. 1. (b) and 3. (b).

212. Zesmer, 249; Loomis, 504; Donaldson, 935.

213. Farmer, 218, 80–1; Percy, 85.

Some poets went on at length, with pastoral images, to tell of the attributes of there paramours. Here is a sample from Thomas Nash (Farmer, 18):

> ...like the riseing of a hill,
> at whose decline the[r] runnes a fountayne still,
> That hath her mouth besett with rugged briers,
> resembling much a duskye nett of wires.

214. The availability, ubiquity, and necessity of minstrels is greatly detailed in Chambers. (I: 42–69)

215. Owen, 542; R. M. Lumiansky, *Of Sondry Folk* (Austin: Univ. of Texas Press, 1955), 91.

216. Chauliac describes such an inflammation as "schynynge." (88)

217. Information and theories about the surface understanding of the arming scene are well covered by Robinson (n. 851 ff.), and Loomis (526–30).

Robertson, speaking of medieval allegory, defines a term used by Isidore of Seville: *alieniloquium*. "One thing is said by the words, but something else is understood." (288) Many figures of speech produce this result. I will not try to put a name to the technique of the arming scene, but what is done precisely is: one thing is said, but another (on the covert level) is to be understood.

218. The twenty-three words are listed by Loomis. (491)

219. Richards, 133.

220. See and hear *Das Alte Werk* recording, SAWT 9549-B.

221. Reginald Pecock, *The Reule of Crysten Religioun*, ed. William Cabell Greet, EETS o.s. 171 (London: Oxford Univ. Press, 1927), 348.

MED, s.v. "spiceri(e," n. 2. quotes Mirk: "Hast þow I-smelled any þynge…Of mete or drynke or spysory þat þow hast after I-sinned by?"

Lanfranck recommends, "In an hoot enpostym of þe ȝerde… þou schalt forbede him wijn & fleisch & al maner swete metis." (228) Chauliac states that "when þat þe ȝerde is…colde…þat þogh he ete alle þe spices of all þe world…it be noght made to stonde vp." (527)

222. *Curye on Inglysch*, ed. Constance B. Hieatt and Sharon Butler, EETS s.s. 8 (London: Oxford Univ. Press, 1985), Glossary: s.v. "(i)tried."

223. MED, s.v. "commun(e," adj. 9. (b) where "common woman" meant "prostitute." See Rowland, 60.

Handlyng Synne tells of common women: "þe seuenest [in categories of lechery] ys foulest leccherye— / Comoun wymmen to lyggë by— / Of al þe ouþer þat we haue seyde." (7427–29)

224. MED, s.vv. "breden," v. (3) 2. and 3; "gangen," v. 2. (a).
Cursor Mundi says of a woman "she bredeþ two for oone / …twinlinges." (3444–45)

225. MED, s.v. "sugren," v. 2. (f). "Sugred flaterie."

226. Manly, *Canterbury Tales*, n. B² 2047; MED, s.v. "ler," n.; OED, s.v. "leer," sb¹, sb⁴.

227. MED, s.vv. "lak(e," n. (1); "lak(e," n. (2); MED, s.v. "brech," n. 1. (a), 3. (a), 4., 5.
 "Þan þou schalt wete a lynnen clooþ in þis medicyn, & leie vpon þe ȝerde." (Lanfranck, 288); see Chauliac, 330, 503, 529, 582.

228. Manly, *Essays and Studies*, 70; MED, s.v. "habergeoun," n. (a).

229. Loomis, 528; Edwin H. Ackerknecht, *A Short History of Medicine* (New York; Ronald, 1955; rev. 1968), 82, 85–86; *Britannica*, s.v. "Jews."
 Lanfranck recommends, "Take a brood plate of iren & make þeron an hole, & leie þat plate þere þou wolt make þi cauterie. & þan þou muste haue an iren maad long & smal & maad hoot, & putte it in þat hole of þe plate/ þis plate wole saue þe place þat þe cauterie schal be nomore but as þou wolt." (306–07)
 Another surgical skill at which Jews had extensive experience, circumcision, was the answer to severe phallic problems. Chauliac instructs, "circumcicioun is made after þe lawe to Iewes." (528)
 Where cautery was inadvisable, applications of slower acting ointments containing caustic lime were often used on ulcers and boils. As you read the descriptions of illnesses and treatments in these medical books, you gain a feeling for the day-to-day lives of the people of the Middle Ages that you don't get from just learning the events of history.

230. Manly, *Essays and Studies*, 70.

231. Skeat, *Complete Works*, V: n. B 2059; MED, s.v. "carbuncle," n. 1. (a); 3. (a), (b). "Carbunculus...brenneþ as cole."

232. "Brenne þe ȝerde wiþ an hoot irn for to constreyne þe flux of blood." (Lanfranck, 176); "Kytte it and bynde þe ȝerde ende... And after cauterize it." (Chauliac, 322)

233. Chauliac, 573–74.

234. Edward J. Kealey, *Medieval Medicus* (Baltimore: Johns Hopkins Press, 1981), 93; MED, s.v. "teien," v. 1. and 2.
 Chauliac, 169, 173. "In þe purs of þe priue stones, make it wiþ a coyfe; in þe ȝerde, with a bagge ybounden to þe breche." (332)

235. "Latoun" is a metal alloy. Robinson identifies it as "compounded chiefly of copper and zinc"; Baugh simply calls it "brass." For commentary on the armor, see Loomis, 526.
 "And laye...leues þeron...of yve, vnder clothes (cloths) or vpon

threfolde cloþes, and some plate of lether or of brasse." (Chauliac, 575)

236. Percy, 69.

237. MED, s.v. "sadel," n. (a). fig.: *Dives and Pauper* 2.305 "The sadil of þin hors schal ben pacience and meknesse"; Kolve quotes St. Gregory: "The horse is the body of any holy soul, which knows how to restrain from illicit action with the bridle of continence." (240); *The Book of Vices and Virtues* speaks of "þe bridel of resoune" to guard one's chastity. (226)

238. Manly, *Essays and Studies*, 71.
 Loomis explains that "no precise parallels" to this armor can be identified in romances, and it is taken to be "Chaucer's ironic perception of the burlesque value...of unsuitable materials." (526) I would rather credit the unusual choices to his imagination and genius for finding comparative elements that serve at two levels of meaning.

239. Bernard Silvestris (12th century) writes of a particular fish "which makes old men fit for Venus's wars again." Ernst Robert Curtius, *European Literature and the Latin Middle Ages*, trans, Willard R. Trask (1948; New York: Pantheon, 1953; repr. Harper Paperback, 1963), 110.

240. MED, s.v. "shethen," v. (b). *Burgeys thou* 35: "Ye tooke a maladie...for excesse of venerye...And ther-with, god thou madest forwarde, That if him liste to helth the restore, Thou woldeste neuere shethen afterwarde So vsely [read: esely] as thow didest by-fore."

241. Farmer, 219, 76. "The lane itt was streat; he had not gone farr."

242. MED, s.v. "fonden," v. 1 (c); 2.

243. MED, s.v. "druerie," n. 1. (b). *Sayings of St. Bede* 146: "Þes proude leuedies þat louen driweries, And breken here spousinge."

244. For historic background of the word, see OED "prise," sb.[1] and "pryse."
 Robbins records a fourteenth-century lyric that also deals with "flower bearing." It is "genuinely popular" and expresses "realistic content." (p. 233)

Al nist by þe rose, rose—
al nist bi the rose i lay;
darf ich noust þe rose stele,
ant ʒet ich *bar þe flour* away.
(*Secular Lyrics*, #17 Italics added.)

245. MED, s.vv. "libber(e," n.; also gerund form, "libbing."

246. MED, s.vv. "gliden," v.; "glouen," v. (1).

247. Rossell Hope Robbins, "Popular Prayers in Middle English
Verse," *MP* 36 (May 1939): 341–2; Carleton Brown, *Religious
Lyrics of the Fourteenth Century* (Oxford: Clarendon, 1924), #26.

248. "Flesshly delyces engendrys fleschly loue…þat brynges a man to
shame and his distruccioun." *Secreta Secretorum*, Robert Steele,
ed., EETS e.s. 74 (London: Paul, Trench, Trübner, 1898), 54.

249. "Capellus or prepucium," (69); MED, s.vv "hod," n.; "hodles," adj.
Leve lystynes p. 30: "Hit growethe all with-in þe here…Stondyng
opon schare, ʒett the schrewe is hodles."

250. OED, s.v. "wanger."

251. "Þe crucifix, at stude vp in þe rude-lofte, lowsyd his handis fra þe
rude, & stoppid his eris þat he sulde nott here þaim." *An Alphabet
of Tales*, ed. Mrs. Mary Macleod Banks, EETS o.s. 126 (London:
Paul, Trench, Trübner, 1904), 67.

252. Annie Dillard, *The Writing Life* (New York: Harper and Row,
1989; New York: HarperPerennial, 1990).

253. I imagine a Middle English version is intended, but I will leave
the interpretation to an expert in the text of *Percyvell*.

VI: The Link Between Sir Thopas and the Tale of Melibee

254. It is possible that the inclusion of the life of St. Cecilia indicates
Cecilia Chaumpaigne as the source of inspiration for Chaucer's
conversion.

255. Rosemary Woolf, *English Lyrics in the Middle Ages* (Oxford: Clar-
endon, 1968), 330.
Many similarities between the *Canterbury Tales* and *Corpus
Christi* plays were noted in *Chaucer's Host: Up-So-Doun.* See
Cullen, especially p. 133, and n. 306.

256. "Gladly," quod I, "by Goddes sweete pyne!
 I wol yow telle a litel thyng in prose
 . . .
 Or elles, certes, ye been to daungerous."
 (B 2126–29)

MED, s.v. "daungerous," adj. 1., 2. (a).

257. Woolf, 219.

 Whan they his pitous passioun expresse—
 I meene of Mark, Mathew, Luc, and John—
 But doutelees hir sentence is al oon.
 (B 2140–42)

The Host makes references to Christ's Passion throughout the
Canterbury Tales. See Cullen, 121–22.

258. ...I telle somwhat moore
 Of proverbes than ye han herd bifoore
 . . .
 To enforce with th' effect of my mateere.
 (B 2145–48)

MED s.vv. "enforcen" v. 3. (d) reinforce, strengthen, or strengthen
an argument or opinion; "mater(e" n. 5b; 5d. (a) refers to a narra-
tive discourse, or the subject matter of a literary work.

259. "And lat me tellen al my tale, I preye." (B 2156)

VII: THE TALE OF MELIBEE

260. Scripture regarded as *sweetness* and *honey* is noted in Gardiner,
 Pilgrimage of Desire, 50 and passim.

261. Baugh, *Troilus*, n. 5.744.

262. Those who have read the *Tales* know that the Host was given a
 name (Herry Bailly); it serves a purpose, but is heard only once.
 In the same way, this daughter's designation serves a purpose and
 is never heard again; but its announcement gives us the cue to see
 simultaneous action on two levels.

263. The events happen within the first fifteen short lines. Twenty
 more pages follow (Robinson's edition) as distraught Melibee and
 clear-thinking Prudence strive to bring the catastrophe to a just
 and moral conclusion.

264. "Thou hast ydronke so muchel hony of sweete temporeel richess-es, and delices and honours of this world, that thou art dronken, and hast forgeten Jhesu Crist thy creatour. Thou ne hast nat doon to hym swich honour and reverence as thee oughte." (B 2600–10)

265. "Thou hast doon synne agayn oure Lord Crist; for certes, the three enemys of mankynde, that is to seyn, the flessh, the feend, and the world, thou hast suffred hem entre in to thyn herte wil-fully by the wyndowes of thy body, and hast nat defended thyself suffisantly agayns hire assautes and hire temptaciouns, so that they han wounded thy soule in fyve places." (B 2610–15)

266. "Dame," quod Melibee, "dooth youre wil and youre likynge; for I putte me hoolly in youre disposicioun and ordinaunce." (B 2915)

267. "God of his endelees mercy wole at the tyme of oure diynge fo-ryeven us oure giltes that we han trespassed to hym in this wrecched world." (B 3070–75)

268. "For doutelees, if we be sory and repentant of the synnes and gilt-es which we han trespassed in the sighte of oure Lord God, he is so free and so merciable that he wole foryeven us oure giltes, and bryngen us to the blisse that nevere hath ende. Amen." [END]

269. Lowes observes, "Chaucer's rejections are often as illuminating as his choices." (122) A careful study of Chaucer's method of work-ing with his source is called for. J. Burke Severs did a complete analysis of the differences for "The Tale of Melibeus," in *Sources and Analogues*, ed. W. F. Bryan and Germaine Dempster (Lon-don: Routledge and Paul, 1941; repr., New York: Humanities Press, 1958).

The entire Old French work is there to be examined. The po-et's additions, deletions, redirections are detailed. Many words are so recognizable that, with a little effort, one can follow along— *The Tale* to one side and *Le Livre* next to it. And, when a word in Old French needs clarification, there is the *Dictionnaire le Anci-enne Langue Française*, ed. Frédéric Godefroy (Paris: Scientific Pe-riodicals Establishment, 1880; repr., New York: Kraus, 1961).

"Chaucer's translation rarely departs" from the French treatise. There are about twenty-five omissions, most are less that ten words long. Severs concludes, "additions are even less important." (564–65)

For my part, our crafty poet has made me question in the past, if the change is *minimal*, why bother to make a change at all?

And is it the *length* of an addition or deletion that indicates its importance? The introduction to the *Tale* said there would be reinforcement of the effect of his subject, then we might imagine that each change—large or small—is reinforcement.

270. Severs, 609, n. 1063–65.

271. 1843 Letter to John Kenyon, in Spurgeon, vol. II, p. 246.
The poet also reinforces his subject matter with touches of God's joy and love. Where the French has a stoic proverb of Solomon: 151, Chaucer inserts "the love of God" twice. (B 2815–20) And when the French only alludes to "Second Corinthians," Chaucer quotes the verse instead: "The joye of God...is perdurable, that is to seyn everlastynge." (B 2700)

272. "Th' ende is every tales strengthe." (*Troilus* 2.260); Severs, 614, n. 1179.

273. This was a well-circulated piece, originally written in Latin, later translated into French. (Robert D. French, 246–47) It was "greatly admired," (Bronson, 115–16); "highly esteemed" (Robinson, 741) on into the 1500s because "our ancestors were very fond of such discussions." (Manly, *Canterbury Tales*, p. 438)

274. "Now swich a rym the devel I biteche!" (B 2114); "Certes for to persevere longe in synne is werk of the devel." (B 2450–55)

275. "And peraventure Crist hath thee in despit, and hath turned awey...his eeris of misericorde." (B 2600–10)

276. Adventures of man's carnal appetite continually astride his "horse," as Thopas would be, is a medieval exemplum "used to persuade the reader of the need for the reason to control the flesh." (Woolf, 12) St. Augustine reflects, in the *City of God*: "We can...*with God's help* so act that we do not yield to lusts of the flesh." (trans. William M. Green, 7 Vols. Cambridge: Harvard Univ. Press, 1957; repr., 1981), VI, 129. Italics added.
Pilgrim Chaucer's being interrupted by Christ is God's help. The Pilgrim does a spiritual "about face," turns his back on the "lusts of the flesh," and embraces the moral challenge.

277. "He hath suffred that thou hast been punysshed in the manere that thow hast ytrespassed." (B 2600–10)

278. Italics added to the Modern English.
"He is wel worthy to have pardoun and foryifnesse of his

synne, that excuseth nat his synne, but knowlecheth it and repen-
teth hym, axinge indulgence. For Senec seith, 'Ther is the remis-
sioun and foryifnesse, where as the confessioun is'; for confes-
sioun is neighebor to innocence." (B 2960–70)

279. Woolf, 101.
 Our fourteenth-century poet adds great imagination to popular
 ideas of his time. "The latest and finest of the early debates...had
 been written in the second half of the fourteenth century...six
 manuscripts are a testimony to [this genre's] popularity within
 that period." (Woolf, 326)

280. A character in the play *Mankind* laments, "Ther ys euer a batell
 betwyx the soull & the body." (Manly, *Specimens of Pre-Shakspere-
 an Drama*, p. 324)
 Petrarch, in a letter to friends, expresses the battle he has won:
 "I admit that I am an old man....I feel that I have triumphed
 over my body, that old enemy which waged many a cruel war on
 me, and I seem to be driving a laureled chariot up the sacred way
 to the Capitol of my soul, dragging...my conquered passions."
 (Letters, 254)

281. "Ye that ben combryd and disseyvid with worldly affeccions,
 cometh now to this sovereyn good, that is God." (III, m. 10)

282. "Hony is the more swete, if mouthes han first tasted savours that
 ben wykke... Thow, byhooldyng ferst the false goodes, bygyn to
 wihdrawe...fro...erthely affeccions; and afterward the verray
 goodes schullen entren into thy corage." (III, m. 1)

VIII: CHAUCER'S RETRACTION

283. Controversies over Fragment X are detailed in Rodney Delasan-
 ta's informative article "Penance and Poetry in the *Canterbury
 Tales*"; Masefield, *Chaucer* (Cambridge: Cambridge Univ. Press,
 1931), 35–36.

284. *The Text of the Canterbury Tales Studied on the Basis of All Known
 Manuscripts*, ed. John M. Manly and Edith Rickert (Chicago:
 Univ. of Chicago Press, 1940), IV: 527; Ruggiers quotes J. W.
 Hales, 24; Delasanta, "Penance and Poetry," 240.

285. Donaldson, 948–49.

286. Spurgeon I, 13–14: "1399, Dec. 24. *Lease by the Warden of St. Mary's Chapel in Westminster Abbey, to Chaucer, of a tenement situate in the garden of the Chapel for 53 years, at the yearly rent of 53s. 4d.; terminable at Chaucer's death. The lessee covenants to repair, and not to sublet, nor to harbour any one having claims against the Abbey, without the Warden's licence.* Muniments of Westminster Abbey." The entry is somewhat ambiguous as to whether the "tenement" is *leased* for 53 years, or has been *"situate in the garden"* for 53 years. Donaldson reads it as a 53-year lease. (947)

287. Donaldson, 949.

288. Donaldson, 948; Cullen's *Chaucer's Host* indicates and explicates many of the poet's multilevel, ambiguous clues, regarding a Christ-centered pilgrimage.

289. Ruggiers, 23.

290. Donaldson, 948–50. Italics added.

291. Donald R. Howard, in *Writers and Pilgrims* (Los Angeles: Univ. of California Press, 1980), 97. Author's italics.
 Those who do insist on "avert[ing] their eyes" are able to view both *Melibee* and the *Parson's Tale* as "jokes." See Barbara Page, "Concerning the Host," *The Chaucer Review* (1970), 8–9.

292. Baldwin, 86; Huppé, 237, 9; Kolve, 371.

293. "And yet be ye fouler for youre longe continuyng in synne and youre synful usage, for which ye be roten in youre synne, as a beest in his dong." (X 135–40); "And how longe thou hast continued in synne." (X 960–65)

294. "God wole the rather enlumyne and lightne the herte of the synful man to have repentaunce." (X 240–45); "Seint Augustyn seith: 'Synne is every word and every dede, and al that men coveiten, agayn the lawe of Jhesu Crist; and this is for to synne in herte, in mouth, and in dede, by the fyve wittes, that been sighte, herynge, smellynge, tastynge or savourynge, and feelynge.'" (X 955–60)

295. "We han trespassed in the sighte of oure Lord God." (B 3075); "A man sholde eek thynke that God seeth and woot alle his thoghtes and alle his werkes; to hym may no thyng been hyd ne covered." (X 1060–65); "Therfore sholde he preye to God to

yeve hym respit a while to biwepe and biwaillen his trespas."
(X 175–80)

296. Ruggiers, 27.

297. MED, s.v. "sounen," v. 7. (a).

298. Rodney Delasanta, "The Theme of Judgment in *The Canterbury Tales,*" *MLQ* 31 (Sept 1970): 307.
Donald Howard, in *The Idea of the Canterbury Tales,* makes an interesting point. He sees the Retraction referring back to the *Parson's Tale* which speaks of doctrine being "under correction." (X 56) Howard questions the statement that "all is written for our doctrine" and "that is myn intente," and goes on to conclude, "It would be inappropriate to say that [Chaucer] means all he has written, including possible errors of doctrine, for the reader's learning!" (59) This thought-provoking interpretation has genuine possibilities. See *Chaucer's Host: Up-So-Doun* which expands and explains such an idea.

299. "Now preye I to hem alle that herkne this litel tretys or rede, that if ther be any thyng in it that liketh hem, that therof they thanken oure Lord Jhesu Crist, of whom procedeth al wit and al goodnesse. And if ther be any thyng that desplese hem, I preye hem also that they arrette it to the defaute of myn unkonnynge, and nat to my wyl, that wolde ful fayn have seyd bettre if I hadde had konnynge. For oure book seith, 'Al that is writen is writen for oure doctrine,' and that is myn entente. Wherfore I biseke yow mekely, for the mercy of God, that ye preye for me that Crist have mercy on me and foryeve me my giltes, and namely of my translacions and enditynges of worldly vanitees, the whiche I revoke." (X 1080–85)

300. "Thank I oure Lord Jhesu Crist and his blisful Mooder, and alle the seintes of hevene, bisekynge hem that they from hennes forth unto my lyves ende sende me grace to biwayle my giltes, and to studie to the salvacioun of my soule, and graunte me grace of verray penitence, confessioun and satisfaccioun to doon in this present lyf, thurgh the benigne grace of hym that is kyng of kynges and preest over alle preestes, that boghte us with the precious blood of his herte; so that I may been oon of hem at the day of doom that shulle be saved. *Qui cum patre et Spiritu Sancto vivit et regnat Deus per omnia secula. Amen.*"

IX: A REVIEW OF THE PERFORMANCE

301. Howard, *Essays and Studies*, 53. Author's italics.

302. MED, s.v. "devisen," v. 4. also communicates "to perform."

303. Howard, *The Idea of the Canterbury Tales*, 175.

304. Baldwin, 110; Ruggiers, xviii.

 "A more recent trend [1976] in Chaucer criticism has advanced
 an even simpler idea: that the pilgrimage to Canterbury is a met-
 aphor for the pilgrimage of human life, that the pilgrimage as a
 penitential act is the heart or backbone of the work." (Howard,
 Essays and Studies, 39)

305. Howard, *Essays and Studies*, 52; Baldwin discusses the craft and
 complexity of "The Narrative Voice" in the *Tales*. (67–74)

306. Ruggiers, 21.

307. John M. Major, "The Personality of Chaucer the Pilgrim,"
 PMLA 75 (March 1960): 160, 162; Howard, *The Idea of the Can-
 terbury Tales*, 370–71.

308. Howard, *Essays and Studies*, 51.

309. Skelton, 46.

 > I, callynge to mynde the great auctoryte
 > Of poetes olde, whyche, full craftely,
 > Under as coverte termes as coude be,
 > Can touche a troughte and cloke it subtylly
 > Wyth fresshe utterance full sentencyously.
 >
 > (8–12)

BIBLIOGRAPHY

Ackerknecht, Edwin H. *History and Geography of the Most Important Diseases.* New York: Hafner, 1965.

——. *A Short History of Medicine.* rev. ed. New York: Ronald, 1968.

An Alphabet of Tales, Mrs. Mary Macleod Banks, ed. EETS, o.s. 126. London: Paul, Trench, Trübner, 1894.

An Anglo-Saxon Dictionary. T. Northcote Toller, ed. 2 vols. Oxford: Clarendon, 1882.

Anomalies and Curiosities of Medicine. George M. Gould, M.D. and Walter L. Pyle, M.D., eds. Philadelphia: W. B. Saunders, 1901.

Atkinson, Donald T. *Magic, Myth, and Medicine.* New York: World Publishing, 1956.

Augustine. *The City of God Against the Pagans.* Loeb Classical Library. Reprint. 1981.

Baldwin, Ralph. "The Unity of the *Canterbury Tales*." *Anglistica* 5 (Copenhagen: Rosenkilde and Bagger, 1955): 11–112.

Barkan, Leonard. *The Gods Made Flesh: Metamorphosis and the Pursuit of Paganism.* New Haven: Yale Univ. Press, 1986.

Baugh, Albert C., ed. *Chaucer's Major Poetry.* New York: Appleton-Century-Crofts, 1963.

Bennett, H. S. *Life on the English Manor: A Study of Peasant Conditions.* 1937. Reprint. Cambridge: Cambridge Univ. Press, 1974.

Bettman, Otto L. *A Pictorial History of Medicine.* Springfield, IL: Charles C. Thomas, 1956.

The Book of Vices and Virtues. W. Nelson Francis, ed. EETS, o.s. 217. London: Oxford Univ. Press, 1942.

Brewer, Derek. "The International Medieval Popular Comic Tale in England." In *The Popular Literature of Medieval England.* Tennessee Studies in Literature, edited by Thomas Heffernan. vol. 28. Knoxville: Univ. of Tennessee Press, 1985.

Bronson, Bertrand H. *In Search of Chaucer.* Toronto: Univ. of Toronto Press, 1960.

Brown, Carleton. *Religious Lyrics of the Fourteenth Century*. Oxford: Clarendon, 1924.

Burne, Alfred H. *The Crecy War: A military history of the Hundred Years War from 1337 to the peace of Bretigny, 1360*. London: Eyre and Spottiswode, 1955.

The Cambridge World History of Human Disease. Kenneth F. Kiple, ed. Cambridge: Cambridge Univ. Press, 1993.

Campbell, Donald J. "The Venereal Diseases." In *The History and Conquest of Common Diseases*, edited by Walter R. Bett. Norman: Univ. of Oklahoma Press, [1954].

Cannon, Christopher. "*Raptus* in the Chaumpaigne Release and a Newly Discovered Document Concerning the Life of Geoffrey Chaucer." *Speculum* 68 (Jan. 1993): 74–94.

Chambers, E. K. *The Mediaeval Stage*. 2 vols. 1903. Reprint. London: Oxford Univ. Press, 1967.

Chaucer's World. Compiled by Edith Rickert, and edited by Clair C. Olson and Martin M. Crow. New York: Columbia Univ. Press, 1948.

Chauliac, Guy de. *The Cyrurgie of Guy de Chauliac*. Edited by Margaret S. Ogden. EETS, o.s. 265. London: Oxford Univ. Press, 1971.

The Compact Edition of the Oxford English Dictionary: Complete Text Reproduced Micrographically. 2 vols. Oxford: Oxford Univ. Press, 1971.

A Concordance to the Complete Works of Geoffrey Chaucer. John S. P. Tatlock and Arthur G. Kennedy, eds. 1927. Reprint. Gloucester, MA: Peter Smith, 1963.

Cowling, George H. *Chaucer*. 1927. Reprint. Freeport, NY: Books for Libraries, 1971.

Cullen, Dolores. *Chaucer's Host: Up-So-Doun*. Santa Barbara, CA: Fithian Press, 1998.

Cursor Mundi. Richard Morris, ed. EETS, o.s. 57. 1874. Reprint. London: Oxford Univ. Press, 1961.

Curtius, Ernst Robert. *European Literature and the Latin Middle Ages*.

Translated by Willard R. Trask. 1948. Reprint. Harper Paperback, 1963.

Curye on Inglysche: English Culinary Manuscripts of the Fourteenth Century. Constance B. Hieatt and Sharon Butler, eds. EETS, s.s. 8. London: Oxford Univ. Press, 1985.

Davenport, S. K. "Illustrations Direct and Oblique in the Margins of an Alexander Romance at Oxford." *Journal of the Warburg and Courtauld Institutes* 34 (1971): 83–95.

Delasanta, Rodney. "Penance and Poetry in the *Canterbury Tales.*" *Publications of the Modern Language Association* 93 (March 1978): 240–47.

——. "The Theme of Judgment in *The Canterbury Tales.*" *Modern Language Quarterly* 31 (March 1970): 298–307.

A Dictionary of the Older Scottish Tongue. Sir William A. Craigie, ed. London: Oxford Univ. Press, [1937].

Dictionnaire le Ancienne Langue Française. Frédéric Godefroy, ed. 1880. Reprint. New York: Kraus, 1961.

Dillard, Annie. *The Writing Life.* 1989. Reprint. New York: HarperPerennial, 1990.

Donaldson, E. T., ed. *Chaucer's Poetry: An Anthology for the Modern Reader.* New York: Ronald, 1958.

Encyclopædia Britannica. 1968 edition.

Farmer, John S., ed. *Merry Songs and Ballads.* 5 vols. 1897. Reprint. New York: Cooper Square, 1964.

Fletcher, Angus. *Allegory: The Theory of a Symbolic Mode.* 1964. Reprint. Ithaca, NY: Cornell Paperbacks, 1970.

French, Robert Dudley. *A Chaucer Handbook.* 2d ed. New York: Appleton-Century-Crofts, 1947.

Gardiner, F. C. *The Pilgrimage of Desire.* Leiden, Netherlands: E. J. Brill, 1971.

Gerould, G. H. "The Second Nun's Prologue and Tale." In *Sources and Analogues of Chaucer's Canterbury Tales*, edited by W. F. Bryan and Germaine Dempster. 1941. Reprint. New York: Humanities Press, 1958.

Gould's Medical Dictionary. R. J. E. Scott, ed. 3d ed. Philadelphia: P. Blakiston's Son, [1931].

Greene, Richard Leighton, ed. *The Early English Carols*. 2d ed. Oxford: Clarendon, 1977.

Hazlitt, William Carew, ed. *Remains of the Early Popular Poetry of England*. 4 vols. 1866. Reprint. New York: AMS, 1966.

Hewitt, Herbert J. *The Organization of War Under Edward III 1338–1362*. New York: Barnes and Noble, 1966.

Hieatt, A. Kent and Constance Hieatt, eds. *The Canterbury Tales by Geoffrey Chaucer*. 1964. Reprint. New York: Bantam, 1981.

Howard, Donald R. "Chaucer's Idea of an Idea." In *Essays and Studies* vol. 29. London: John Murray, 1976.

——. *The Idea of the Canterbury Tales*. 1976. Reprint. Berkeley: Univ. of California Press, 1978.

——. *Writers and Pilgrims: Medieval Pilgrimage Narratives and Their Posterity*. Berkeley: Univ. of California Press, 1980.

Huppé, Bernard. *Doctrine and Poetry*. [Albany]: State Univ. of New York, 1959.

——. *A Reading of the* Canterbury Tales. rev. ed. Albany: State Univ. of New York, 1967.

Jackson, W. T. H. *The Literature of the Middle Ages*. New York: Columbia Univ. Press, 1960.

Jacobus de Voragine. *The Golden Legend of Jacobus de Voragine*. Translated by Granger Ryan and Helmut Ripperger. 1941. Reprint. Salem, NH: Ayer, 1987.

Jacquart, Danielle, and Claude Thomasset. *Sexuality and Medicine in the Middle Ages*. Translated by Matthew Adamson. 1985. Princeton: Princeton Univ. Press, 1988.

Jantzen, Hans. *High Gothic: The Classic Cathedrals of Chartres, Reims, Amiens*. Translated by James Palmes. 1957. New York: Minerva, 1962.

Jember, Gregory K. *The Old English Riddles*. Denver, CO: Society for New Language Study, 1976.

Kealey, Edward J. *Medieval Medicus: A Social History of Anglo-Norman Medicine*. Baltimore: Johns Hopkins Univ. Press, 1981.

Ker, William Paton. *English Literature: Medieval*. New York: Henry Holt, [1912].

Kittredge, George Lyman. *Chaucer and His Poetry*. 1915. Reprint. Cambridge: Harvard Univ. Press, 1946.

Kökeritz, Helge. "Rhetorical Word-Play in Chaucer." *Publications of the Modern Language Association* 69 (Sept. 1954): 937–952.

Kolve, V. A. *Chaucer and the Imagery of Narrative: the First Five Canterbury Tales*. Stanford: Stanford Univ. Press, 1984.

Lanfranck. *Lanfrank's Science of Cirurgie*. Edited by Robert V. Fleichhacker. EETS, o.s. 102. London: Paul, Trench, Trübner, 1894.

Langland, William. *The Vision of Piers Powman II Text B*. Edited by Walter W. Skeat. EETS, o.s. 38. London: Trübner, 1869.

Lawrence, William Witherle. "Satire in *Sir Thopas*." *Publications of the Modern Language Association* 50 (March 1935): 81–91.

Legge, M. Dominica. *Anglo-Norman Literature and Its Background*. Oxford: Clarendon, 1963.

Legouis, Emile. *A History of English Literature 650–1660*. Translated by Helen Douglas Irvine. 1927. rev. ed. (2 vols. in 1) New York: Macmillan, 1930.

Loomis, Laura Hibbard. "Sir Thopas." In *Sources and Analogues of Chaucer's Canterbury Tales*, edited by W. F. Bryan and Germaine Dempster. 1941. Reprint. New York: Humanities Press, 1958.

Lounsbury, Thomas R. *Studies in Chaucer: His Life and Writings*. 3 vols. New York: Harper and Brothers, 1892.

Lowes, John Livingston. *Geoffrey Chaucer*. [1934]. Reprint. Bloomington: Indiana Univ. Press, Midland, 1958.

Lumiansky, R. M. "The Meaning of Chaucer's Prologue to 'Sir Thopas.'" *Philological Quarterly* 26 (Oct. 1947): 313–320.

——. *Of Sondry Folk*. Austin: Univ. of Texas Press, 1955.

Lyndesay, David. *Ane Satyre of the thrie Estaits*. Edited by F. Hall EETS, o.s. 37. London: Trübner, 1869.

MacLeish, Kenneth. "Canterbury Cathedral." *National Geographic* 149 (March 1976): 364–79.

The Macmillan Dictionary of Historical Slang. Edited by Eric Partridge. 1961. Abridged by Jacqueline Simpson. (2 vols. in 1) New York: Macmillan, 1974.

Major, John M. "The Personality of Chaucer the Pilgrim." *Publications of the Modern Language Association* 75 (March 1960): 160–62.

Manly, John Matthews, ed. *Canterbury Tales by Geoffrey Chaucer*. New York: Henry Holt, [1928].

——. "Sir Thopas: A Satire." In *Essays and Studies*. vol. 13. Oxford: Clarendon, 1928.

——. ed. *Specimens of Pre-Shaksperean Drama*. 2 vols. New York: Ginn, 1897.

Manly, John M. and Edith Rickert, eds. *The Text of the Canterbury Tales Studied on the Basis of All Known Manuscripts*. Chicago: Univ. of Chicago Press, 1940.

Masefield, John. *Chaucer*. Cambridge: Cambridge Univ. Press, 1931.

The Middle Ages: A Concise Encyclopædia. H. R. Loyn, ed. 1989. Reprint. New York: Thames and Hudson, 1991.

Middle English Dictionary. Hans Kurath and Sherman M. Kuhn, eds. Ann Arbor: Univ. of Michigan Press, in progress, 1956–

Owen, Charles A., Jr. "Thy Drasty Rymyng…." *Studies in Philology* 63 (July 1966): 533–64.

Owst, Gerald R. *Literature and Pulpit in Medieval England: A Neglected Chapter in the History of English Letters and of the English People*. 2d ed. Oxford: Basil Blackwell, 1961.

Page, Barbara. "Concerning the Host." *The Chaucer Review* (1970): 1–13.

Pecock, Reginald. *Reule of Crysten Religioun*. Edited by William Cabell Greet. EETS, o.s. 171. London: Oxford Univ. Press, 1927.

Percy, Thomas. *Bishop Percy's Folio Manuscript*. Edited by John W. Hales and Frederick J. G. Furnivall. 3 vols. London: N. Trübner, 1868.

Petrarch, Francesco. *Letters from Petrarch*. Edited and translated by Morris Bishop. Bloomington: Indiana Univ. Press, 1966.

Pollard, Alfred W., ed. *The Works of Geoffrey Chaucer*. 1898. Reprint. London: Macmillan, 1904.

Randall, Lilian M. C. "Exempla as a Source of Gothic Marginal Illumination." *The Art Bulletin* 39 (June 1957): 97–107.

The Receyt of the Ladie Kateryne. Gordon Kipling, ed. EETS, o.s. 296. Oxford: Oxford Univ. Press, 1990.

Richards, I. A. *The Philosophy of Rhetoric*. London: Oxford Univ. Press, 1936.

Robbins, Rossell Hope, ed. *Historical Poems of the XIVth and XVth Centuries*. New York: Columbia Univ. Press, 1959.

———. "Popular Prayers in Middle English Verse." *Modern Philology* 36 (May 1939): 337–50.

———. ed. *Secular Lyrics of the XIVth and XVth Centuries*. 2d ed. Oxford: Clarendon, 1955.

Robert of Brunne. *Robert of Brunne's "Handlyng Synne."* Part I. Edited by Frederick J. Furnivall. EETS, o.s. 119. London: Paul, Trench, Trübner, 1901.

Robertson, D. W., Jr. *A Preface to Chaucer: Studies in Medieval Perspectives*. 1962. Reprint. Princeton: Princeton Univ. Press, 1969.

Robinson, F. N., ed. *The Works of Geoffrey Chaucer*. 2d ed. Boston: Houghton Mifflin, 1957.

Rosenburg, Bruce A. "Medieval Popular Literature: Folkloric Sources." In *The Popular Literature of Medieval England*. Tennessee Studies in Literature, edited by Thomas Heffernan, vol. 28. Knoxville: Univ. of Tennessee Press, 1985.

Rowland, Beryl. *Animals with Human Faces: A Guide to Animal Symbolism*. Knoxville: Univ. of Tennessee Press, 1973.

Rubin, Miri. *Corpus Christi: The Eucharist in Late Medieval Culture*. 1991. Reprint. Cambridge: Cambridge Univ. Press, 1993.

Ruggiers, Paul G. *The Art of the Canterbury Tales*. Madison: Univ. of Wisconsin Press, 1965.

Saintsbury, George. *A History of Criticism and Literary Taste in Europe*. 3 vols. New York: Dodd, Mead, 1900.

Salusbury, John. *Poems by Sir John Salusbury and Robert Chester*. Edited by Carleton Brown. EETS, e.s. 113. London: Paul, Trench, Trübner, 1914.

Secreta Secretorum. Robert Steele, ed. EETS, e.s. 74. London: Paul, Trench, Trübner, 1898.

Severs, J. Burke. "The Tale of Melibeus." In *Sources and Analogues of Chaucer's Canterbury Tales*, edited by W. F. Bryan and Germaine Dempster. 1941. Reprint. New York: Humanities Press, 1958.

Seward, Barbara. *The Symbolic Rose*. New York: Columbia Univ. Press, 1960.

Seward, Desmond. *The Hundred Years War: the English in France 1337–1453*. New York: Atheneum, 1978.

Skeat, Walter W., ed. *The Complete Works of Geoffrey Chaucer*. 2d ed. 7 vols. Oxford: Clarendon, 1924.

Skelton, John. *John Skelton: The Complete English Poems*. Edited by John Scattergood. New Haven: Yale Univ. Press, 1983.

Smith, Alexander. *Dreamthorp*. London: Oxford Univ. Press, 1914.

Speirs, John. *Chaucer the Maker*. London: Faber and Faber, 1951.

Spurgeon, Caroline F. E., ed. *Five Hundred Years of Chaucer Criticism and Allusion 1357–1900*. 3 vols. 1925. Reprint. New York: Russell and Russell, 1960.

Strong, Caroline. "Sir Thopas and Sir Guy. II." *Modern Language Notes* 23 (April 1908): 102–06.

Thorndike, Lynn. *A History of Magic and Experimental Science*. 8 vols. New York: Macmillan, 1923–58.

———. *Michael Scot*. London: Thomas Nelson and Sons, 1965.

Tout, T. F. *The History of England: from the Accession of Henry III to the Death of Edward III. (1216–1377)*. 1905. Reprint. New York: Haskell House, 1969.

Vicary, Thomas. *The Anatomie of the Bodie of Man*. Edited by Frederick J. Furnivall and Percy Furnivall. EETS, e.s. 53. London: Oxford Univ. Press, 1888.

Wagenknecht, Edward. *The Personality of Chaucer*. Norman: Univ. of Oklahoma Press, 1968.

Watts, P. R. "The Strange Case of Geoffrey Chaucer and Cecilia Chaumpaigne." *The Law Quarterly Review* 63 (Oct. 1947): 491–515.

Wilson, J. Dover. *What Happens in Hamlet.* 1935. Reprint. Cambridge: Cambridge Univ. Press, 1956.

Wilson, R. M. *Early Middle English Literature.* 2d ed. London: Methuen, 1951.

Woolf, Rosemary. *English Lyrics in the Middle Ages.* Oxford: Clarendon, 1968.

Wright, David, trans. *Geoffrey Chaucer: The Canterbury Tales.* 1985. Reprint. Oxford: World Classics, 1991.

Wright, Thomas and James Orchard Halliwell. *Reliquæ Antiquæ.* 2 vols. London: William Pickering, 1843.

Zesmer, David M. *Guide to English Literature: From Beowulf through Chaucer and Medieval Drama.* New York: Barnes & Noble, 1961.